CW00765216

*Museums, Health and Well-Being*

# Museums, Health and Well-Being

HELEN CHATTERJEE
*University College London, UK*

GUY NOBLE
*University College London Hospitals, UK*

© Helen Chatterjee and Guy Noble 2013

All rights reserved. No part of this publication may be reproduced, stored in a retrieval system or transmitted in any form or by any means, electronic, mechanical, photocopying, recording or otherwise, without the prior permission of the publisher.

Helen Chatterjee and Guy Noble have asserted their right under the Copyright, Designs and Patents Act, 1988, to be identified as the authors of this work.

Published by
Ashgate Publishing Limited
Wey Court East
Union Road
Farnham
Surrey, GU9 7PT
England

Ashgate Publishing Company
110 Cherry Street
Suite 3-1
Burlington, VT 05401-3818
USA

www.ashgatepublishing.com

**British Library Cataloguing in Publication Data**
A catalogue record for this book is available from the British Library

**Library of Congress Cataloging-in-Publication Data**
Chatterjee, Helen.
  Museums, health and well-being / by Helen Chatterjee and Guy Noble.
    pages cm
  Includes bibliographical references and index.
  ISBN 978-1-4094-2581-6 (hardback) -- ISBN 978-1-4094-2582-3 (ebook) -- ISBN 978-1-4724-0211-0 (epub)  1. Art therapy. 2. Museums--Therapeutic use. 3. Imagery (Psychology)--Therapeutic use. 4. Clinical health psychology.  I. Noble, Guy. II. Title.
  RC489.A7C478 2013
  615.8'5156074--dc23

2013004546

ISBN 9781409425816 (hbk)
ISBN 9781409425823 (ebk – PDF)
ISBN 9781472402110 (ebk – ePUB)

Printed in the United Kingdom by Henry Ling Limited, at the Dorset Press, Dorchester, DT1 1HD

# CONTENTS

# FIGURES AND TABLES

Figures

Tables

# FOREWORD

This book could not be more timely. The challenges to health and well-being have never been greater as we journey into the second decade of the new millennium. The so-called 'lifestyle' diseases of developed countries are now increasingly afflicting the developing world. In this very real sense, globalisation means the exportation of poor health from rich countries to less well-off nations. Inequalities in health are growing, both between countries and among social groups in individual nation states. Economic prosperity is not evenly distributed. The old adage that it is the health of your state more than the state of your health that counts could not be more true when it comes to health and well-being. Health and illness are rooted in society and culture plays a major role in determining our capacity for well-being.

In addition to the plethora of potentially avoidable non-communicable diseases, ranging from cardiovascular ill health and cancers to depression and dementia, we also face the ever-present challenge of communicable disease. New and re-emerging diseases travel with increasing impunity across the globe and we can never be certain what is just round the corner – perhaps a new strain of pandemic influenza or another SARS-type infection.

At its heart, public health is about the organised efforts of society in preventing disease, encouraging well-being and building resilience for when ill health strikes. All sectors have a role to play in creating the context for better health and museums can contribute significantly to our 'social capital' for better health.

Recent years have seen a rapid growth in our understanding of the role that the arts play in health and well-being. The relationship between culture and health is indivisible and the arts reflect the very essence of that culture. They provide a window into our values, beliefs and behaviours. They contribute to health literacy and our understanding of society and its impact on the way we live our daily lives. They provide an essential conduit between the environment and our inner selves, highlighting the interrelationship between the individual and the wider determinants of health.

Museums have not always been considered a resource for health and well-being, despite their obvious potential. As we move from a world where populations have

been defined almost entirely by their disease profile to a focus on community assets, museums must surely be one of the key 'tools in the toolbox' for well-being in the future. On the one hand, museums are observatories on history and culture, providing a lens on the relationship between health and society over time. On the other hand, from a more contemporary perspective, they offer an interactive environment that can contribute positively to present day well-being. Gone are the days when museums were viewed as static and inert. Many museums these days make the most of the latest communications media, providing engaging environments that contribute to a positive state of psychological and physiological health. Modern-day museums are multi-dimensional and multi-sensory in their approach, increasingly tactile and 'hands on'.

Museums not only allow us to reflect on our heritage and the relationship between health and society in the past, they are also part of our modern-day social capital, contributing positively to health in the future. For the present, museums offer a truly therapeutic environment with consequential emotional and physiological benefits.

The Marmot Review highlighted the social determinants of health and illness. The findings strengthened the case for an 'assets'-based approach to building capacity for better health and well-being. Health and Well-being Boards, now established in local authorities across the country, are looking at the assets in their communities as they build their capacity for health in the future. We know that health is determined largely outside of the health sector; it is not primarily a medical construct. Health, well-being and our resilience at times of stress are functions of the many formative influences upon us at every stage of the life course, and the arts in their various manifestations have so much to offer. The most significant improvements in human health have come from public health interventions, such as better nutrition and improved sanitation, not from medical care, important though it is. Of course, more evidence about the potential contribution of museums is needed, but this book sets out what we already know and understand, and provides a building block for future planning and evaluation.

The interrelationship between health, society and culture is complex. Health is part of our human capital, a resource for economic prosperity and social development. In turn, our social circumstances and environment determine in large measure our capacity for health and well-being, and we must exploit all of our assets if we are to achieve our health potential and reduce inequalities between different social groups. What better asset can there be than the most fundamental of all windows on society – museums? They allow us as individuals and communities to connect with our cultures and it is these very cultures, past and present, that set the context for health in the future.

<div style="text-align: right;">

Professor Richard Parish, CBiol, FSB, FFPH, FRSPH,
Chief Executive, Royal Society for Public Health and Chair,
National Pharmacy and Public Health Forum, UK

</div>

# ACKNOWLEDGEMENTS

We are extremely grateful to numerous collaborators and colleagues who helped make this book possible. First, we thank Dr Linda Thomson who has worked with us as a Postdoctoral Research Associate over the past five years on various research projects associated with museums, health and well-being. Linda's depth and breadth of knowledge, and her commitment and dedication to our research programme have significantly contributed to the field of museums, health and well-being, and have helped to inform the content and direction of the book. We are deeply indebted to her.

We are very grateful to the Arts and Humanities Research Council, which has sponsored several research projects discussed in this book, including the *Heritage in Hospitals* research project. We gratefully acknowledge the following awards (PI: HJ Chatterjee): AH/G000506/1; AH/J500700; AH/J008524/1.

We are also grateful to several collaborators with whom we have enjoyed many lively and informative discussions: Dr Anne Lanceley; Professor Usha Menon; Professor Paul Camic; Jocelyn Dodd; Erica Wheeler; Hannah Paddon; and Nic Vogelpoel. We especially acknowledge Paul Camic for his support, encouragement and help during the writing of this book. We are also very grateful to Raquel Pinto, Mary Gillespie and Lindsay Bontoft, MA Museum Studies students, who assisted in the collation of a database comprising details of museums, health and well-being projects; much of their hard work is evident in the chapters, providing information about current health and well-being provision in the UK and beyond.

Colleagues at UCL, UCL Museums and Public Engagement and UCL Hospitals NHS Foundation Trust have been extremely supportive, and we thank in particular: Sally MacDonald; Michael Worton; Hannah Umar; Lauren Sadler; and Annie Lindsay. We are especially grateful to those museum staff that provided access to their collections for use in our research: Jack Ashby; Nick Booth; Mark Carnall; Ian Carroll; Subhadra Das; Jayne Dunn; Andrea Fredericksen; Wendy Kirk; Susi Pancaldo; Nina Pearlman; Stephen Quirke; and Rachel Sparks.

We are also grateful to Damian Hebron, Director of the London Arts and Health Forum for his support.

Numerous colleagues from museums, galleries and other organisations across the UK and internationally contributed information for this book, for which we are very grateful. The following colleagues generously donated case study and other supplementary material: Manchester Museums and Galleries (Wendy Gallagher, Myna Trustram and Emma Anderson), Nottingham City Museums & Galleries (Annabel Elliott); Bethlem Art and History Collections Trust (Annabel Elliott); Bethlem Royal Hospital Archives and Museum (Victoria Northwood); Beamish Museum (Michelle Ball and Helen Barker); the Museum of Oxford (Helen Fountain); Salford Museum and Art Gallery (Naomi Lewis); the British Museum (Harvinder Bahra and Laura Phillips); Thackray Museum and the UK Medical Collections Group (Joanne Bartholomew and Alison Bodley); Colchester and Ipswich Museums (John Pollard and Lynette Burgess); Healing Arts: Isle of Wight (Guy Eades); Tyne & Wear Archives & Museums (John Hentley); the Lightbox (Rib Davis); Glasgow Museums (Claire Coia, Chris Jamieson, Mary Johnson, John-Paul Sumner and Caroline Currie); Leicestershire's Open Museum (Nikki Clayton); the Museum of Hartlepool (Sandra Brauer); Sudley House, National Museums Liverpool (Justine Karpusheff and Mandy Chivers, Assistant Chief Executive, Mersey Care NHS Trust); National Museums Liverpool (Claire Benjamin); Acces3Ability (Colette Neal); Waterford Healing Arts Trust (Mary Grehan); the Irish Museums Association (Gina O'Kelly); Heritage Council Ireland (Geni Murphy); the Museum Standards Programme for Ireland (Lesley-Ann Hayden); Macquarie University Art Gallery (Rhonda Davis and Sara Smyth-King); the History Trust of South Australia, Government of South Australia (Pauline Cockrill and Allison Russell); Arts in Health at Flinders Medical Centre (Sally Francis); Helping Hand Aged Care (Susan Emerson); Helsinki Metropolia University of Applied Sciences (Pia Strandman); Medical Museion, University of Copenhagen (Professor Thomas Söderqvist); American Alliance of Museums (Ariana Carella); and many other colleagues from museums and arts organisations. We also thank all of the participants in the projects and programmes discussed in this book; their feedback and input has been invaluable.

We gratefully acknowledge the kind words provided by Professor Richard Parish, Chief Executive, Royal Society for Public Health and Chair, National Pharmacy and Public Health Forum, for writing the Foreword to this book. We are also very grateful to Lois Silverman, Constance Classen and Mark O'Neil for reading and reviewing the manuscript.

Finally, we thank our families and friends for their enduring support.

# MUSEUMS, HEALTH AND WELL-BEING

## INTRODUCTION

Many populations are facing an unprecedented socio-economic challenge. Individuals are living longer but with unhealthier lifestyles, with a significant rise in age- and lifestyle-related diseases, such as Alzheimer's and diabetes. A key consequence of these trends is considerable pressure on health services (including the National Health Service (NHS) in the UK) and social services. In addition, evidence reveals that there is a 'social gradient' in relation to health, whereby individuals from poorer socio-economic backgrounds experience reduced health, well-being and social resilience (the Marmot Review: Marmot et al. 2010; GCPH 2010). The Marmot Review recognises that a range of social factors must be taken into account in order to alleviate health inequalities and that services such as the NHS alone cannot reduce health inequalities. It goes on to suggest that social networks and local communities strongly influence individual health and well-being, and, further, that the extent to which people are able to participate in society and control their own lives makes a 'critical contribution to psychosocial well-being and health' (Marmot et al. 2010).

Health reforms in the UK as part of the Health and Social Care Act 2012 are also placing greater emphasis on the role of communities through the notion of a *Big Society*, which seeks to create an environment that empowers local communities and people to take collective responsibility for their environment, communities and public health. A key focus of these health reforms sees a shift towards 'prevention is better than cure', within a model which will require a multi-agency approach with an increased reliance on third-sector organisations such as charities, voluntary and community organisations. Not without controversy and opposition, these radical health reforms will change the way in which health and social care services are delivered; this may create not only new challenges but also opportunities for organisations such as museums, which have traditionally not been part of the 'public health offer'. The inclusion of museums under the Arts Council England umbrella is also likely to encourage a museum sector shift which recognises the value of creative experiences and access to knowledge and information in relation to health and well-being (ACE 2011).

This book seeks to define a new field of study and practice in museology, namely *Museums in Health*. The field is grounded in *Arts in Health* and draws heavily from research stemming from this field of study and associated good practice (Chapter 2). The book aims to encourage heritage professionals to promote museums as assets for enhancing health and well-being. It brings together a breadth of literature pertinent to the debate around the value of museums and cultural encounters in relation to tangible health and well-being outcomes, and explores the underlying psychological and physiological mechanisms which explain the value of Museums in Health (Chapter 3). Practice-based examples are explored in detail, including several case studies written by museum professionals, exemplifying the diversity of current Museums in Health practices (Chapter 4). The evaluation methods and approaches for measuring health and well-being in relation to cultural encounters are critically examined (Chapter 5) and recommendations for the future development of the field are offered (Chapter 6).

## BACKGROUND

It is widely acknowledged that the environment has a significant effect on individual health and well-being. Roger Ulrich's seminal study from 1984, for example, provided some of the first quantitative evidence to show that patients with views of nature recover more quickly after surgery compared to those with no view of nature (Ulrich 1984). The idea that objects may have therapeutic value is also not new. Florence Nightingale noted the effects that objects could have on patient recovery, suggesting that the 'variety of form and brilliancy of colour in the objects presented to patients are actual means of recovery' (Nightingale 1860: 58). It is well established that museums are custodians of objects of historical, scientific or other significance, and are concerned with collecting, cataloguing, displaying and providing interpretations of objects for the benefit of furthering knowledge and encouraging the public to engage with, and learn about, their own and others' heritage. However, museums and galleries are now beginning to articulate a less paternalistic approach to engaging with their public by recognising the therapeutic and health benefits that their collections and resources can offer.

Not surprisingly for some, this raises the question of why should museums be involved in the business of delivering health benefits to their audiences in the first place? The same argument has been directed at the arts more generally. Belfiore, for example, has questioned the impact that museums and galleries have made to social outcomes. She explores the 'instrumental' aspects of government policy and public arts organisations in using the arts as a means to tackle social inclusion, drawing attention to a shift towards 'an instrumental cultural policy, which justifies public expenditure in the arts on the grounds of the advantages that they bring to the nation' (2002: 92). This stance focuses on the policy implications for the future funding of subsidised arts and arts organisations as agents of social

change, arguing that if social benefits cannot be demonstrated, funding will be lost to those organisations that are better set up to deal with social issues. Whilst this may be a worthwhile debate, rather than justify the wider role and funding for museums and the cultural heritage sector, this book primarily seeks to explore the evidence base for museums' role in healthcare and does not set out to make a case for instrumentalism in museums. However, it does recognise that individual and community health and well-being is complex and fluid, and as such the health services offered should reflect this. The increasing pressures on health services and governments on personal choice in healthcare do provide potential opportunities for museums to use their collections in a more altruistic way. Notwithstanding this, we are in agreement with Belfiore and others who recognise the importance of gathering a strong evidence base which is grounded in a critical evaluation of the social impact of the arts (Belfiore 2002; Staricoff 2006; Belfiore and Bennett 2007). It is vital that Museums in Health is supported by robust and reliable evidence, not only to justify public expenditure in this area, but crucially to ensure that museums and their partners deliver effective and efficient services which meet the needs of their audiences. Thus, the debate as to whether museums should consider health and well-being outcomes at all is largely beyond the remit of this book, as the same argument could be levelled at virtually any area of museum programming; for example, why should museums focus on the intrinsic educational value of their collections? Does this imply that the intrinsic value of objects is more important than the instrumental value of using them for societal benefit, whether that be for educational or well-being objectives? We argue that it is not a case of 'either/or' and that museums can be viewed in their widest sense as more than simply places where objects are kept for posterity:

> Museums and galleries have always served a number of purposes other than the evident one of enabling visitors to appreciate their collections of art and artefacts. They are a site for social interaction and for acquiring and conveying an air of cultural authority. They may provide a cool place on a hot day or a quiet retreat. (Classen 2007: 897)

Many authors have described the social role of museums (e.g. Sandell 2002; Classen 2005; Silverman 2010) and the link between health and socio-economic status is well understood, as discussed above (e.g. Marmot et al. 2010; GCPH 2010). Most Western approaches to healthcare are firmly rooted within the medical profession, despite increasing awareness of the negative health outcomes associated with low income, poor housing and other socio-economic factors (Dodd et al. 2002). As Dodd describes, 'medical expertise can diagnose disease, treat individuals' symptoms but do little or nothing to prevent the cause of depression, stress and chronic disease resulting from unemployment, the disintegration of stable relationships, poor housing and poverty' (Dodd et al. 2002: 183). The concept of preventative versus remedial medicine is also not new, but for many people preventative approaches to medicine are shrouded in doubt and disbelief.

This is for good reason in many cases; as with remedial healthcare, preventative healthcare requires a robust evidence base gathered using standardised, reliable and repeatable techniques. Sadly the latter is lacking for many preventative approaches to healthcare, but with museums' expertise in evaluation, albeit often geared towards educational outcomes, the transition to securing health and well-being outcomes should not, in theory, be too onerous. Furthermore, given the forthcoming health and social care reforms in the UK, it is extremely timely for the museum sector to reposition itself as a core asset in the new framework, the central tenet of which will see a focus on 'prevention is better than cure'.

One of the biggest challenges for museums is *understanding*, *demonstrating* and *articulating* their value (both preventative and remedial) to individual and societal health (both physical and psychological) and well-being. These three challenges form the focus of this book, which seeks to define a new field of Museums in Health.

## THE THERAPEUTIC POTENTIAL OF MUSEUMS

Lois Silverman has described the museum as a promising tool for therapy and, further, that 'through their therapeutic potential, museums have a means to social inclusion of individuals who are often overlooked by cultural institutions' (2002: 70). She advocates that one pathway to expanding the social role of museums is to recognise their therapeutic potential. By acknowledging that museums assume a healthy visitor population and that those facing health challenges, such as people with depression, adjusting to older age and associated loss of function, those with terminal illness or those dealing with substance abuse, are often excluded from museums, Silverman proposes that museums could play a valuable therapeutic role.

In her recent book *The Social Work of Museums*, Silverman suggests that museums contribute to the pursuit of health in five major ways: promoting relaxation; an immediate intervention of beneficial change in physiology, emotions or both; museums encourage introspection which can be beneficial for mental health; museums foster health education; and museums are public health advocates and enhance healthcare environments (Silverman 2010: 43). The role of museums as agencies which encourage social cohesion and interaction, affording enhanced psychosocial well-being, might also be added to this list. These are, by necessity, generalisations and not all museums are working to address these agendas, but they highlight the potential contribution that museums can make to individual psychological and physiological health, and public health.

Silverman (2002) describes a collaborative project from 1997 at Indiana University (MATA: Museums as Therapeutic Agents) which brought together

museum staff, social/mental health programmes, researchers and students. The aim of this innovative project was to study a set of pilot museum programmes with explicitly therapeutic goals and to develop a better understanding of the therapeutic potential of museums. The study resulted in the identification of eight concepts pertaining to the theory and practice of museums as therapeutic agents; four of these concepts relate to mental healthcare and four to the unique environment of museums (Silverman 2002: 71). Regarding the latter, Silverman identified the following concepts as fundamental to the therapeutic role of museums: 1) people's response to artefacts in museums, where she explores the power of objects to elicit responses from people; 2) interpretive media, where she advocates that a wide variety of media can be harnessed towards therapeutic outcomes; 3) the social roles possible in museums, where museums can help reinforce a sense of self and connection to others, which is particularly important for those experiencing decreased health or function; and 4) the need for ongoing evaluation.

Many of these themes plus new ideas pertinent to the emerging Museums in Health field will be developed throughout this book. The themes are helpful as a vehicle for exploring not only the therapeutic potential of museums but also the underlying theoretical and conceptual basis for understanding the value of museums for enhancing health and well-being. A wider exploration of these issues is crucial in order to clearly articulate the therapeutic value of museums across the cultural sector and beyond, particularly to the health sector.

Silverman advocates a focus on outcomes since this provides a framework to acknowledge and support the varied aspects of a museum encounter (2002). This is a valuable approach as it is also the framework for evaluating individual health and well-being. Outcome measures in healthcare are the key criteria for assessing the impact of a particular intervention (be it pharmacological or otherwise) and for assessing change in patients over time. For Silverman, lessons from the field of mental healthcare can enrich our understanding of what sorts of therapeutic outcomes that museums might facilitate, since 'mental health can remind museums of the range of goals that are essential for a health society' (2002: 75). Whilst this is undoubtedly valuable, we advocate incorporating a wider spectrum of healthcare outcomes, including physical and psychological, into the planning, design, evaluation and communication of the therapeutic value museums. Healthcare outcomes are the main currency and language used by healthcare professionals, and if museums are to clearly articulate their therapeutic potential, it is essential to communicate and define a system which is understood and valued by both sectors. Practitioners need to think strategically, focusing first on health priorities and how they in turn can support heritage priorities. Through establishing better links with health organisations, practitioners can begin to understand the business and management of health which is essential if this field of work is to be sustained.

## SOME DEFINITIONS

Since the study of the role of Museums in Health is relatively new, it is appropriate to attempt to define some recurring terms. The focus of this book is museums (to include galleries) and the cultural heritage collections (see Article 1, UNESCO 1972) such institutions house or represent. The word 'culture' is used as a catch-all term in this and comparable contexts (e.g. Ruiz 2004) to include museums, galleries, libraries, literature, theatre, dance, festivals and celebration, music, crafts, film and art. 'The arts' is often referred to as a separate entity, but includes not only the people and places producing and experiencing art but also artworks and art collections. Davies et al. (2012) recently sought to define arts engagement via art forms, activities and level (magnitude) of engagement, and proposed that arts engagement can be defined by five art forms: performing arts; visual arts, design and craft; community/cultural festivals, fairs and events; literature; and online, digital and electronic arts. Interestingly, this study and other literature refer to visiting a museum or gallery as arts engagement. In other words, there is some overlap between the use of the terms 'culture' and 'the arts', but suffice to say that although the focus of this book is on the cultural heritage sector (museums, galleries and heritage sites), examples, evidence and ideas from the broader cultural sphere will, through necessity, be drawn upon. The term 'cultural encounter' is used here to define any interaction with a cultural heritage organisation and its collections, including: visiting museums, galleries and heritage sites; exhibition and gallery tours; talks and lectures; and participatory and creative sessions such as art workshops, object handling and reminiscence activities. The term 'museum encounter' is likewise used to refer to any interaction with a museum (or gallery), its collections, its staff or its spaces.

Health and well-being are two of the top agenda items for most developed and developing countries, and are often used in combination with each other. The World Health Organization (WHO) defined health as 'a state of complete physical, mental and social well-being and not merely the absence of disease or infirmity' (WHO 1946: 100). There is relatively little dispute about the definition of health, but the same cannot be said for well-being. Well-being is an ambiguous term which has little agreement among disciplines on its definition or measurement and is often conflated with 'health', 'quality of life' and 'happiness' (Galloway and Bell 2006; Ander et al. 2011; Thomson et al. 2011). Ereaut and Whiting, writing for the Department for Children, Schools and Families, suggest that 'well-being is no less than what a group or groups of people collectively agree makes "a good life"' (2011: 1). A useful definition is that by the UK Think Tank the New Economics Foundation (NEF). NEF defines well-being as 'most usefully thought of as the dynamic process that gives people a sense of how their lives are going, through the interaction between their circumstances, activities and psychological resources or "mental capital"' (NEF 2009: 3). NEF suggests that in order to achieve well-being, people need:

a sense of individual vitality to undertake activities which are meaningful, engaging, and which make them feel competent and autonomous, a stock of inner resources to help them cope when things go wrong and be resilient to changes beyond their immediate control. It is also crucial that people feel a sense of relatedness to other people, so that in addition to the personal, internally focused elements, people's social experiences – the degree to which they have supportive relationships and a sense of connection with others – form a vital aspect of well-being. (NEF 2009: 9)

## THE CONCEPTUAL BASIS FOR MUSEUMS IN HEALTH

In Chapter 2 we explore the role of Arts in Health, what it means and how Museums in Health has emerged from the Arts in Health field. Within the chapter, there is description of the five main domains (Dose 2006) of Arts in Health and an exploration of some of the challenges facing both the Arts in Health and the Museums in Health sectors in measuring impact and in particular the health and well-being benefits that the arts can bring to society. Chapter 2 touches on some of the academic literature and references, including the most recent reviews of Arts in Health activity across the UK, in order to provide a picture of practice and how that might inform museum professionals embarking on Museums in Health projects. For practical reasons, it does not review all the academic literature in the field; however, it is worth noting here some of the most influential studies that evidence culture's impact on health and well-being.

Although anecdotal, observations by Florence Nightingale made over 150 years ago are still powerful today when expressing the possible power that museum objects could have on the health of a population. Nightingale's *Notes on Nursing* highlights the importance of variety in patient's environment, noting that views out of a window or of different objects are actual means of recovery (Nightingale 1860). It is easy to dismiss Nightingale's observations, particularly in the light of healthcare practitioners' requirements of a robust, systematically derived, evidence base which is founded on a standardised experimental approach (which is important in the validation of the evidence base). However, anecdotal observations such as Nightingale's are useful in combining both the quantitative and qualitative evidence base when presenting a more approachable face to research.

There has been significant effort by some in the Arts in Health sector to move away from a purely anecdotal approach to one which is more rigorous and respected within both the health and academic communities of healthcare. This has created some tensions within the sector over the suitability and appropriateness of evaluating arts-based activities within a medical evaluation framework (which is touched on in Chapter 2), not least because of the inherent difficulties facing Arts in Health researchers (Raw et al. 2012). These difficulties stem from the breadth,

depth and variety of art forms and delivery methods, the varying healthcare contexts in which projects operate, and the numerous health needs of the participants and how these needs might be addressed. Despite this, the sector has been rewarded with an ever-increasing evidence base.

Clift et al. (2009) provide a current picture of this provision as well as the practice, policy and research in England today. This review, coupled with Rosalia Staricoff's literature review (2004), is an excellent starting point for Museums in Health professionals wishing to delve deeper into the evidence base. Below are a number of other noteworthy studies concentrating on particular health issues, including dementia, cancer and mental health.

## DEMENTIA

Several studies highlight the value of Arts in Health for older adults and older adults with various forms of dementia, including Alzheimer's disease (Cohen 2009; Cutler 2009; Zeisel 2009). It has been suggested, for instance, that the actual aesthetic response of viewing and making art within an art gallery has a positive effect on people with dementia (Eekelaar et al. 2012). Furthermore, Cohen (2009) reviews several studies which show that the arts and music contribute to healthy ageing.

## CANCER

Within cancer care, increasing numbers of arts-focused interventions have employed quantitative methods to assess health and well-being. These are summarised in Thomson et al. (2012a) as follows:

- Weekly live-music and art exhibitions for patients receiving chemotherapy were assessed over two months. The Hospital Anxiety and Depression Scale (HADS; Zigmond and Snaith 1983) demonstrated lowered anxiety and depression compared with non-intervention controls, though differences were non-significant (Staricoff and Loppert 2003).
- A pre-test post-test, six-month trial with caregivers of cancer patients tested the effectiveness of a caregiver-delivered, creative arts intervention. The Mini Profile of Mood States (Mini-POMS; McNair et al. 1992) showed significant decreases in caregiver stress (patients were not assessed) (Walsh et al. 2004).
- A pre-test post-test trial employing one-hour art therapy sessions for patients with cancer was used to explore symptom control. The Edmonton Symptom Assessment Scale (ESAS; Bruera et al. 1991) and State-Trait Anxiety Index (STAI-S; Spielberger and Sydeman 1994) demonstrated significant reductions in post-intervention symptoms (Nainis et al. 2006).

- A randomised controlled trial (RCT) piloting four, weekly creative arts interventions was conducted with participants with newly diagnosed breast cancer. The Short Profile of Mood States (POMS-SF; Shacham 1983) showed enhanced psychological well-being where positive emotions increased and negative emotions decreased (Puig et al. 2006).
- An RCT was used to evaluate a dance-and-movement programme for breast cancer survivors. The Functional Assessment of Cancer Therapy-Breast (FACT-B; Brady et al. 1997) showed significant improvements in quality of life after 12 weeks (Sandel et al. 2005).

The studies exemplify the diversity of Arts in Health interventions used with cancer patients as well as the range of health measures used to assess outcomes.

## MENTAL/GENERAL HEALTH

Cuypers et al. (2012) conducted a large population study in Norway involving over 50,000 adult participants to assess the role of cultural activities on perceptions of health, anxiety, depression and satisfaction with life. Questionnaires were used to ascertain that participation in both receptive and creative cultural activities was significantly associated with good health, good satisfaction with life, low anxiety and depression, even when the data was adjusted for confounding factors. More specifically, the effects of singing on mental health and other aspects of health have also been widely studied. Cohen et al. (2006) outline a study comprising 166 healthy older adults based on a singing (choral) intervention. Using a quasi-experimental approach, approximately half of the participants joined a singing group (intervention group) and the rest continued activity as usual (comparison group); groups were assessed at baseline and after 12 months. Results revealed that the intervention group reported a higher overall rating of physical health, fewer doctor visits, less medication use, fewer instances of falls, fewer other health problems, increased morale and less loneliness than the comparison group. Clift et al. (2010a) review a number of research reports investigating the link between singing and health and well-being in non-clinical samples, and subsequently a large-scale study led by Clift involving over 600 choral singers from English choirs resulted in the identification of a series of positive benefits affecting happiness, a sense of social support and friendship which ameliorate feelings of isolation and loneliness, and keeping the mind and body active (Clift et al. 2010b). Devlin (2010) also highlights how the arts contribute to good health, as opposed to how the arts are used to combat ill health.

The above draws attention to a range of studies which examine the effects of Arts in Health on different aspects of health and well-being; further studies are discussed in Chapter 2. Froggett et al. (2011) point out that despite a diversity of studies that seek to address the impact of arts participation on health and well-being, the absence of a common framework to evaluate these effects

is problematic. Clift is in agreement, stating that 'progress in the field of arts and heath is crucially dependent upon the development of coherent theoretical frameworks for understanding how involvement in the arts can result in benefits for well-being and health' (Clift et al. 2009: 17). The same is also true regarding the effects of museum engagement.

## CULTURAL PARTICIPATION: THE EVIDENCE

Matarasso (1997) reports one of the most comprehensive and widely cited studies to date regarding the wider impact of participation in arts, although it should be noted that this work is not without its critics (Merli 2002). The research draws from a diverse range of participatory arts programmes including cultural festivals, museum outreach programmes and community arts projects. A total of 60 projects were looked at in detail, with a further 30 used more peripherally; 513 participant questionnaires were completed and data from a further 500 participants were included from case studies. The study employed a range of social science methodologies including questionnaires, interviews, formal and informal discussion groups, participant observation and other survey techniques. During the planning stages, the study team developed six key themes against which to assess and organise response material. These are outlined below, including the statistics derived from the more quantitative aspects of the study.

### Personal Development

- 84 per cent felt more confident about what they can do.
- 37 per cent decided to take up training or a course.
- 80 per cent learnt new skills by being involved.

### Social Cohesion

- 91 per cent made new friends.
- 54 per cent learnt about other people's cultures.
- 84 per cent became interested in something new.

### Community Empowerment and Self-determination

- 86 per cent wanted to be involved in further projects.
- 21 per cent had a new sense of their rights.

### Local Image and Identity

- 40 per cent felt more positive about where they live.
- 63 per cent became keen to help in local projects.

## Imagination and Vision

- 86 per cent tried things they had not done before.
- 49 per cent thought taking part had changed their ideas.
- 81 per cent said being creative was important to them.

## Health and Well-being

- 52 per cent felt better or healthier.
- 73 per cent were happier since being involved.

Matarasso identified a series of generic findings regarding health and well-being which suggest that participation in the arts can have a positive impact on how people feel, be an effective means of health education, contribute to a more relaxed atmosphere in health centres, help improve the quality of life of people with poor health and can provide a unique and deep source of enjoyment (1997: 64). Again, due to the lack of studies focused on heritage and health, these outcomes pertain to projects and programmes focused on broader cultural and arts participation, such as community arts projects with health education aims. The full spectrum of outcomes from Matarasso's research cannot be done justice here, but of particular significance is a set of 50 social impacts of participation in the arts which have been widely cited across the arts/culture and health literature (1997: VI):

1. Increase people's confidence and sense of self-worth.
2. Extend involvement in social activity.
3. Give people influence over how they are seen by others.
4. Stimulate interest and confidence in the arts.
5. Provide a forum to explore personal rights and responsibilities.
6. Contribute to the educational development of children.
7. Encourage adults to take up education and training opportunities.
8. Help build new skills and work experience.
9. Contribute to people's employability.
10. Help people take up or develop careers in the arts.
11. Reduce isolation by helping people to make friends.
12. Develop community networks and sociability.
13. Promote tolerance and contribute to conflict resolution.
14. Provide a forum for intercultural understanding and friendship.
15. Help validate the contribution of a whole community.
16. Promote intercultural contact and cooperation.
17. Develop contact between the generations.
18. Help offenders and victims address issues of crime.
19. Provide a route to rehabilitation and integration for offenders.
20. Build community organisational capacity.
21. Encourage local self-reliance and project management.

22. Help people extend control over their own lives.
23. Be a means of gaining insight into political and social ideas.
24. Facilitate effective public consultation and participation.
25. Help involve local people in the regeneration process.
26. Facilitate the development of partnership.
27. Build support for community projects.
28. Strengthen community cooperation and networking.
29. Develop pride in local traditions and cultures.
30. Help people feel a sense of belonging and involvement.
31. Create community traditions in new towns or neighbourhoods.
32. Involve residents in environmental improvements.
33. Provide reasons for people to develop community activities.
34. Improve perceptions of marginalised groups.
35. Help transform the image of public bodies.
36. Make people feel better about where they live.
37. Help people develop their creativity.
38. Erode the distinction between consumer and creator.
39. Allow people to explore their values, meanings and dreams.
40. Enrich the practice of professionals in the public and voluntary sectors.
41. Transform the responsiveness of public service organisations.
42. Encourage people to accept risk positively.
43. Help community groups raise their vision beyond the immediate.
44. Challenge conventional service delivery.
45. Raise expectations about what is possible and desirable.
46. Have a positive impact on how people feel.
47. Be an effective means of health education.
48. Contribute to a more relaxed atmosphere in health centres.
49. Help improve the quality of life of people with poor health.
50. Provide a unique and deep source of enjoyment.

The outcomes derived from Matarasso's study are unavoidably broad due to the nature of the research and diversity of projects included, so it is difficult to draw more direct and tangible outcomes. There is also an issue regarding the transparency of the correlation between the questionnaire responses and the outcomes discussed above, which is in part due to the limited details provided about the research methods employed to derive the outcomes. This was highlighted by Merli (2002) in a critical review of the Matarasso study (for a rebuttal, see Matarasso 2003). Merli's review proposes several methodological shortcomings, including questions that are leading and may have encouraged respondent bias. For example, as Merli points out, questions such as 'Since being involved, have you felt better or healthier?' (where the permissible answer was: 'yes/no/I don't know') allowed the respondent to express either no change or a positive improvement but no negative change, which means the respondent was unable to state if he or she felt worse. This positivist approach is not uncommon in the

evaluation of social and cultural activities, including museum evaluation, and this highlights the value in adopting more objective and transparent methods, even when subjective data forms the basis of the evaluation, and here qualitative and quantitative methods used within a mixed-methods, interdisciplinary framework may be of benefit (Pope and Mays 2006; Staricoff 2006; Raw et al. 2012). Further criticisms levelled at the Matarasso study include the fact that the research design had no control groups, so confounding variables could not be accounted for, and the study was not longitudinal (Merli 2002). Again this is not uncommon in many areas of research, but the 'causal' relationship is a common issue in this area of study, and determining whether a cultural activity and health is correlational or causal is problematic (Davenport and Corner 2011). Even when a study is able to show statistically significant results which indicate a correlation between the tested variables, proving that the effects are caused by a particular intervention or activity is challenging, and again it is here that the use of mixed methods may be advantageous. Finally, there is also a distinction between active and passive engagement in the arts and the need for a common terminology from which research can be developed, as discussed by Davies et al. (2012) and Raw et al. (2012). This, in turn, highlights the need for focused heritage-specific research, and in the decade or so since the Matarasso study, this has been forthcoming, albeit on a small scale and often largely restricted to case studies. This is not to say that case studies and reviews are not of value; indeed, the opposite is true as these contributions give life to an otherwise largely inaccessible (to the non-academic community) and often hard-to-navigate landscape. Some of the most significant studies and reports are discussed in this book, but this is by no means all of the literature that is relevant to this debate.

Ruiz (2004) reviewed a range of literature regarding the benefits of participating in culture and sport in order to inform Scottish policy development and future investment in culture, the arts and sport. The report examines a variety of evidence that demonstrates both social and economic benefits from wider participation in culture and sport, and highlights an important and recurring challenge, namely that there is no consistent approach to evaluating or measuring the impact of participation or those programmes and organisations (such as museums) offering such programmes. This will be discussed in further detail in Chapter 5, but it is a common problem faced by many reviews, and this book is no exception.

Of the studies reviewed by Ruiz pertaining to museums, she concluded that: 'Innovative and creative outreach work in museums can reach socially excluded groups and develop new skills, increase self-esteem and confidence and enhance formal and informal learning' (Ruiz 2004: Chapter 2) and, furthermore, that whilst minority groups recognise that museums and galleries play a valuable role, they view them as 'elitist and not for them' (Ruiz 2004: Chapter 3). There are plenty of examples from museums where this is not the case, however. Work undertaken at the Manchester Museum with diaspora communities highlights the unique

social role that museums can play in helping to overcome the many challenges faced by individuals from such communities; including tackling issues such as social isolation, exclusion, anxiety, insecurity, sadness, loss, fear, intimidation and sometimes confusion. This is eloquently explored by Lynch (2008) following sustained work with several diaspora groups, with a particular focus around using museum objects to provide a sensory process for exploring emotions, stories, knowledge and experiences. The work highlights the value of touch and the sensory experience, which is the theme of other chapters from the same book (Chatterjee 2008), showing that objects can provide a route to recovery and enhanced understanding about emotional states.

O'Neill (2009, 2010) provides a useful review of studies which have sought to capture the impact of cultural participation (referred to by O'Neill as 'general cultural participation', including visiting museums and galleries, going to the cinema, attending music events, singing in a choir and reading books) on health and well-being. The studies ranged in scope, size and the target population demographic, but the large-scale studies in particular are compelling. For example, in a study comprising 10,600 Swedish adults, Konlaan et al. (2000) found higher mortality risk for those people who rarely engaged in cultural activities (visiting cinemas, concerts, museums and art exhibitions) compared to those who engaged in such activities more frequently, when the study cohort were followed up after 14 years. The authors controlled for variables such as age, sex, educational standard and smoking. Another Swedish study assessed the effects of cultural attendance on cancer-related mortality (Bygren et al. 2009) and determined that from a cohort of 9,000 cancer-free adults, death from cancer was 3.23 and 2.92 times more likely among rare and moderate attendees respectively, compared to frequent attendees. Other studies report that increased cultural participation leads to increased self-reported health status (Johansson et al. 2001; Wilkinson et al. 2007). Furthermore, a study of 1,200 mothers in Lebanon revealed that maternal cultural participation was a significant predictor of child health (Khawaja et al. 2007).

## SUMMARY

In summary, there is considerable evidence regarding the health and well-being benefits of cultural/arts participation and this is extremely beneficial in helping to define the emerging field of Museums in Health, but navigating this literature and understanding the discrete role of museums and cultural heritage is challenging for two reasons: first, few studies have been carried out to explicitly understand the value of museums to health and well-being, despite numerous examples of good practice; and, second, a problem highlighted earlier, is the lack of a unified, agreed evaluation or measurement approach for assessing the contribution of museums to individual and/or community health and well-being. These two challenges will be explored in the following chapters of this book.

# THE ROLE OF ARTS IN HEALTH

It is crucial to stress that Museums in Health is grounded in the field of Arts in Health and it is this sector that currently provides the majority of literature demonstrating arts contribution to health. Whilst there is not space here to do justice to the full scope of literature covering Arts in Health, it is useful to explore its background and in so doing provide the context in which Museums in Health work has developed. This chapter will offer insights into some of the political challenges and practical issues of working in the health sector that may well be pertinent to museum professionals.

In the summer of 2005, University College London Hospitals NHS Foundation Trust opened its new flagship hospital on Euston Road: University College Hospital. Surprisingly it was not the state-of-the-art facilities offered by the hospital that caught the attention of the press, but the art within it, notably a sculpture by John Aiken entitled *Monolith and Shadow*, which sits on the steps just outside the main entrance to the hospital. The sculpture, a beautifully polished composite granite sourced from a prehistoric river bed in Brazil, was quickly nicknamed the 'Pebble' by tabloid newspapers and became the centre of a wider press furore over NHS spending on art. The press had great fun, with headlines such as: 'Taking the Picasso – £9 million NHS Art Bill' – and – 'Off Their Rockers, Hospital Spends £70,=000 on Giant Pebble'. Despite the vast majority of money spent on the arts coming from charitable sources – the 'pebble', for example, was funded charitably by the Kings Fund's Enhancing the Healing Environment programme[1] – the tabloids did not let this get in the way of a good story and buried the facts at the end of their articles. For some NHS boards, who were sensitive to media criticism, this created a lasting nervousness around the use of the arts within healthcare, and consequently the need to justify the arts role has never been stronger. However, in spite of this negative coverage around spending on art, it served to open a debate around the role of arts in health and in so doing demonstrated to the public the

---

1    The King's Fund's Enhancing the Healing Environment Programme encourages and enables nurse-led teams to work in partnership with patients to improve the environment in which to deliver care. See http://www.kingsfund.org.uk/publications/ehe_care_environment. html.

breadth and depth of the sector. The media spotlight energised the Arts in Health sector to lobby the Department of Health (DH) and Arts Council England (ACE) to publish the case for the role of arts in health. The result was the publication of two documents: *Report of the Review of Arts and Health Working Group* (2007);[2] and *A Prospectus for Arts and Health* (2007).[3] These documents draw on evidence such as Dr Rosalia Staricoff's medical literature review in 2004, which cites 385 papers that explicitly link the benefits of the arts on a wide range of health and well-being outcomes. Within the *Report of the Review of Arts and Health Working Group*, the DH made a clear statement in support of the role of the arts in health: 'The Arts are, and should be firmly recognised as being integral to health, healthcare provision and healthcare environments' (2007: 3).

But what do we mean when we talk about Arts in Health and exactly how are the arts integral to health, healthcare provision and healthcare environments? In their illuminating article, Clift et al. (2009) offer an overview of Arts in Health work in the UK and Ireland today, focusing on policy, practice and research as well as highlighting the various descriptions and definitions of what Arts in Health work is all about. The Waterford Healing Arts[4] programme based in Ireland, for example, sees it as 'arts practice with clear artistic vision, goals and outcomes that seeks to enhance individual and community health and well-being'. Mike White defines Arts in Health work as 'creative activities that aim to improve individual or community health using arts-based approaches, and that seek to enhance healthcare delivery through provision of artworks or performances' (White 2009: 2).

It was Aristotle who wrote that 'the quality of life is determined by its activities', and it is tantalising to imagine that one of the activities to which Aristotle is referring is indeed the arts and the active engagement and participation with them determining the quality of one's life. This in essence is what Arts in Health work is all about; the aspiration to improve and maintain individuals' and communities' quality of life or health through the arts. The commonality threading through these definitions is that Arts in Health practice transforms the quality of individuals' and communities' lives.

Arts in Health work is as varied as the communities and individuals its serves, and not surprisingly this has led to various attempts at categorising the work (Angus 2002; Macnaughton et al. 2005; Dose 2006; Sonke et al. 2009; Davies et al. 2012). For the purposes of this chapter, Dose's four-strand typography is a useful model that can be used to explore the various components that make up Arts in Health work. These are: 1) Arts in the Healthcare Settings; 2) Community Arts for Health; 3) Medical

---

2    *Report of the Review of Arts and Health Working Group*, 2007, DH: http://www.dh.gov.uk/ prod_consum_dh/groups/dh_digitalassets/@dh/@en/documents/digitalasset/dh_073589.pdf.

3    *A Prospectus for Arts and Health*, 2007, Arts Council England: http://www.artscouncil. org.uk/publication_archive/a-prospectus-for-arts-and-health.

4    http://www.waterfordhealingarts.com.

Training and Medical Humanities; and 4) Arts Therapy. This chapter will narrow its focus further on the first three of these, which are the Arts in Health activities that have the most bearing on Museums in Health's development as a practice.

The justification for the exclusion of arts therapies within this discussion is based not only on expediency but also because it is important to make the distinction that art therapy is a treatment based on 'therapeutic intervention informed by the practice of psychology, psychotherapy and psychiatry' (Broderick 2011: 96) with a set code of ethics and practice run by a professional body. The work undertaken by the wider Arts in Health sector (Museums in Health included) is concerned with a wider spectrum of potential benefits. This is not to say that museums and galleries have nothing to offer qualified art therapists who use objects, paintings and creative activity (making, craft, painting, singing, performing, etc.) with patients as a psychotherapeutic tool, usually to deliver medical outcomes on a one-to-one basis.

## ARTS IN THE HEALTHCARE SETTINGS

This encompasses a broad spectrum of activity, including architectural design and the full gamut of art forms within healthcare environments. It is based on the idea, and indeed a considerable amount of evidence that, the arts have a huge impact on humanising healthcare facilities as well as contributing to improved clinical outcomes for patients. The arts transform sterile, inhospitable clinical environments into more welcoming, uplifting environments offering patients comfort when they are sick, addressing their suffering and isolation, and providing them with solace in their time of need. Participatory art projects within healthcare environments also offer patients, staff and carers the opportunity to be creative and expressive, and so improve their mental health (Windsor 2005). The art historian Richard Cork writes that:

> Across the world, there is an ever-increasing awareness that art can do an immense amount to humanise our hospitals, alleviate their clinical harshness and leave a profound, lasting impression on patients, staff and visitors. Hospitals can undoubtedly do more to look after the whole person, not just the patient's bodily ailment. Many critical moments in our lives occur there, from birth through to death, and they deserve to take place in surroundings that honour their true significance. (2012: 5)

Whilst painting, site-specific commissions, gardens, music, lighting, proper signage, interior design and even the view afforded to patients in hospital can all contribute to making an environment that improves the patient's experience, the artist Grayson Perry argues for art in hospitals that challenges us and helps us face up to the significant moments in our lives:

> Hospitals are places of extreme drama: death, injury, birth and the saving of life are hourly occurrences. This is not reflected in the hospital art that ends up in them ... If hospitals want to use art, please can they treat us as adults? Part of healing might be facing up to the realities of being stuck in a fallible body. I don't want the last thing I see from my deathbed to be a jaunty painting of fishing boats.[5]

Interestingly, looking back at the early history of art in hospitals, patients were confronted with exactly the kind of art that Perry calls for. For example, from medieval times, visual art played a part in the healing process. During this period, caring for the sick (and poor) was generally the domain of the church. Being physically ill was often seen as a sign of spiritual weakness, and so monasteries and churches were, not surprisingly, embellished with spiritual and devotional works of art often portraying images of the sick and the dying receiving treatment at the hands of a saint, which in turn conveyed a spiritual message to the sick in an attempt to offer them solace and to heal the soul. The art also served to reinforce the powerful status of the church and emphasised its charitable practices in order to encourage rich patrons to donate funds. A fine example of this can be seen in Europe's – and possibly the world's – earliest hospital, Santa Maria della Scala in Sienna, which was founded in 1090. Within the Pellegrinaio (pilgrim) halls in Santa Maria della Scala, where patients were treated until 1983, there are a number of fourteenth-century frescoes commissioned by the then rector Giovanni Buzzichelli. Buzzichelli commissioned the finest Siennese painters of the time to create frescoes that celebrated the hospital's glorious past, whilst creating an environment that showed the healing, caring and charitable activities of the hospital (Baron 1990). Domenico di Bartolo's *The Care and Healing of the Sick* (1440/1441) is probably the most famous of these frescos.

The link between arts and healthcare environments can be traced back even earlier to ancient Greece and the town of Epidaurus, when people from all over Greece went to visit the Temple of Asklepios, who was the god of healing. As part of the healing process, they were prescribed walks to 'the amphitheatre (which is still in use today) to attend performances of tragedies or comedies' (Senior and Croall 1993: 3). The arts were part of the everyday life and environment, part of the process of living and healing.

In England, hospitals followed Santa Maria della Scala's example by using art not to only beautify the surroundings of hospitals but also as a device for propaganda, highlighting the greatness of the institution and its patrons and the charitable acts that were performed within it. Vast sums of money were spent on these important civic buildings and rich patrons came forward to pay for them, commissioning the great artists of the day in order to establish their name amongst the great and the

---

5    Grayson Perry, *The Times*, 12 September 2007.

good of society, and in so doing securing their place in heaven. Perhaps one of
the most impressive examples of this can be seen in St Bartholomew's Hospital in
Spitalfields, London, where one of the most competitive artists of his generation,
William Hogarth, painted two enormous murals, *The Pool of Bethesda* (1735–6)
and *The Good Samaritan* (1737), in the staircases of the great hall to the Hospital.
Hogarth may not have had completely altruistic motives in painting the works;
he was made governor of the Hospital and he donated and painted many more
pictures for St Bartholomew's, the Foundling Hospital and the London Hospital.
According to the doctor and hospital art historian Hugh Baron, he was also the first
to recognise the potential of hospitals as gallery spaces. He organised exhibitions
within the Foundling Hospital, recognising the opportunity not only to provide
his friends with an exhibition space but also to encourage the public to see new
artwork and the foundlings simultaneously (Baron 1987).

It remained fashionable to furnish the walls of hospitals with paintings of the
great patrons and physicians of the day throughout Queen Victoria's reign.
However, there were a number of instances where hospitals recognised the arts'
more instrumental impact. For example, etchings in the collection of the National
Hospital for Neurology and Neurosurgery in London (previously the National
Hospital for Nervous Diseases) show it to be full of ornate furniture, with plants,
books and pictures present. The archives also reveal that the founders of the
Hospital, Louisa, Johanna and Edward Chandler, organised music and poetry
recitals for the amusement of the patients. This may in part be due to Florence
Nightingale's comments in *Notes on Nursing*, where she noted the effect that a
considered environment could have on patients' recovery (Nightingale 1860).

In 1915 Edmund Davis, a South African mining magnate, banker and the Vice
President of Middlesex Hospital, commissioned four enormous murals for the
entrance hall from the artist Frederick Cayley Robinson. The paintings adorned
the main foyer entrance of the Hospital until it was knocked down in 2005 and they
are now housed in the Wellcome Library and the UCH Macmillan Cancer Centre.
The subject matter of the paintings was again in the tradition of great hospital
art: the depiction of charitable deeds and the healing of the sick. The paintings,
entitled *Acts of Mercy*, are essentially two pairs: *The Orphans* and *The Doctors*.
*The Doctors* portrays soldiers returning from the Great War receiving treatment on
the steps of a medical institution and *The Orphans* shows a number of girls seated
at a table receiving sustenance. Davis' motives for commissioning the works were
also perhaps not completely altruistic, as he certainly recognised the role that
art played in creating an impressive and perhaps awe-inspiring environment for
patients, which reflected well on the patron.

Sheridan Russell, an Almoner (chaplain) at London's National Hospital for
Neurology and Neurosurgery, was passionate about art's effect on the patient's
environment and he energised his artist friends and gallery contacts to donate

works of art to the hospital's corridors and waiting rooms. Russell's passion for art in hospitals was infectious and he persuaded the Nuffield Foundation to help him establish a unique paintings library that loaned artworks to other hospitals. This marked the founding of the charity *Paintings in Hospitals* in 1959. Today the *Paintings in Hospitals* collection contains over 4,000 artworks for loan to all healthcare environments.

In his book *The Healing Presence of Art* (2012), Richard Cork provides a detailed historical account of the presence of arts in Western hospitals up to 1975. The case study below provides a contemporary account of the role of arts in the healthcare environment. For alternative case studies, see Clift et al. (2009).

## UCLH ARTS: A CASE STUDY

UCLH Arts is the hospital arts project that serves University College London Hospitals NHS Foundation Trust and its surrounding community. It is funded by charitable donations and fundraising. It aims to provide a welcoming, uplifting environment for all patients, visitors and staff through the use of a varied and stimulating arts programme that reflects the diversity of all users of the Trust and in so doing improves patient well-being, boosts staff morale and widens access to the arts. The programme was established in September 2005 and since then has developed a reputation for programming innovative, challenging art events and projects committed to raising the standard of the arts within the health sector.

The UCLH Arts core programme of work includes:

- running three exhibition spaces, including the Street Gallery in University College Hospital (UCH), hosting some 12 exhibitions a year;
- hosting eight music concerts per month in the public areas across the University College London Hospitals NHS Foundation Trust;
- providing musicians to perform by patients' bedsides;
- running projects with museums and galleries to bring their collections to patients and the public;
- commissioning artists to create artworks for the Trust;
- hosting dance and other performing arts events within wards and public areas;
- running professional development projects for staff;
- instigating research into the impact of arts and heritage interventions on patient well-being;
- providing advice on interior design and wayfinding;

Since 2005, UCLH Arts has been gathering evidence to demonstrate the impact that the arts have on the patient experience, the hospital environment and staff morale.

The arts programme has received some impressive feedback that demonstrates that the arts have a real impact on patients' experience of the Trust. Patients across the Trust are convinced of the benefit of the arts to them, as some of the comments taken from an evaluation carried out by the University of Central Lancashire suggest:

> 'What is fantastic about the arts programme is how often it changes, it is a very vibrant programme, the gallery is noticeable from the road and people do look at it.'
> 'It's music. I love music, it's the second time I've been to the hospital as an in-patient, I normally don't come here, it's nice to know that someone takes an interest in art.'
> 'I enjoyed it, the little moment they were here I enjoyed it, I saw that there is kind of life somewhere, you see, even though I am sick, there is still life.'
> 'Funny little things, that you don't expect to register, really came out with a bang ... these musicians; they hit a chord that puts you on the stroke of life.'
> 'The arts programme in UCLH is vibrant, diverse and engages fully with all stakeholders. The numerical data demonstrates that there are high levels of engagement with the programme.'
> 'The new environment is calculated to lift the spirits of the sick and must contribute to helping them on their way to health, as well as to encourage the staff in their efforts.'
> 'I am very impressed both from an architectural point of view and as a user. The building is very inviting and welcoming.' (Froggett and Little 2008: 16–19).

Stakeholders report that they find the programme a source of interest, enjoyment and relaxation. The independent evaluation carried out by the University of Central Lancashire revealed some interesting data around the active engagement of patients with the arts programme. Their initial evaluation detailed types and levels of engagement with the arts programme. It established that the long-term value of the programme lies in its ability to awaken or nourish sensory faculties, give pleasure and stimulate curiosity (Froggett and Little 2008). The second report found that 'the programme continued to exhibit high quality artworks that were appreciated by service users, visitors and staff, and which added instrumental, institutional and intrinsic value to the setting. Significantly, the diversity of the programme, which includes live music, visual art in a variety of media and handling of museum objects, builds high levels of interest that are crucial to its success' (Froggett and Little 2008: 2).

This case study highlights some of the anecdotal evidence gathered through patient questionnaires and interviews at UCLH, but it is worth noting the substantial and ever-growing evidence base now in place demonstrating the role of arts in healthcare environments. Staricoff's review (2004) highlights examples of the impact of arts on patient outcomes, including reduction of stress, depression and anxiety, reduced blood pressure, reduced pain intensity and the reduced need for

medication. For example, an evaluation of 425 patients, 181 staff and 395 visitors at Chelsea and Westminster Hospital showed that the presence of the visual and performing arts in hospitals can bring down stress levels and help take patients' minds off medical problems (Staricoff et al. 2001).

Music also plays a major role in healthcare environments and has been shown to: reduce levels of anxiety (Frandsen 1990; Wang et al. 2002; Staricoff and Loppert 2003) and stress (Miluk-Kolasa et al. 1994) prior to surgery; lower blood pressure among pregnant women at antenatal clinics (Staricoff 2003) and patients with heart conditions (Elliot 1994); reduce pain intensity and improve sleep after coronary bypass surgery (Zimmerman et al. 1996); reduce perceptions of pain among people with rheumatoid arthritis (Schorr 1993); and reduce the need for sedatives after urological (Koch et al. 1998), orthopaedic or plastic surgery (Walther-Larsen et al. 1998) and analgesics following gynaecological surgery (Good et al. 2002). The effect of listening to music was also found to be of significant relevance in activating the immune system and decreasing the levels of the hormone cortisol, an indicator of stress, in cancer patients (Burns et al. 2001).

The arts have also been shown to have an impact on the staff working within the healthcare organisation, and art and design interventions have been shown to have an impact on staff satisfaction, which in turn could contribute to the recruitment and retention of staff (Ulrich 1992). Furthermore, a study of the impact of an active arts programme integrated into the healthcare environment showed that it is a major consideration for staff when applying for a job or remaining in their current positions (Staricoff et al. 2001; Staricoff and Loppert 2003).

## COMMUNITY ARTS FOR HEALTH

Community arts for health activity operates in a variety of contexts, such as primary care settings (GP surgeries, mental health outpatient services, care homes, respite care facilities, rehab centres, etc.) and more informal community groups (schools, museums, galleries and art groups). This area of work aims to encourage people to come together in creative endeavour to address particular health issues or enhance individuals' sense of well-being. It serves a range of people, including those with disabilities, mental health problems, terminal illnesses and long-term health conditions, older adults, carers, and diaspora communities. Research shows that the physical act of participating in the creating and making of art and the engagement within cultural activity improves well-being and reduces stress (Windsor 2005; Devlin 2010). Often the environment created by the communal act of creating and experiencing culture assists in shaping a safe environment where people can form friendships and acquire new life skills (Stickley and Hui 2012a). As touched on earlier within Chapter 1, Francisco Matarasso, in his research investigating the impact of participatory arts, notes a number of benefits, including the following:

**Table 2.1    World Health Organization Quality of Life domains: WHOQOL-BREF**

| Domain | Facets incorporated within the domains |
|---|---|
| 1. Physical health | Energy and fatigue<br>Pain and discomfort<br>Sleep and rest |
| 2. Psychological | Bodily image and appearance<br>Negative feelings<br>Positive feelings<br>Self-esteem<br>Thinking, learning, memory and concentration |
| 3. Levels of independence | Mobility<br>Activities of daily living<br>Dependence on medicinal substances and medical aids<br>Work capacity |
| 4. Social relationships | Personal relationships<br>Social support<br>Sexual activity |
| 5. Environment | Financial resources<br>Freedom, physical safety and security<br>Health and social care: accessibility and quality<br>Home environment<br>Opportunities for acquiring new information and skills<br>Participation in and opportunities for recreation/leisure activities<br>Physical environment (pollution/noise/traffic/climate)<br>Transport |
| 6. Spirituality/religion/personal beliefs | Religion/spirituality/personal beliefs |

*Note*: http://www.who.int/mental_health/media/68.pdf.

- Participation in the arts is an effective route for personal growth, leading to enhanced confidence, skill-building and educational developments that can improve people's social contacts and employability.
- It can contribute to social cohesion by developing networks and understanding, and building local capacity for organisation and self-determination.
- It brings benefits in other areas such as environmental renewal and health

promotion, and injects an element of creativity into organisational planning.
- It produces social change which can be seen, evaluated and broadly planned.
- It represents a flexible, responsive and cost-effective element of a community development strategy.
- It strengthens rather than dilutes Britain's cultural life and forms a vital factor of success rather than a soft option in social policy (Matarasso 1997: vi).

The above can also be seen to be contributors to improved well-being (see Table 2.1 above) and it is not a big jump to recognise museums' potential in delivering similar benefits through participatory activity. In terms of specific health benefits, Matarrasso also recorded the following anecdotal benefits from his research in the area of mental health:

- positive impact on how people feel;
- effective means of health education;
- contributing to a more relaxed atmosphere in health centres;
- helping to improve the quality of life of people with poor health;
- providing a unique and deep source of enjoyment. (1997: 68).

Mike White, a leader in managing and researching arts projects addressing community health issues, provides a detailed account of the development of community arts practice in his book *Arts Development in Community Health: A Social Tonic* (2009). In it he traces arts and community work back to the community arts movement of the 1960s in terms of both the techniques and approaches that have been developed (2009: 13). He reflects on Owen Kelly's work *Community, Art and the State*, which expressed community arts as a type of cultural activism that enabled people to gain control over their lives. He discusses the importance of SHAPE[6] as a driver of community health in the 1970s and 1980s, 'which bought arts access issues into the health and social services domain from the perspective of service users themselves' (2009: 15). He goes on to discuss additional projects such as START,[7] which provided arts activity for mental health service users in a non-institutional setting. White's own personal journey with community Arts in Health is an interesting one, particularly his collaboration with Dr Malcolm Riggler, a GP based in Withymoor in the West Midlands, who recognised that patients required more than a merely medicalised approach to their care. Riggler understood that good health came from the idea of a healthy community and striving for this is part of the common good:

---

6    SHAPE, an organisation established by Gina Levete which now provides art opportunities for disabled artists: http://www.shapearts.org.uk/aboutshape.aspx.
7    START, an art initiative for mental health service users to experience arts in a non-institutional setting. This was set up as part of the Manchester Hospital Arts Project established by Peter Senior in 1973.

I always wanted to do all I could to help patients to fully appreciate and understand the fragility and complexity of their own bodies, but I wanted this to go beyond biological facts and simple health education. I believe we could sow the seed of total enchantment with the human, help us all to find a meaning in life and so to value ourselves, our neighbours and the community in which we live. (White 2009: 18)

Riggler identified with the arts' role in achieving this and collaborated with White to create a project tackling some of the psychosocial conditions that were presented to him at the surgery. Working with a range of people suffering from depression, anxiety, and isolation, White teamed up with the artist Alison Jones to develop a project that truly unified the community by establishing a lantern procession that grew from strength to strength, with over 1,000 people participating in its tenth anniversary procession (White 2009: 20). White lists the goals achieved through the programme, which bear some resemblance to Matarasso's findings above:

Increased access to information, increased understanding of health issues, development of and access to lay referral systems, development of communications skills and confidence, reduction in social isolation, development of a sense of community, increased confidence to tackle causes of ill health, reduced anxiety associated with visiting the surgery, patients' involvement in their own care plans, and improved understanding of patients' own and their communities' health needs. (White 2009: 20)

For many working in the Arts in Health sector in the 1990s, the two Windsor Seminars organised by the Nuffield Trust, chaired by the then Chief Medical Officer Kenneth Calman, marked a unification in the Arts in Health sector. The seminars were important because they resulted in a statement arguing that 'the link between art and health is now recognised to be a social process requiring new and fundamental research'.[8] This resulted in a concerted effort to gather evidence and commission research into the field. Academic institutions such as Anglia Ruskin University, the University of Central Lancashire, University College London, Manchester Metropolitan University, Durham University and Canterbury Christ Church University have all since set up research groups dedicated to investigating culture's relationship to health. A website[9] set up by the National Alliance for Arts Health and Well-being provides information about the impact of creativity on health and well-being. It also includes a database of research on the ways in which the arts benefit health, examples of Arts in Health projects from across England and links to organisations working in this area.

---

8     See Calman (2002), http://www.nuffieldtrust.org.uk.
9     http://www.artshealthandwellbeing.org.uk.

## MEDICAL TRAINING AND MEDICAL HUMANITIES

As previously touched upon, the relationship of the arts with medicine goes back many thousands of years, so it is no surprise that the arts have a huge amount to offer in the training of medical students in terms of developing the practice of medicine and assisting in the understanding of well-being. Many medical schools, nursing colleges and professional development programmes for clinicians now use the arts and humanities in medical training, including: assisting in the development of better communication skills; improving empathy and thus humanising the medical experience of patients; and improving observational skills, which in turn assist in the better understanding of patient conditions and patient diversity. This area of Arts in Health practice offers great potential for cross-disciplinary working which brings scientists, patients, clinicians, patients and their carers onto a level playing field to explore issues around medicine, culture and scientific research, and in so doing engages with the public in a more accessible manner.

The fact that the arts have so much to offer medical training – and indeed health generally – indicates that science does not hold all the answers to, or about, health, both in terms of its language and its tools of treatment. White refers to Michael Wilson's book *Health is for People* (1975), in which Wilson alludes to the alternative perspective that the arts can bring:

> Factors which make for health are concerned with a sense of personal and social identity, human worth, communication, participation in the making of political decisions, celebration and responsibility. The language of science alone is insufficient to describe health; the languages of story, myth and poetry also disclose its truth. (White 2009: 17)

The arts then provide the physician, surgeon, nurse and health practitioner with an avenue to explore these factors of health, and projects across the country have been established to complement medical education. Suzy Wilson, Artistic Director of the theatre company Clod Ensemble and an Honorary Senior Lecturer at Bart's and the School of Medicine and Dentistry at Queen Mary, University of London, runs a programme entitled *Performing Medicine* aimed specifically at medical students and healthcare professionals. Wilson believes that the 'arts can have a role in medical education in three ways: practical skills; examination of cultural and ethical issues through the arts; and introduction to artists working in health' (2006: 368). It seems that central to Wilson's approach to working within this domain is the ability of the arts to cross boundaries, challenge the status quo and encourage cross-disciplinary working. Today, theatre is commonly used in medical education and UCLH Education Centre employs actors to play the role of patients in order to act out different scenarios for students to respond to in a safe environment. Wilson is in no doubt of the benefits that performance can bring to students: 'An understanding of the practical skills of voice, body language and use of space can

make a huge difference to the way doctors communicate and perhaps even to the way they diagnose' (2006: 368).

Healthcare operates in a variety of contexts within diverse populations and healthcare professionals need to be equipped to deal with this heady mix. For example, how can a young medical student be expected to relate appropriately or know how to communicate with an elderly patient when he or she has no understanding of what it is to be old? Theatre and, indeed, museum and gallery collections have a lot to offer the medical profession in the consideration of the cultural and ethical heritage of the population they serve, and good communication is essential to this. Some of the findings from a research project set up by UCL using medical students (as part of their SSM)[10] to deliver and run handling sessions of museum objects with patients demonstrated this, emphasising the importance of providing medical students with opportunities to communicate with patients in a non-clinical way, encouraging them to consider the whole person and not just the illness (Chatterjee and Noble 2009). This project demonstrated that challenging students' perceptions of what patient care can be leads to improvements in student communication skills and consequently an improved patient experience.

Medical schools use a variety of approaches in developing their students' skills and a number of studies have revealed that the arts can be used to enhance the observational skills of healthcare professionals to better understand the human body from a biological, biomechanical, relational and ethical perspective (Dolev et al. 2001; Shapiro et al. 2006; Kirklin et al. 2007; Naghshineh et al. 2008; Fougner and Kordahl 2012). In particular, life drawing, and looking at art within a gallery setting, has been shown to improve (albeit short-term) observational skills. For example, first-year medical students taking part in art appreciation classes which involved describing dermatological lesions significantly improved their observational skills (Dolev et al. 2001). Furthermore, a cluster design controlled trial of arts-based observational skills training in primary care also demonstrated statistically significant improvements in the observational skills of doctors and nurses (Kirklin et al. 2007).

The actual process of looking at, discussing and deciphering paintings also has a lot to offer the healthcare professional and, indeed, patients and their carers. Rembrandt's *Anatomy Lesson of Dr Nicolaes Tulp* (1632) and *Anatomy Lesson of Dr Joan Deyman* (1656) depict physicians in the process of understanding the workings of the human body and perhaps placing those physicians closer to God. As Cork explained, 'the Dutch believed that dissection engendered a greater awareness of

---

10    SSMs are defined by the UK's General Medical Council as: 'that part of the course which goes beyond the limits of the core, that allows students to study in depth in areas of particular interest to them, that provides them with insights into scientific method and the discipline of research and that engenders an approach to medicine that is constantly questioning and self-critical'.

God's identity, an examination of brain tissues was tantamount to probing the very workings of His mind' (2012: 122). These paintings provide an ideal scaffold for discussions around dissection and the role of the physician, his or her perceived power and the position of the patient within this dynamic (Wilson 2006). A painting such as *Extreme Unction* by Poussin again allows exploration and discussion around issues of death and the last rites. Students who are encouraged to reflect on their role as caregiver will gain greater insights into the patient/carer/doctor relationship. The use of creative art has also been shown to be effective in enhancing the counselling skills of hospice professionals working with the bereaved (Zamierowski and Gordon 1995).

Artists working alongside healthcare professionals can also offer further stimulus to clinicians to reflect on the patients' own experience of their illness and care. The artist Deborah Padfield[11] worked within the Eastman Dental Hospital, UCLH, using photography to help patients visualise their perception of facial pain. Clinicians normally have a standardised scoring chart for pain that merely describes the amount of pain a patient is in, as opposed to the type of pain a patient might be feeling (heavy constant pain, electric pulsating pain, etc.). The description of pain does not necessarily provide the clinician with the relevant information needed to treat the patient and Padfield was able to develop a visual dictionary of cards which patients were able to hold up to illustrate how they were feeling. This obviously has uses for patients whose first language is not English. This is but one of many possible examples of how artists and the arts can provide a valuable insight into the human condition and reinforce the need for holistic care.

For many medical professionals, the present available research and case studies touched on here do little to justify the inclusion of arts in an already-packed core medical curriculum. The arts operate on the periphery of the curriculum, and Dr Helen Smith, Professor of General Practice at Brighton and Sussex Medical School, writes that the position of arts in the medical curriculum is a precarious one and one that can only be resolved with a solid evidence base: 'One way of sustaining art/medicine initiatives in the medical curriculum is to orchestrate a shift from the peripheral to the core curriculum. This desirable scenario can only be achieved if there is sound evidence that prescribed learning objectives, for example, fostering critical thinking, self-reflection or understanding the meaning of illness, can be acquired more efficiently and effectively by the additional study of art and the humanities' (Smith 2012: 107). Where art does feature in the curriculum, it is part of the student-selected component that the General Medical Council (GMC) currently suggests should make up a minimum of 10 per cent of the curriculum (it stood at 25 per cent in 2003).

---

11    The artist Deborah Padfield was artist in resident at UCLH NHS Foundation Trust from 2008 to 2011. An exhibition entitled face2face was shown in the Street Gallery, UCH and is still available to see through UCH.

## ARTS IN HEALTH: THE FUTURE

In spite of the already-extensive evidence available, some of which has been referred to within this book, the Arts in Health sector is conscious of the need to continue to build on the evidence base in a way that demonstrates impact and thus contributes to the case in persuading funders to make policy decisions that encourage engagement with the arts. For some academics, however, it seems that this preoccupation with evidence gathering is a cause for concern that creates instability within the sector. Raw et al. argue that resistance to definitions, disagreements over what constitutes a valid evidence base and a lack of consideration of the practice and theory of Arts in Health detrimentally affect the academic status of the field. Without a more concentrated effort away from evidence gathering 'towards analysing and theorising the practice in question, the basis for understanding and accepting the findings of impact studies will remain insubstantial' (2012: 98). Raw et al. suggest that developing an interdisciplinary theoretical framework exploring key themes and concepts that have emerged from participatory arts practice will best serve the sector in ensuring 'a healthy and robust arts and health debate' (2012: 105).

Susan Potter also identifies with this interdisciplinary approach and stresses that in our ambition to find appropriate means to measure the impact of the arts, we must still seek to find a common language in which to communicate. Artists working in healthcare settings, or indeed within the community, are in a unique and often ambiguous position, and questions remain as to whether it is even appropriate (or ethical) to apply an evidence-based methodology to contemporary art practice within clinical practice (Broderick 2011; Potter 2012). Potter reminds us that to achieve improvements in public health, a range of approaches are necessary, and argues that if the Arts in Health sectors are to truly work together, there has to be a consensus, a sharing and a mutual respect of values. She argues for a progressive research programme to be implemented to generate 'hypotheses, while remaining sensitive and flexible to the unique "nuanced and intangible" nature of the art' (2012: 18).

As this discussion within academia goes on, the grassroots work of Arts in Health continues and it is important not to understate the important place of anecdotal evidence: the informal stories of the ability of the arts to impact on people's lives are still worth recording and celebrating. Lord Howarth of Newport writes thatr 'the real energy however will always come from the grass roots – from the practitioners and the artists ... Arts are the index of the health of a nation and not the ill health of society, and the process of creating art is healing for the individual artist as much as it is for all of us collectively. It's not just about a remedy to certain ailments but it is certainly about maintaining a good life balance'.[12]

---

12    Extract from *Voluntary Arts Network* paper, p. 14.

As important as the evidence is, so too is a sector's ability to support and celebrate good practice, lobby opinion formers and disseminate the evidence. The recent establishment of an *International Journal of Arts & Health* has done much to achieve this, as has the work of a number of networking organisations such as the London Arts and Health Forum who have been instrumental in attracting funding from the Arts Council to establish a website for the sector, as well as to support the formation of a National Alliance for Arts Health and Well-being. It is clear that this is a vital service bringing together all the professions and evidence assisting the sector in speaking with one unified voice. With the pressures of funding requirements and the museum sector's own need to demonstrate wider social impact, it would be astute to not only look within its own sector for shared expertise and resources but also to take note of the existing models, arguments and examples presented within this chapter when expounding the value of Museums in Health activities.

## SUMMARY

This chapter has provided a summary of the numerous ways in which the arts permeate health and well-being. Art projects up and down the country continue to practice with the aim of transforming the quality of life of individuals and communities. Arts in the healthcare settings, community arts for health, and the arts in medical training and medical humanities have all been discussed. The case studies and evidence that have been presented here give an idea of the enormous breadth of the sector in which Museums in Health is grounded. The chapter has offered a synopsis of the ongoing discussions within the Arts in Health sector around what should be measured, what the appropriate measurement methods should consist of, what the appropriate frameworks for evaluation should be, the need for a common language across the art and health sectors, and how the evidence of impact should be disseminated. These discussions are all relevant to the Museum in Health professional.

# THE LINK BETWEEN MUSEUMS AND HEALTH AND WELL-BEING

The museum sector has become increasingly aware of the value that their collections and resources can bring to individual and community health and well-being. This chapter first discusses some of the best-known examples pertaining to this work, some of which broadly fit under the therapeutic arts umbrella, whilst other work can be considered part of the sector's wider contribution to social engagement and cohesion. In addition, some of the key health and well-being outcomes derived from such encounters are explored in the context of defining a lexicon of museum-specific health and well-being outcomes. Second, this chapter examines the underlying mechanisms which help to explain why and how cultural encounters contribute to improvements in health and well-being, and in so doing defines the conceptual framework for Museums in Health. Evidence from a broad spectrum of disciplines (including psychology (psychosocial, psychoneurology, psychophysical and psychoneuroimmunology), neuroscience and physiology) is reviewed in order to begin to understand why and how museum encounters can enhance health and well-being.

## MUSEUMS IN HEALTH: THE EVIDENCE BASE

Perhaps one of the best-known and most widely cited Museums in Health examples is the Museum of Modern Art's (MoMA, New York) *Meet Me* project. This initiative offers guided tours for small groups of around eight people with dementia plus their family members and carers, providing facilitated tours which take in four or five artworks related to specific themes. Research undertaken at MoMA by New York University across nine months employed a psychosocial framework using a variety of scales to assess participants' responses to the sessions. The measurement scales included self-rating scales, which sought to capture the emotional state of participants, and observer-related scales, which allowed researchers and museum staff to record their observations of participants and group dynamics. The research found improved relationships with carers, and improved interaction and happiness for adults with dementia after viewing and discussing artworks (Rosenburg et al. 2009). MoMA's

*Meet Me* project was part of an international initiative involving other organisations in the USA (including the Harvard Museum of Natural History and the Lexington Museum of National Heritage), France and Australia (Zeisel 2009).

The *Good Times* programme run by the Dulwich Picture Gallery in London has received considerable attention in the media and won a variety of awards and commendations, including a Royal Society for Public Health award for excellence and innovation, in 2011. The programme provides a range of activities, including creative workshops, art appreciation talks and gallery tours for older adults, targeting socially isolated members of the community. The Gallery also offers a *Prescription for Art* service in association with local doctors' surgeries, where nurses with special responsibilities for older adults invite patients to creative workshops run by the gallery. A retrospective qualitative evaluation of the *Good Times* programme, undertaken by the Oxford Institute of Ageing at the University of Oxford, used existing post-session questionnaires, diaries and personal testaments, selected interviews with participants and observations from creative workshops to evaluate the impact of the programme. The research determined that the programme enhances the lives of local people, helps combat social isolation and improves the efficacy of conventional medical treatment (Harper and Hamblin 2010).

The Open Museum is the outreach service run by Glasgow Museum which seeks to take the museum's collections to hard-to-reach audiences and non-traditional users. Dodd et al. (2002) showed that creative activities gave participants a means of self-expression that was effective in countering mental health issues and enabling new skills. More recently, Balshaw et al. (2012) describe eight projects carried out in seven museums across the north-west of England. These projects ranged in scope, size and target audience, but all were organised under a 'health and culture' banner. Healthy walks organised by Bolton Museum and Archive and the People's History Museum (Manchester) targeted mental health service users and socially isolated older adults (aged between 60 and 80) respectively. These sessions combined in-house museum activities such as museum object-handling and creative and reminiscence activities with opportunities to explore social history through guided walks in the local areas. Outreach activities run by Manchester Museum and Salford Museums and Art Gallery focused on providing opportunities for reminiscence through handling museum objects in hospital wards, care homes and day centres. Other museums used their collections for public health education, such as the *Fit for Life* exhibition at Portland Basin Museum (Ashton-under-Lyne) and a programme to encourage breastfeeding in north Manchester developed by Manchester Art Gallery. Another project at Manchester Art Gallery, delivered by Wigan Child and Adolescent Mental Health Services, sought to enhance recovery and build self-esteem in young people with eating disorders and a history of self-harm. Two psychiatrists, employed as part of the project team, encouraged participants to explore issues such as relationships, identity or bullying through gallery visits and creative art sessions.

The *Heritage in Hospitals*[1] project, run by University College London (UCL) Museums and Public Engagement in association with University College Hospital Arts, took museum loan boxes to hospital patients and care home residents in London. Organised as a research project (funded by the Arts and Humanities Research Council), the study gathered audio data from recordings of conversations for qualitative analysis and quantitative data from psychometric well-being scales completed before and after handling sessions (Noble and Chatterjee 2008; Chatterjee et al. 2009; Ander et al. 2011; Lanceley et al. 2011; Thomson et al. 2011; Ander et al. 2012a; Thomson et al. 2012a and 2012b; see below for further details of aspects of this work). The research was awarded a certificate of commendation by the Royal Society of Public Health in the same year as the Dulwich Picture Gallery and Manchester Museums and Galleries, thus demonstrating wider recognition of the contribution that museums make to health and well-being. Further recognition is afforded by the Happy Museum Project.[2] Funded by the Paul Hamlyn Foundation, the Happy Museum Project is seeking to encourage a community of practice through funding a series of museum-led projects and initiatives focused on enhancing well-being and the notion of a more sustainable society.

As indicated above, much of the evidence and activity regarding museum-specific contributions to health and well-being has focused on mental health. The Lightbox (Woking) has also been working with mental health professionals and service users for some years, offering therapeutic arts activities to help counter isolation for local people with mental health issues (Nightingale 2009). Many museums and galleries see this work as part of their usual outreach/inreach programming, albeit targeted at specific demographics, such as socially isolated older adults or mental health service users; the Tate Modern's (London) Community Arts Programme, for example, works with several health and mental health organisations, but the activities, although tailored to mental health service users, are the same as those offered as part of their adult education programme.

Culture Unlimited, another UK think tank, created a manifesto for museums' potential benefit in the mental health field. *Museums of the Mind* argues that museums are ideally placed to tackle issues that affect mental health, including socio-economic disadvantage, social or cultural discrimination, isolation and lack of recreational and cultural services (Wood 2008: 9). Following a review of evidence regarding the contribution of cultural participation to mental health, O'Neill argues that "cultural attendance provides a distinct stimulus to human beings that has an impact on their well-being to such a degree that it prolongs their lives" (2010: 25). Whilst there is currently no direct quantitative evidence to support O'Neill's claim that cultural participation prolongs life, there is correlational evidence that cultural attendance has health benefits, as demonstrated by Cuypers et al. (2012) and other studies

---

1     http://www.ucl.ac.uk/museums/research/touch/heritageinhospitals.
2     http://www.happymuseumproject.org.

which found a link between mortality risk and cultural participation (Konlaan et al. 2000; Bygren et al. 2009). O'Neill goes on to suggest that it is the opportunity for participants to decide for themselves on their level of involvement, both cognitively and emotionally, alone or in groups, that explains why cultural stimuli such as museums visits or musical activities are beneficial. He further proposes that such experiences are self-regenerating in a positive cycle, i.e. the better they are, the more people engage, and he suggests that this is akin to the experience of *flow* described by the psychologist Csikszentmihalyi (2000). Understanding the psychological and cognitive functioning value of museum engagement for those with mental health problems is, however, more problematic and will be discussed in more detail below.

There are also numerous examples of the contribution of museums to public health. Traditionally, medical and scientific museums have led the way in this field. From large organisations such as the science museums (London and Manchester) and the Natural History Museum (London), through to smaller museums such as the Thackray Museum (Leeds), the Florence Nightingale Museum (London) and the Wellcome Collection (London), these institutions have utilised their collections and resources to highlight a wide range of public health issues. Similarly, medical museums in universities, such as the Medical Museion (University of Copenhagen) and the Steno Museum (Aarhus University) in Denmark, the Medical Museum (University of Iowa), the Medical History Museum (University of Melbourne) and Tayside Medical History Museum (University of Dundee), are just a few examples of university museums using their collections to communicate public health messages as well as in the training of students and medical health professionals. London alone is home to over 20 different medical museums, brought together under the *London Museums of Health and Medicine*[3] banner, and in 2005 the *UK Medical Collections Group* (UKMCG)[4] was founded as a way of bringing together the diverse variety of medical museums and collections across the UK in a virtual forum. A key objective of the UKMCG, which is hosted by the Thackray Museum, is encouraging the use of medical and healthcare collections in innovative ways to engage diverse audiences in health-related initiatives. In a project funded by Arts Council England, the group has published an extremely useful guide for practitioners outlining the UK's changing health agendas and advice on how museums might adapt their services to meet these agendas (Bodley 2012).

## MUSEUMS AS THERAPEUTIC SPACES

There is also evidence for the incorporation of museums as therapeutic spaces within healthcare organisations. Newham University Hospital's 'Nostalgia Room' (London) is a specially designed public museum space with a 1940–1950s theme for use by patients, relatives, carers and clinical staff at the hospital. The room was

---

3    http://www.medicalmuseums.org.
4    http://www.thackraymuseum.org/ukmcg.html.

developed as a response to concerns expressed by staff at Newham Hospital about the isolation and despondency felt by many of their older adult patients. It contains a mix of loaned museum objects, second-hand furniture (including a piano) and donated paraphernalia (magazines, books, a record player, records and other household items) all dating from the 1940–1950s. The primary use of the space is for rehabilitation activities (e.g. using object manipulation to improve dexterity, knitting, singing), reminiscence, social interaction or simply a space in which to relax away from the clinical surroundings of the rest of the hospital. O'Sullivan (2008) describes a range of case studies highlighting the often profound impact that using the space and its objects has had on patients, their carers and family members, as exemplified in the quotes below:

'Thank you for helping my mum know she can be happy again.'
'This room makes me feel ten years old again.'
'It's wonderful to hear my mum singing again.'
'When I am well enough, may I come back and volunteer?'
'Mum sewing, it's a miracle!' (O'Sullivan 2008: 229)

The Museum für Lebensgeschichten (Museum of Life Stories) is housed within a residential care home in Switzerland. The museum and associated exhibitions provide a space for residents to reflect on their lives (Pes 2009). A regular programme of changing displays and exhibitions based on resident's lives also form the focus for storytelling activities in a café housed within the care home. Pes reports that the museum receives an average of about 3,000 visitors per year, and that residents, relatives and friends are proud of the life stories on display, indicating that the space is well used and valued by its visitors.

Finally, whilst there is relatively little direct consideration of the role of heritage spaces, settings and sites, in their broadest sense, to health and well-being, Butler offers an insightful exploration of 'healing heritage' in the context of conflict and displacement in the Occupied Palestinian Territories (Butler 2011). Here, Butler tackles heritage from an ethnographic perspective, invoking the relationship between heritage and the 'muses' as a route to well-being.

## UNDERSTANDING WHY AND HOW MUSEUMS BENEFIT HEALTH AND WELL-BEING

The examples above provide plenty of evidence of good practice in the field of Museums in Health, showing that there is already a wide diversity of activities targeting various cohorts of society (older adults, socially excluded/vulnerable groups such as mental health service users, etc.). Further examples are explored in Chapter 4. Whilst there is a growing body of evidence demonstrating the therapeutic value of cultural encounters, a key issue is the lack of robust quantitative and

qualitative evidence derived from standardised studies (e.g. where confounding effects are controlled for) which explain why and how cultural encounters enhance health and well-being. As discussed in Chapter 2, this issue has also been a cause for concern across the arts and health sector. Understanding and articulating why museums are good for you and how museum interaction benefits health and well-being is critical in order to advocate for closer links between the museum sector and the health and social care sectors. The rest of this chapter explores existing evidence for the therapeutic impact of cultural encounters and seeks to understand how such encounters can improve health and well-being.

The underlying basis for *Museums of the Mind* (Wood 2008) is the premise that psychological health is intrinsically tied to physical health. There is considerable evidence which demonstrates that poor mental health increases the risk of cardiovascular disease, cancer and diabetes. The Royal College of Psychiatrists' *No Health Without Public Mental Health* (2010) lists numerous studies which exemplify the link between mental health and physical health. Studies by Mykletun et al. (2007, 2009), for example, showed the following sobering statistics:

> Depression is associated with 50% increased mortality after controlling for confounding factors (such as lifestyle), 67% increased mortality from cardiovascular disease, 50% increased mortality from cancer, two-fold increased mortality from respiratory disease and three-fold increased mortality from metabolic disease. (Royal College of Psychiatrists 2010: 14)

To better understand the link between emotional well-being and museum engagement, Culture Unlimited (Wood 2008) conducted interviews with 37 people involved in museum-led work that focused on mental health. Using observations from project sessions and semi-structured interviews, the findings were incorporated into a qualitative, inductive, content analysis to extract themes derived from participants' responses to the sessions. The themes indicate the often unique role that museums can play in enhancing emotional well-being and outline some of the ways in which participants value museums:

- Sense of connection, and belonging.
- Human capital: using and improving skills.
- Optimism and hope.
- Moral values, beliefs.
- Identity capital, self-esteem.
- Emotional capital, resilience.
- Opportunity for success.
- Recognition of achievement.
- Support.
- Quiet, rest, sanctuary.
- Social capital, relationships.

- Meaningful pursuits.
- Safe, rich museum environment.
- Access to arts and culture (Wood 2008: 24–5).

Similar research, this time focused on the value of handling museum objects as a therapeutic intervention in hospitals and care homes (the *Heritage in Hospitals* project), identified a comparable set of themes which emerged from a qualitative study involving 51 hospital inpatients and care home residents, using a grounded theory approach:

- New perspectives.
- Positive feelings (excitement, enjoyment, wonder, privilege, luck, surprise).
- Learning (including skills and confidence).
- Energy, alertness.
- Positive mood (e.g. cheered up).
- Sense of identity.
- Something different, inspiring.
- Calming, relieves anxiety.
- Passing time.
- Social experience.
- Tactile experience (Ander et al. 2012a: 9–11).

Quantitative evidence from the same study with 158 hospital inpatients and outpatients (from the following settings: gynaecological oncology, general female and male oncology, acute and elderly care, neurological rehabilitation) plus care home residents employed a quasi-experimental mixed-method design based on self-report measures assessing psychological well-being (Positive Affect Negative Affect scale (PANAS); Watson et al. 1988) and two visual analogue scales for assessing subjective well-being and happiness (EuroQol Group 1990) (Thomson et al. 2012a). The experiment tested two conditions: a 'tactile' condition, where patients handled and discussed museum objects, and a control 'visual' condition for comparison, whereby participants discussed photographs of museum objects. The study revealed that all participants showed increased psychological and subjective well-being across the three emotion scales, but that those in the 'tactile' condition showed a statistically significant increase in well-being compared to the control condition, which involved no museum object handling.

Davenport and Corner (2011) reviewed a range of studies and reports regarding the relationships between the cultural sector (to include museums, galleries and heritage sites) and older adults, and suggested that health and well-being can be fostered through the following:

- An experience of calm.
- A positive social experience.

- An experience involving mild physical exercise.
- A creative experience.
- An experience that involves (re-)learning and gaining mastery over tasks.
- An experience of being absorbed in a task.
- An experience that gives self-esteem to participants, their lives and their memories.
- An experience that involves the sharing of skills.
- An experience that opens participants up to new experiences (2011: 14).

Evaluation of the *Arteffact* project, which was run across four museums in North Wales, used a mixed-methods approach to address the question 'Can creative engagement in museums improve the mental health and well-being of people experiencing mental distress?' (Neal 2012a and 2012b). The qualitative aspects of the evaluation focused on interviews with participants, whilst the Warwick-Edinburgh Mental Well-being Scale (WEMWBS 2006) was used as a quantitative measure to assess participants at the start and the end of the programme. Themes derived from the qualitative analysis resulted in two key sets of outcomes:

Immediate effects:

- Enjoyment.
- Absorbing.
- Relief from physical pain.
- Takes mind off problems.
- Calming, healing, therapeutic, relaxing.
- Gives structure to life.

Long-term effects:

- Feeling better.
- Increased confidence.
- Increased ability to accept praise.
- Stimulated self-motivation.
- Increased awareness.
- Increased ability to deal with problems.
- Something to live for.
- Making plans for the future.
- Engagement/isolation.
- Group dynamics.
- Group supporting each other.
- Fun.
- Independence.
- Overwhelmed.
- Confidence in artistic ability.

- New experience, sense of achievement at learning new skills.
- Sense of satisfaction and pleasure in what produced.
- Ownership.
- Artistic ability.
- Art as a leveller (Neal 2012a: 19–27).

## OBJECTS, MEMORY AND REMINISCENCE

There are numerous examples of objects being used in reminiscence activities (e.g. Arigho 2008; Phillips 2008). Kavanagh (2000) has written extensively about the role of memory and reminiscing during cultural encounters, and reminiscence activities using museum objects have been shown to have therapeutic value (e.g. Phillips 2008). Arigho (2008) describes the value of objects in reminiscence work, advocating a multi-sensory approach where objects are used to trigger memories and shared experiences within a person-centred, safe environment. Several authors note that museum objects trigger memories in ways that other information-bearing materials do not (Kavanagh 2000; Phillips 2008; Lanceley et al. 2011) and Mack (2003) describes museum objects as 'containers of memory'.

In describing the reminiscence programme at the British Museum, Phillips notes that 'objects promoted learning, creative thought, skills development and greater confidence in the participants' (2008: 204). Kavanagh (2000) suggests that the process by which museum objects trigger memories can affect mood, ideas of self-worth and a general sense of well-being. The power of objects is further explored by Phillips (2008), Pye (2008), Chatterjee et al. (2009), Ander et al. (2012a) and Lanceley et al. (2011); all of these studies report the awe and amazement experienced by participants during object handling, where participants note that objects help them to recall and share memories and emotions. During such encounters, the importance, intrinsic material properties and significance of the objects is often highlighted, and participants report a sense of privilege at being 'allowed' to handle 'valuable' items. Perhaps it is the handling of such cultural assets, within the safe space created during a facilitated museum object-handling session, which leads to therapeutic outcomes? There is now considerable case-specific evidence for this view from various projects (e.g. Ander et al. 2012a).

Another example of the therapeutic potential of reminiscence is the *House of Memories* programme at National Museums Liverpool (NML). A recent review of the programme states that: 'House of Memories is a training and delivery programme built around the objects, archives and stories held within the Museum of Liverpool. It aims to provide social and health care staff (in domicile and residential settings) with new skills and resources to share with people living with dementia, and to promote and enhance their well-being and quality of life, as a potential alternative to medication' (NML 2012: 9). The programme has recently

been cited in the *Prime Minister's Challenge on Dementia* report published by the Department of Health (DH 2012: 8); this further exemplifies the wider recognition of the contribution that museums make to health and well-being, beyond the cultural heritage sector. Evaluation of the *House of Memories* programme involved researchers who employed an ethnographic, mixed-methods, reflexive approach to capture the variety of impacts of the programme (NML 2012). The researchers used both quantitative and qualitative techniques, such as questionnaires, participant observation, interviews and documentary methods, targeting 1,200 training participants, including NML staff, social care staff and those living with dementia and their families. Ethnographic Content Analysis (Glaser and Strauss 1967; Altheide 1987) was used to analyse the data, which revealed the following themes about the NML training programme:

- Increasing awareness of and understanding of dementia: seeing a person-centred approach.
- Being in their world, not mine.
- Living with dementia is different for every individual.
- Increased understanding that listening and communicating effectively can make a difference to the person living with dementia and can help them to live well.
- Increased knowledge about different stages and types of dementia and effect on behaviour.
- Understanding the family's perspective and increased confidence to engage with family members.
- Relevance of training to current guidance on caring for people living with dementia identified in the National Strategy.
- Relevance to personal lives as well as to work roles (NML 2012: 35).

## PYSCHOSOCIAL EVIDENCE

Practice-based evidence from several museums and galleries in the north-west of England, under the umbrella of Renaissance North West, is neatly drawn together by Froggett et al. (2011) reporting on the *Who Cares? Museums, Health and Well-being Research Programme* run in collaboration with the Psychosocial Research Unit at the University of Central Lancashire.

The *Who Cares?* programme was an ambitious project carried out over two years (2009–11) involving six museums: Tullie House Museums and Art Gallery (Carlisle), the Harris Museum and Art Gallery (Preston), Bolton Museums and Library Service, the Manchester Museum, the Whitworth Art Gallery (working with the Manchester Schools Hospital Service) and Manchester Art Gallery. The explicit aim of the research was to investigate the effect of access to museum activities on health and well-being across disadvantaged groups in each museum

(Froggett et al. 2011). The research employed a qualitative psychosocial framework and focused on the meaning and uses of objects and artworks by individuals, relationships between participants and museum staff and partners, and the implications of the programmes for cultural inclusion. Analysis and exploration of self-evaluation questionnaires, video, semi-structured and narrative style interviews, in-depth observation of group process and creative outputs such as artworks was undertaken across the six participating museums. The study revealed that museum work which specifically targets small groups can extend opportunities for interaction with people and objects in ways that enhance a sense of cultural inclusion. Froggett et al. propose that:

> This happens not only because participants have new experiences and opportunities for social interaction but also because interaction with museum collections in favourable conditions offers people the opportunity to find new cultural forms in which to express their experience. Personal experience can then be communicated to others. This is a distinctive contribution that museums can make to well-being which on the one hand draws on the nature of their collections and their symbolic *cultural* significance, and on the other hand the *personal* symbolic significance the collections hold for individuals.
> (2011: 72, emphasis in original)

The conceptual basis for this research was grounded in the psychosocial benefits of museum engagement, which are explored in the context of 'symbolisation, meaning-making, affect, embodiment, identity, feelings of belonging and social and cultural inclusion, memory/reminiscence, and the therapeutic potential of museum engagement' (Froggett et al. 2011: 7).

## MEANING MAKING AND SYMBOLISM THROUGH CULTURAL ENCOUNTERS

There is now substantial evidence drawn from the field of psychosocial research (Froggett et al. 2011; Lanceley et al. 2011), which helps to explain why cultural encounters such as museum visits and museum object handling are beneficial. Froggett et al. (2011) provide a useful summary of relevant research in this area and there is some insightful evidence derived from robust research, which is explored below.

It is argued that when individuals interact with museums and their collections, the object's properties, including their intrinsic, physical and material properties, trigger sensory, emotional and cognitive associations, memories and projections (Froggett et al. 2011). This experience leads to a process of symbolisation, whereby museum objects function as symbols of identity, relationships, nature, society and religion, according to Pearce (1995). Dudley (2010) argues that it is

the multi-sensory experience which elicits ideas and meaning. Meaning making as part of a multi-sensory cultural encounter is also discussed by Gregory and Whitcomb, who quote Marius Kwint. Kwint explored the importance of objects for their capacity to invoke memory and sensual engagement, stating that objects can both trigger memory and carry meaning, which he argues 'can open a space of evocation which implies an open dialogue between the object, the maker and the consumer in constructing meaning' (Gregory and Whitcomb 2007: 263).

Researching Glasgow Open Museum's object-handling sessions, Dodd et al. (2002) revealed that participants construct meaning for the objects through their past experiences and that all of the participants consulted in the research were able to articulate a significant and substantial experience from object handling. They found that objects:

- can act as a catalyst for a range of cognitive and emotive processes;
- stimulated individual creativity, particularly of artwork, and opportunities for discovery and learning
- acted as a catalyst for increased self-expression;
- acted as a trigger for the recall of memories and for social interaction both between participants and between participants and carers;
- enabled individuals to make connections with the past, to 'make it feel real' and to develop a deeper understanding of what the past was like;
- gave participants a reason to communicate with others and to share their memories and emotions;
- had a symbolic and political significance;
- played an important role in contributing towards a sense of place and identity for marginalised individuals and communities and in helping to promote understanding, respect and tolerance between communities;
- led to higher levels of interest and motivation, and tangible improvements in written work, more exciting practical work and improved examination grades (2002: 37).

The opportunity for meaning making is further exemplified in a therapeutic context through research undertaken by the authors with hospital patients at University College London Hospitals NHS Foundation Trust, or UCH for short (Chatterjee et al. 2009; Thomson et al. 2011; Lanceley et al. 2011; Ander et al. 2012a; Thomson et al. 2012a and 2012b). Meaning making emerged as a theme from the qualitative analysis of conversational data derived from museum object-handling sessions conducted at the bedsides of hospital patients. Using an inductive technique of constant comparative analysis (Glaser 1965) revealed a range of themes which explain how patients responded to such cultural encounters. The research illustrated that patients used the sessions to help make meaning of their lives and to come to terms with their illness, often making comments about their state of health, concerns over mortality, regrets and loss experienced in their

personal lives. In this context, patients appeared to be connecting with objects through Gardner's existential or foundational point of entry (Gardner 2006: 140), such that the handling sessions provided the opportunity to address deeper, often more philosophical questions about their life, through the handling of museum objects (Chatterjee et al. 2009: 172, which also provides more detail on a full range of themes which emerged from this study).

A further example of the therapeutic potential of a multi-sensory museum object encounter is provided by a more in-depth study of 10 females conducted as part of the same research programme at UCH (Lanceley et al. 2011). Participants were recruited from a gynaecological cancer centre and had either had a recent surgery for gynaecological cancer and knew their diagnosis or had a family history of ovarian cancer. Gynaecological cancer nurse specialists carried out the museum object-handling sessions, which were conducted within the cancer centre, following training by co-authors from UCL Museums. The constant comparative method was again used to analyse the recorded conversations and to identify themes. The authors undertook further analysis of field notes collected by the nurses and interpreted these and the session recordings using a psychodynamic framework relying on Kleinian theory.

The latter pertains to psychoanalytical work carried out by Melanie Klein, a post-Freudian psychoanalyst who developed her own school of thought and was responsible for the term 'object relations'. Klein's work involved the study of children playing with objects, where objects were used to facilitate the expressions of the child's thoughts and feelings (Klein 1997 [1932]). Her model encapsulates the interplay between the internal world of phantasy, the world of fantasy and the external world, whereby she argues that the inner world is as real as the external world. She suggests that the mind's construction of the inner world shapes our view of the outer world and vice versa. Following on from this, during development, children deal with separation and loss (e.g. of the breast/mother) by recreating the lost 'object' or person symbolically and this can be understood through interaction with, for example, an object (or image, sound, etc.) (Lanceley et al. 2011: 3). Lanceley et al. (2011) argue that heritage objects can carry symbolic meaning in this way if feelings are projected onto them, and in this context the object can act as a repository for projections of different and difficult states of mind. In this study, participant interactions with objects, and the associated conversations, revealed that the symbolic attributes of museum objects were being used for representing loss, in this case the loss of 'the healthy self' (Lanceley et al. 2011: 3). Here it is apparent that the object may take on a transitional role, as per Winnicott's 'transitional object' (Winnicott 1992 [1951]), whereby the museum object is a vehicle to explore unconscious feelings. The layered analytic process of this study revealed that objects were a powerful medium which enabled the female participants to explore issues such as survival, fear of cancer, powerlessness, reproductive capacity and female family history.

The below excerpt from a conversation between a nurse and one of the study participants eloquently demonstrates the power and potential of museum objects:

> 'I wish I'd told my mother to bog off, or not control me so much. She was a refugee and had a dreadful life. Very frightened, very scared. Yes, and so when my dad died, which was now 19 years ago, and although we didn't live together, it's 200 miles between us, nevertheless I was the carer and um before my Mum died herself, she pinpointed one very important thing for me, she said your life has been on hold for about 16 years and it was like a revelation to me. You know, I was stressed by her and all the rest of it. Well, I loved her in some ways but, so I suppose if I was really feeling sorry for myself, I would say did I waste the last 18 years of my life? Not living but existing. So this (the object; Bastet, a small bronze figurine dating to 500–650BC from the Petrie Museum of Egyptian Archaeology, UCL) is giving me perhaps a little sense of the ability to strike back.' (Lanceley et al. 2011: 9)

Camic's work around 'found objects' (referred to as material objects that are found or discovered, are not usually purchased, hold no intrinsic financial value and have personal significance) may help to further explain the therapeutic role and use of objects. In a study focused on non-clinical adult populations from eight countries, he identified a "found object process that involves the interaction of aesthetic, cognitive, emotive, mnemonic, ecological, and creative factors in the seeking, discovery, and utilization" of finding and using objects (2010: 87–8). A further study focused on the use of found objects in individual and group therapy, including participants with a range of disorders, such as schizophrenia, personality disorder, obsessive compulsive disorder (OCD), anxiety and depression, and determined that found objects enhanced engagement, increased curiosity, reduced difficult feelings, evoked memories and provided a sense of agency through increased physical activity and interaction with the environment (Camic et al. 2011). This evidence adds further support to the therapeutic potential of using material objects in health and social care, although further research is warranted to fully understand the use of objects as a therapeutic tool in clinical practice.

## CONCEPTUAL FRAMEWORKS FOR MUSEUMS IN HEALTH

Evidence for phenomena such as symbolisation and meaning making in relation to health and well-being are tricky to derive, and usually come from focused studies involving health practitioners, academics and museum professionals, where an understanding of the physical and/or psychological challenges facing participants is known and can be incorporated into study design and the development of associated museum activities. The same applies to clinically defined improvements in physical and psychological health and well-being, and this exemplifies the urgent

need for more robust museums in health studies which incorporate a complete view of individual or community health.

Simmons (2006) proposed that art therapy practices are grounded in two psychological approaches: 'dual coding' (Paivio 1986) and the 'contiguity effect' (Clark and Paivio 1991), both of which focus on the interplay between sensory modalities. This is particularly pertinent for interventions that employ a range of modalities, such as touch, vision and verbal senses, as discussed by Thomson et al. (2012a: 3). Dual-coding theory suggests that cognitive ability and memory function are enhanced by using more than one sensory modality, e.g. tactile and visual (Atchison et al. 2007) and, furthermore, that verbal and visual material are connected in a short-term store or 'working memory' during encoding and are integrated with material retrieved from long-term memory (Thomson et al. 2012a). The contiguity effect suggests that when verbal and visual explanations are coordinated, rather than presented separately, this leads to a stronger and more lasting association between memories. Baddeley (1992) proposed that the working memory comprises two components, involving auditory and visual memory stores. Since each store is likely to have limited capacity, Baddeley suggested that an encoding strategy that draws simultaneously upon both modalities should demonstrate a 'modality effect' in reducing the cognitive load of one and exploiting the available capacity of the other. In relation to 'levels of processing', Craik and Lockhart (1972) hypothesised that the 'deeper' an item was encoded, the better it would be remembered. Thomson et al. (2012a) suggest that the more elaborate the material or activities are, in the case of cultural encounters involving museum objects, for example, this theoretically leads to deeper encoding and more connections being laid down in memory. They further suggest that heritage and arts interventions draw upon the modality effect and elaborative processing, since they combine conversation with visual exploration (2012a: 3). If it is the case that touch also enhances well-being, as the *Heritage in Hospitals* research suggests that it does, Thomson et al. propose that this implies the presence of a short-term memory tactile representation in addition to the verbal and visual representations proposed by dual-coding (Paivio 1986), thus supporting the idea of a triple-coding model comprising tactile, visual and verbal elements (Thomson et al. 2012a: 3).

The therapeutic value of combining the senses has been demonstrated by Spector et al.'s Cognitive Stimulation Therapy (CST; 2001, 2003). CST is an intervention for people with dementia and comprises a range of activities involving physical games, sound, activities relating to themes (e.g. childhood, food, current affairs), word association games, quizzes and creative exercises. A randomised controlled trial involving over 200 older adults with a dementia diagnosis showed significant improvements in cognitive function and quality of life after participants took part in 14 sessions, twice a week for seven weeks (Spector et al. 2003). Parallels could be drawn between CST activities and Museums in Health activities such as museum object-handling sessions, which usually always involve tactile, visual

and verbal associations. It is proposed that Museums in Health activities tap in to biopsychosocial factors (Engel 1977) that impact on cognitive processing such as sensory stimulation (verbal, visual and tactile) and could help lay down new connections in the brain through repeated encounters with novel stimuli (such as museum objects, exhibitions or other multi-sensory heritage experiences) and the social environment in which they are experienced.

The concepts of Positive Psychology (Seligman 2002) and Mental Restoration (Kaplan et al. 1993) may also help to explain the therapeutic value of museum encounters. The first approach is the study of optimal human functioning or 'flourishing' that shifts the focus from a 'disease model' to one enabling individuals and communities to improve their quality of life. A study by Pressman and Cohen (2005) showed that faster hospital recovery rates, improved coping strategies and increased resilience were associated with positive well-being judgements. Kaplan (1995) showed that natural environments and art museums were found to be restorative for visitors to these sites, suggesting that recovery from mental exhaustion can be brought about by a continuous focus of attention. Kaplan proposed that important factors in mental restoration included the mental or physical 'removal from one's everyday environment' and being 'so fascinated with an activity that it leads to effortless engagement' (Kaplan 1995). Again, a positive psychology approach and engagement in a novel and 'out of the ordinary' activity could explain the therapeutic basis for museum encounters.

The science of touch is explored in Chatterjee's *Touch in Museums* (2008), where it is proposed that the sense of touch actually combines a mix of visual, olfactory and auditory cues in order for our brains to make sense of what it is we are touching (Spence and Gallace 2008). This multi-sensory experience has links with both psychological and physiological states. Experimental research, explored by Critchley, McGlone and Spence and Gallace, suggests that there are physiological aspects to touch which are directly linked to emotion, and which in turn guide and motivate behaviour and reinforce memories. Advances in neuroimaging, psychoneurology and psychophysical research have enabled a more detailed understanding of the relationship between touch and emotion, starting from the skin, where sensory information is first perceived, through to the brain, where this information is processed and translated into emotional states; this enhanced understanding is referred to as 'emotional touch' (Critchley 2008: 61–71; McGlone 2008: 49; Spence and Gallace 2008: 33). Critchley proposes that emotional feeling states are directly integrated with the regulation of internal bodily states; a simple example is pain, which carries significant emotional meaning (2008: 68). He goes on to describe that sensual touch has a calming effect on autonomic and behavioural arousal, which can enhance physiological and subjective well-being (2008: 69). This has potentially profound implications for the role of touch in health and well-being, and helps to explain why a multi-sensory Museums in Health experience involving touch is likely to have a greater impact on health and well-being.

Cohen (2009) highlighted the importance of understanding the underlying mechanisms which explain why and how music and art have an effect on health, and this issue can be extended to Museums in Health. In a review about the theories of the underlying mechanisms that explain why active involvement with music and art promote health in relation to ageing, Cohen refers to a range of evidence from the fields of psychoneuroimmunology and behavioural neuroscience. Regarding the former, Cohen draws attention to the influence of the mind on neurological centres of the brain and the immune system. Studies focusing on people experiencing a new sense of mastery (e.g. when undertaking a new activity) revealed an increase in the level of T cells (lymphocytes that ward off bacterial infections) and NK cells (natural killer cells which combat cancer cells) in the bloodstream (see Cohen 2009 and references therein). This indicates that positive psychological experiences can have beneficial physiological effects. Similarly, evidence of brain plasticity shows that when 'the brain is challenged through our activities and surroundings, it is altered through the formation of new synapses ... More synapses means better communication among brain cells and increased opportunities for new ideas connecting' (Cohen 2009: 50). The importance of keeping the brain active as a means of maintaining good health is now well established. Research shows that engaging in new experiences and challenging activities, such as learning, induces the growth of new dendrites, the branch-like extensions which connect brain cells, affording greater opportunities for forming new synapses, which are the mechanism by which information is transmitted around the brain (Cohen 2009). Through extension, then, engaging in new, challenging, museum activities should afford the same therapeutic benefit.

Finally, evidence from physiological research into the effects of non-pharmacological interventions may also help to explain the effects of cultural encounters. One of the earliest studies to investigate the physiological effects of non-pharmacological interventions involved dog patting (Vormbrock and Grossberg 1988) and is now widely cited, along with other studies, as good evidence for the value of pet therapy. Vormbrock and Grossberg showed that petting a dog lowered blood pressure (a good indicator of stress levels), but, interestingly, that talking to the dog whilst petting it did not result in the same effect, and in fact increased blood pressure. Staricoff and Loppert (2003) also showed reduced blood pressure and a reduction in the stress hormone cortisol in patients receiving chemotherapy who participated in weekly live-music performances in hospital wards. The same study also found reduced levels of drug consumption in patients who participated in arts and health activities. Some studies, however, have shown that physiological measures remained unchanged after a short therapeutic intervention, whereas psychological measures demonstrated differences. Bygren et al. (2009), for example, found that health workers participating in weekly arts activities, such as concerts or exhibitions, showed an increase in perceived health based on psychometric measures, but no change in physiological measures (e.g. cortisol level). This suggests that further

work is required to fully understand the physiological impact of Arts in Health and other non-pharmacological interventions, and this would be particularly valuable in understanding the effects of cultural encounters on aspects of health.

## LEARNING AND WELL-BEING

Salom states that museums can 'supply therapeutic experiences that can significantly impact our well-being if we place the emphasis in learning about ourselves through the contents in them' (2008: 10.) Learning (including skills acquisition) as a therapeutic mechanism and an outcome is a common theme is many museum activities (e.g. Dodd et al. 2002; Wood 2008; Davenport and Corner 2011; Ander et al. 2012a; Balshaw et al. 2012). Museum learning theory is grounded in constructivist learning theory, which suggests that learning is not a simple matter of transferring content from stimulus to a receiver (learner), but rather that learning builds on individual experience, motivation and development whereby each learner constructs their own learning world and meaning (Hein 1998).

Ander et al. (2012a) propose that Falk and Dierking's (2000) work on learning in museums is helpful in articulating health and well-being outcomes. Falk and Dierking's 'Interactive Learning Model' proposes that the physical environment, the social context, the personal background of the museum visitor and subsequent experiences all affect the learning that happens during a museum visit, and help make meaning and connections. Ander et al. argue that such 'learning' concepts apply to well-being too: 'One could argue that people construct their own well-being from the situation they are in, the life resources they have and the experiences they encounter. When they have a museum encounter, whether in everyday life or in a healthcare institution, the impact the museum resource will have on their well-being should be affected by their physical environment, the social situation and their personal levels of interest, motivation and current well-being and health' (2012a: 2).

Salom recognised that museum spaces can inspire visitors to learn about a technique, explore certain themes or delve into existential questions, whilst the collections they hold are symbolic 'physical manifestations of the creative force that runs through humanity' (2008: 4). This implies that not only can museums and their objects be used to convey meaning and information, but that they may play a role in issues pertaining to identity or more personal connections between people and things. This is borne out in Newman and McLean's studies around social inclusion in Glasgow and Newcastle upon Tyne (2006). This research demonstrated links between loss of identity and social exclusion from society, and that museum-based community development projects enabled participants to create new social identities through shared experiences.

## ARTICULATING THE THERAPEUTIC VALUE OF CULTURAL ENCOUNTERS

It is notable that several themes repeatedly emerge from the aforementioned studies. These themes can help to articulate how cultural encounters, be they guided gallery tours or object-handling sessions, can contribute to enhanced health and well-being (Table 3.1 below). Research to date exemplifies that cultural encounters with museums and their collections:

- provide a positive social experience;
- provide opportunities for learning and acquiring new skills;
- are calming and reduce anxiety;
- elicit an emotional response that encourages positive feelings such as optimism, hope and enjoyment;
- promote self-esteem and a sense of identity and community;
- provide new experiences which may be novel, inspirational and meaningful.

Cultural encounters can also help reduce feelings of isolation and this is particularly important for those who are socially isolated and those in care, including hospitals and care homes where institutionalisation can have a devastating effect on quality of life, health and emotional well-being. Through engaging individuals facing such challenges, we can afford the opportunity to create an environment where the person and their identity, ideas, and opinions are valued, leading to increased energy, alertness, focus and purpose – all of which may be genuinely restorative.

The evidence clearly shows that such outcomes are beneficial for psychological health and well-being, but many cultural encounters are also beneficial for physical health. Healthy walks offered by some museums, for example, in the north-west of England (Balshaw et al. 2012), have been deliberately developed to address this issue, but physical exercise to some degree is involved in most cultural encounters, from wandering around an exhibition through to creative art workshops and handling sessions. Interactive multi-sensory activities such as object handling also provide a tactile experience which is beneficial in a rehabilitative context and so help rehabilitate fine motor skills (see O'Sullivan 2008; Ander et al. 2012a); these activities provide both physical and cognitive stimulation and therefore have the potential to be incorporated into mainstream occupational therapy within healthcare and social care settings. Research undertaken as part of the *Heritage in Hospitals* project with neurological rehabilitation patients (individuals who have had a stroke or suffered other neurological damage, for example, through an accident) afforded the opportunity for tactile stimulation, encouraging manual dexterity and associated cognitive stimulated through discussing and handling objects at the same time (Ander et al. 2012a; Thomson et al. 2012a).

**Table 3.1    Health and well-being outcomes derived from cultural encounters (repeated themes shown in bold)**

| Wood (2008) *Museums of the Mind* project | Davenport and Corner (2011) *Ageing, Health and Vitality* project | Ander et al. (2012a) *Heritage in Hospitals* project |
|---|---|---|
| Sense of **connection** and belonging | An experience of **calm** | **New perspectives** |
| Human capital: using and improving **skills** | A positive **social experience** | **Positive feelings** (excitement, enjoyment, wonder, privilege, luck, surprise) |
| Optimism and hope | An experience involving mild physical exercise | |
| Moral values, beliefs | A creative experience | **Learning** (including skills and confidence) |
| **Identity** capital, **self-esteem** | An experience that involves (re-)**learning** and gaining mastery over tasks | Energy, alertness |
| **Emotional** capital, resilience | | **Positive mood** (e.g. cheered up) |
| Opportunity for success | An experience of being absorbed in a task | Sense of **identity** |
| Recognition of achievement | An experience that gives **self-esteem** to participants, their lives and their memories | Something different, inspiring |
| Support | | **Calming**, relieves anxiety |
| **Quiet, rest, sanctuary** | | Passing time |
| **Social** capital, relationships | An experience that involves the sharing of **skills** | **Social** experience |
| Meaningful pursuits | | Tactile experience |
| Safe, rich museum environment | An experience that opens participants up to **new experiences** | |
| Access to arts and culture | | |

## DEALING WITH NEGATIVE OUTCOMES

Whilst there are many potentially positive outcomes elicited by cultural encounters, negative outcomes are also just as likely and should not be overlooked when developing and evaluating the impact of museums. As numerous case studies and projects have demonstrated, cultural encounters can elicit deep emotional responses; this may include unearthing negative emotions and remembering negative experiences, thoughts or ideas. As Phillips (2008) points out, museum professionals should be aware of the power of evoking memories and should recognise the importance of seeking advice. She goes on to add that the presence of an appropriately trained individual who knows the participants is valuable not only during the session but also afterwards to provide sustained support following the cultural encounter (2008: 203). The same applies to those museum professionals facilitating sessions. Working with vulnerable individuals who are facing mental and physical health challenges is a relatively new area of work for the museums

sector and may cause concern, distress, fear or anxiety for those running such projects, especially if they are working with people facing serious ill health or those who are near to the end of their life.

Recognising and addressing the issue of negative as well as positive outcomes brings concomitant resource implications for the cultural sector; museum professionals are not trained in psychology or mental health practice, so it is important when planning any Museums in Health activity to consult with associated healthcare practitioners and develop a support plan that includes how to deal with issues such as negative outcomes, for both the participants and facilitators. In essence, it is important to be clear about the reasons for implementing such an activity, to understand as much as possible about the target audience's needs, to build in relevant planning and training in order to support all of the individuals involved, to set clear expectations from the start, to prepare for all eventualities and to do all of this through consultation with relevant health and social care professionals; for further guidance and information, see Ander et al. (2012b).

## SUMMARY

In summary, it is clear that museums are powerful agents of social enrichment and that they have a significant therapeutic potential. Museums and bespoke health and well-being activities, involving their spaces and collections, can be both restorative and curative if careful consideration is given to the plethora of preventative and remedial outcomes developed in close affiliation with healthcare professionals. Museum objects carry meaning and may be symbolic. In this context, multi-sensory encounters with museum objects can elicit ideas and afford opportunities for meaning making, helping people to explore and convey emotions. Finally, museum interventions and other cultural encounters can bring about tangible psychological and physiological changes which affect health and well-being, but, crucially, focused research is warranted to fully understand the impact of museums on health and well-being.

# MUSEUMS AND HEALTH IN PRACTICE

As previously discussed, there has been a considerable rise in the number of museums developing programmes targeting specific health and well-being outcomes. This chapter details the scope of many recent and ongoing projects across the UK and beyond. Here we describe the results of a one-year study, funded by the UK Arts and Humanities Research Council in 2011, to explore the museums, health and well-being 'scene' in order to ascertain the breadth of practice, target audiences, modes of working and methods of evaluation.

The *Museums, Health and Well-being* study involved a variety of survey approaches, including a literature review, detailed Internet searches, a survey (Figure 4.1) which was emailed directly to some museums and a scoping email which was also sent to various museum mailing lists. It should be noted that the results of this study inevitably do not cover the full breadth of all of the work undertaken by museums in the field of health and well-being as this was not possible within the scope of the project. Further, we cannot account for any inaccuracies in the information provided to us, although we have done our best to check the data and information provided. There is also a bias towards UK museums, since access to this information was generally easier and quicker to acquire given the timescale of the project, although several international examples are included. Data and information from the survey were collated into a database comprising over 100 entries. The database contains information about one-off projects (short and long term) and ongoing programmes (including activities such as the use of loan boxes, handling collections, creative/participatory exercises and exhibitions); all projects and programmes were included which either the survey team or individual museums or services classed as targeting health and well-being. The database also includes arts and health programmes, arts and heritage services, and library and archive services, but the focus here will be on describing museum provisioning and broader heritage services, since arts and health has been tackled elsewhere (see e.g. Chapters 1 and 2). For useful information about the provision of libraries in the area of health and well-being, see the public library health and well-being advocacy toolkit[1] and Hicks et al. (2010).

---

[1]    http://www.readingagency.org.uk/about/the-universal-reading-offer.

**Museums, Health and Well-being:**
**A Survey of Projects in the UK**

| Museums, Health and Well-being |
| --- |
| Museum/Gallery: |
| Project title: |
| Project contact (leader/coordinator/facilitator) + their job title: |
| Contact details: |
| Summary (aims and objectives): |
| Health/well-being outcomes: |
| Learning outcomes: |
| Evaluation or measurement methods used (Formative and/or Summative): |
| Participants (e.g. hospital outpatients/inpatients, care home residents, GP referrals): |
| Project Partners: |
| Length of project (indicate if ongoing): |
| Cost of project (estimate if not known): |
| Funders: |
| Sustainability of the project: |
| Advice/Challenges: |
| Training: |
| Further information: |

Thank you for completing this form. Finally, please indicate if you would be happy for us to contact you for further information: Yes/No

**Figure 4.1    Museums, Health and Well-being survey form**

In this chapter, we provide an overview of the survey with a focus on the main areas of museum and heritage activity, and provide more detailed case studies for eight recent UK Museums in Health programmes.

## THE MUSEUMS, HEALTH AND WELL-BEING SCENE

Following a review of the results from the *Museums, Health and Well-being* survey, activities were grouped into the following categories:

- Public Health Education.
- Mental Health Services/Users.
- Older Adults and Reminiscence.

**Older Adults and Reminiscence**
Dulwich Picture Gallery
Geffrye Museum
Bristol Museum, Galleries & Archives
St Albans Museums
Beamish Museum
Tyne & Wear Archives & Museums
Tullie House Museum & Art Gallery
Salford Museum & Art Gallery
Museum of Oxford
Oxfordshire Museum Service
Reading Museum
Nottingham City Museums & Galleries
Leicestershire Open Museum
The Museum of Liverpool
Glasgow Open Museum
Tate Modern
British Museum
Museum of Modern Art, USA
Amon Carter Museum of American Art

**Public Health Education**
Wolverhampton Arts and Heritage Service
Croydon Libraries
Slough Libraries
Kent Libraries and Archives
Stockport Libraries
Manchester Museum
Shrewsbury Museum and Art Gallery
Wellbeing Heritage Centre, St Mary at the Quay Church
Discovery Museum (Tyne & Wear Archives & Museums)
Wellcome Collection, Thackray Museum, Royal College of Surgeons of
England Museums and numerous other medical museums
Asian Art Museum of San Francisco
Museum of Menstruation and Woman's Health, USA
Museu Nacional do Pão (National Bread Museum), Portugal
Museu da República, Brazil
Museu do Indio, Brazil
Museu da Vida (The Life Museum), Brazil

**Other (including rehabilitation)**
The Fitzwilliam Museum
Museum of Hartlepool
Glasgow Life (Museums)
Heritage2Health, National Trust and
English Heritage

**Mental Health Service Users**
National Museums Liverpool (Sudley House)
Bolton Museum
Manchester Art Gallery
English Heritage
The Light Box
The Freud Museum
Tate Modern
Leicestershire Open Museum
Glasgow Open Museum
Together Our Space Gallery
Mansfield Museum
The Harris Museum and Art Gallery
Bolton Museum and Library Service
Colchester and Ipswich Museums
Bethlem Art and History Collections Trust

Examples of Health and Wellbeing
provision across the Cultural Sector

**Children and Hospital Schools**
National Portrait Gallery
Whitworth Art Gallery
Leicestershire County Council Heritage & Arts
Service
Leeds Library and Information Service
V&A Museum of Childhood
Bassetlaw Museum
Queens Museum of Art , USA
DuPage Children's Museum , USA
Please Touch Museum, USA

**Health Professionals/Carers Training**
Wiltshire Libraries
National Museums Liverpool

**Figure 4.2    Schematic of museums, health and well-being provision by type**

- Children and Hospital Schools (including services for children with learning difficulties/autism spectrum disorders/physical health problems).
- Health Professionals/Carers Training.
- Other (including rehabilitation and intergenerational health projects).

Figure 4.2 shows a breakdown of this provision and also includes services offered by libraries and archives, although 'arts and health' (including hospital and community arts programmes) are not listed here since they are discussed elsewhere (see Chapter 2). The first three categories – Public Health Education, Mental Health Services/Users and Older Adults and Reminiscence – account for the majority of museums and heritage provision, with services for older adults forming the largest area of activity.

## PUBLIC HEALTH EDUCATION

The scope and diversity of the work undertaken under the Public Health Education umbrella mirrors the general societal, political and economic focus on health and well-being for individuals through to populations. This category includes

temporary and permanent exhibitions, displays and roadshows geared towards raising awareness of particular public health challenges, such as mental health, obesity and ageing. The fact that the cultural heritage sector is responding to this global agenda is a valuable use of the museum as a public space where challenging, contentious and potentially distressing issues can be explored openly, affording opportunities for debate and two-way engagement. Cultural heritage organisations, such as museums and libraries, are unique in this capacity as, unlike many public sector institutions, their agendas are usually geared towards inclusivity, engagement and education. As Silverman says: 'Museums serve as agents of public health mobilization' (2010: 47). In such a 'mobilising' role, museums have a potentially powerful part to play in raising awareness of the biggest health concerns (e.g. nutrition, dementia), although in the UK, libraries have, to date, taken the lead in public health education (e.g. Stockport, Croydon, Slough and Kent library services) along with medical museums such as the Wellcome Collection in London.

One innovative project in Ipswich seeks to take the role of a public health education provider and therapeutic agent to a new level. Following an award from the Heritage Lottery Fund, St Mary-at-the-Quay Church is being converted into a Heritage Well-being Centre with the help of the mental health charity Suffolk Mind and the Churches Conservation Trust. The aim of the project is to create a community space for heritage and arts workshops, performances, exhibitions, activities and learning opportunities. The renovated church will also provide areas for alternative therapies, reflection and contemplation.[2]

Another example of the use of heritage buildings and sites in addressing health and well-being outcomes is the *Heritage2Health* project. Coordinated through the Faculty of Health and Social Care Sciences at St George's University of London, the project works in collaboration with English Heritage, the National Trust, various health and social care providers, local authorities and rehabilitation centres 'to develop shared solutions to empowering and improving well-being and participation of vulnerable groups'.[3]

For some museums, public health education forms part or all of their core business, such as the Thackray Museum in Leeds and many other medical museums. Exhibitions at the Wellcome Collection in London attract hundreds of thousands of visitors each year and offer an impressive array of temporary and permanent exhibits renowned for their contemporary, engaging and sometimes controversial content. The Medical Museion (Denmark) is part of the University of Copenhagen's Faculty of Health and Medical Sciences. As with many university medical museums, as well as playing an important role in training healthcare professionals, it seeks to

---

2    http://www.visitchurches.org.uk/ipswich.
3    http://www.heritage2health.co.uk.

raise public awareness about the importance of medical science and technology, in the past, in the present and in the future, through public exhibitions, events and an interactive website.[4] The Museu da Vida[5] (the Museum of Life) in Brazil serves both as a place to contemplate health-related information and to tackle current health difficulties within the community. The *Travelling Science: Life and Health for Everyone* project is based inside a large truck that moves from city to city, taking with it an interactive exhibition, handling collections, games, workshops, interactive equipment, videos, storytellers and talks about health. The truck operates in the south-west region of Brazil and often adapts its content to subjects relevant to the location in which it will be temporarily based. Many smaller towns in the region do not house museums, galleries or other public institutions that can address local health needs, so the Museu da Vida fulfils this role in an interactive and kinaesthetic way, employing a community arts and health model.

## MENTAL HEALTH SERVICES AND SERVICE USERS

Many museums offer innovative programmes targeting mental health service users and this area of provision accounts for much of the UK's contribution to health and well-being-related programming. National Museums Liverpool (NML), Bolton Museum, Manchester museums and galleries, Leicestershire Open Museum and Colchester and Ipswich Museum Service are all examples of museums that work in partnership with healthcare service providers such as GPs, Primary Care Trusts (PCTs), hospitals and social services directly aimed at remedial and preventative healthcare.

The Colchester and Ipswich Museum Service used project funding to employ a Mental Health Project Officer in an innovative two-year project to develop new programmes geared towards mental health service users. Part of the remit of the project officer was to review the museums service and make recommendations on how it could best meet the needs of users with mental health issues and encourage the museum to develop their socially inclusive practices. In collaboration with a variety of partners, such as local mental health support groups, charities and community arts organisations, the project provided opportunities to gain knowledge of the museums and local heritage through guided tours, object handling, conversation and creative exploration. Regrettably, the Service has been unable to continue to fund this post, despite evidence of the positive impact of the programme. This illustrates the reliance on time-limited funding to deliver many such museum programmes that ultimately affects the sector's ability to contribute to the health and well-being in a sustained way and across extended time periods,

---

4    http://www.museion.ku.dk.
5    http://www.museudavida.fiocruz.br.

which is essential in order to gain the maximum benefits afforded by museum encounters.

The Emotional Well-being Project developed by NML, in partnership with the Liverpool PCT's Active Ageing portfolio, explored how culture can be used as a tool for improved health and mental well-being. The project targeted people at risk of developing mental health problems, including vulnerable older adults and socially excluded groups such as homeless people and people with disabilities, as well as those individuals who have experienced issues such as bereavement, drug abuse and domestic violence, or who may already be experiencing mental ill-health. Individuals being treated for serious mental health problems such as clinical depression or Obsessive-Compulsive Disorders (OCD) were also involved. The project used art, craft, reminiscence and cultural references to enable participants to express themselves and explore their well-being and place in society. A range of activities were offered to allow flexibility and choice for participants, supporting the idea of the social prescribing of culture as an enhancement to medical care.

Other museums work in partnership with mental health charities and support organisations. The award-winning Lightbox in Woking, Surrey, is renowned for its community programmes targeting mental health service users. Since it opened in 2007 it has developed several programmes, the most notable of which was a community arts project funded by the Heritage Lottery Fund entitled *Ways of Seeing*. The aim of the project was to create new art works and exhibit these alongside selected works from the Ingram Collection, part of the permanent collections at the Lightbox, to produce a major public art exhibition. Participants were recruited from the local community and all had some form of mental or physical disability. The project was evaluated and documented by a team at Brunel University, who followed participants on their journey, revealing a range of positive health and well-being benefits, including enhanced self-confidence and self-worth, a positive group experience, a new sense of self, acquisition of new skills and an active meaningful experience (Bryant et al. 2011). The researchers also highlighted negative aspects of the project, such as the pressure felt by some participants to produce high-quality artworks and the physical challenges of engaging in the project experienced by some participants. The Lightbox continues to offer services for mental health service users and the report produced by Bryant et al. serves as a useful guide for other museums looking to develop community arts and health projects.

The *Arteffact*[6] project in North Wales involved four museums: Bodelwyddan Castle, Llandudno Museum, Gwynedd Museum and Gallery Bangor and Oriel Ynys Môn in Anglesey. The initiative used creative engagement in museums

---

6    http://www.lemproject.eu/in-focus/news/arteffact-museums-and-creativity-for-better-mental-health.

to improve the mental health and well-being of people who had a history of mental health problems or who were experiencing an episode of stress. Groups of participants took part in a series of arts-based workshops lasting up to 10 weeks, which were evaluated in a pilot study by an external evaluator using a mixed-methods approach (Neal 2012a, 2012b). Qualitative evaluation focused on interview feedback and the Warwick Edinburgh Mental Well-being Scale (WEMWBS 2006) was used as a quantitative measure which was taken at the start of the project as a baseline and as participants finished the programme. Qualitative data showed that participants 'experienced immediate changes to their mental wellbeing as a result of the art activity' and further that there was a 'change in many of the common symptoms of depression, anxiety and stress' (Neal 2012a: 4). Participants reported several immediate effects, including relief from physical pain, distraction from problems and structure being provided to their lives, and some participants reported a number of long-term benefits, such as feeling better, increased confidence, increased ability to accept praise, increased self-motivation, increased awareness, increased ability to deal with problems, something to live for, making plans for the future and a desire to give something back (Neal 2012a: 4). The results of the WEMWBS questionnaire showed a statistically significant increase in mean score from baseline to follow-up at the end of the programme. Although much of the data collected revealed that there were many positive outcomes from the art sessions, negative feedback was also experienced, including concerns expressed about the museums and gallery environment, which invoked a sense of being overwhelmed and was distracting for some participants. Furthermore, the organisers, the artists and the participants expressed concerns that positive effects would be short-lived and would disappear as soon as the participant stopped attending the sessions. Another key outcome of this pilot study was to provide information and feedback on how to develop future museum-based mental health projects and Neal's report provides useful guidance of the variety of factors to consider when developing such programmes (2012a).

Community involvement in the interpretation of museum and gallery collections as a means to improve mental health and well-being is exemplified by several museums. Mansfield Museum recently reinterpreted its natural history collection with the help of staff and clients from the Nottinghamshire branch of the mental health charity Mind. Museums in Manchester asked mental health service users to create a well-being trail to encourage people to visit during their lunch breaks from work. In another example, the *Museum of the Mind* project initiated by Bethlem Art and History Collections Trust, based at Bethlem Royal Hospital in Beckenham, a range of in-patients, out-patients, staff and community groups (including self-help and local residents) are involved in the reinterpretation, relocation and redevelopment of its collections, new museum spaces and its business plan. The *Museum of the Mind* project is using the consultation process to raise awareness of mental health issues, to represent the lifestyle and artworks of those with mental health issues, to develop and expand its learning programme, to

inform community engagement, outreach, and the events and exhibitions offered on-site. In addition to verbal consultation, the process will also be informed by observations on wards, photography and creative activities with inpatients and outpatients. The aforementioned are interesting departures from the usual use of art collections to inspire therapeutic practice in museums, which is by far the largest area of provision for those museums working with mental health service users (e.g. Bolton Museum, the Harris Museum, Preston and the Tate Modern, London).

## OLDER ADULTS AND REMINISCENCE

Another significant area of provision is targeted at older adults and older adults with dementia. Much of this provision revolves around the use of memory or reminiscence boxes, often but not exclusively, in outreach sessions offered in care homes and daycare centres (e.g. the Geffrye Museum; Bristol Museum, Galleries and Archives; St Albans Museums; Reading Museum; Beamish Museum; Tullie House Museum and Art Gallery; Salford Museum and Art Gallery; and National Museums Liverpool). Key characteristics of these sessions include the opportunity to observe, handle and discuss objects from the museums, share stories, reminisce and interact with museum professionals, carers and often healthcare staff. Several museums host established activities and events targeting older adults, such as the Dulwich Museum's *Good Times* programme, the Tate Modern's *Seniors Events* and the British Museum's *Shared Experience* programme. Many of these museums have explicitly designed the sessions to have therapeutic outcomes. *Afternoons at the Museum*, for example, are monthly sessions at the British Museum targeting those aged over 55. The sessions are designed to stimulate conversation and provide participants with the opportunity to handle objects, take guided tours of the galleries and share experiences, stories and memories over a cup of tea. Many of the participants have poor mobility or are visually impaired, so the sessions have been explicitly developed to accommodate their needs. In the same vein, the museum offers object-handling sessions at local community centres, targeting participants who find it difficult to visit the museum. The Geffrye Museum in London runs object-handling sessions for specific groups (e.g. older adults with dementia and stroke survivors) to enable them to remember the past and help them keep their memories active. For stroke survivors, rehabilitative talks and craft sessions allow participants to practise their communication skills and develop their physical skills through making. The Museum of Modern Art (also discussed in Chapter 1) and the Amon Carter Museum of American Art in the USA both offer activities for those affected by Alzheimer's disease and other forms of dementia or cognitive disabilities.

In Australia there are several examples of programmes in museums and galleries which are specifically tailored towards the needs of older adults and older adults

with dementia. Macquarie University Art Gallery's *Art and Dementia*[7] programme was first established in 2001. Although a lack of resources and funding caused the programme to cease running in 2005, the University has recently reinvigorated the initiative as a sociological research project, using art as a means of renewing cognitive facilities of expression, emotions, thoughts, laughter, story and actions in adults with dementia. In another university collaboration, the University of Tasmania and the Tasmanian Museum and Art Gallery are working on a research project to find out how memories can help people with dementia. The *iRemember*[8] project will use memory cases which contain objects from the 1930s to the 1970s, with an emphasis on everyday items. The Hurstville City Museum and Gallery in New South Wales offers *Reminiscence Therapy Kits*[9] for older adults and carers. The kits (which cost AU$50, about £33, to borrow for three weeks) contain images and objects from the past designed to aid in the recollection of memories. The Museum also offers reminiscence sessions whereby groups from local community venues and care homes take part in group tours and handling sessions using objects from the collections. Museum Victoria is an amalgamation of several museums and collections in Melbourne, which also offers reminiscence kits designed for older adults. Furthermore, there are numerous examples of arts-led reminiscence projects in Australia; for some examples, see Clifford and Kaspari (2003).

Finally, the Fitzwilliam Museum in Cambridge developed a project which worked with the local Chinese community to develop a trail for the exhibition *The Search for Immortality: Tomb Treasure of Han, China*. This not only gave the local Chinese community an opportunity to explore their heritage but also allowed the elders within the community to teach their British-born children about their Chinese heritage, thus contributing to the community's sense of identity.

## CHILDREN AND HOSPITAL SCHOOLS

The *Museums, Health and Well-being* survey revealed relatively few examples of museums offering health and well-being programmes or projects geared towards children. Whether this is a true reflection of the museum sector's contribution to children's health and well-being or a failure of the data collection methodology, or perhaps an unwillingness of the sector to engage with this group because of child protection issues, is not known, but the result is nonetheless surprising given that schools and children are a key target audience for many museums. Of those museums surveyed, there were several examples of programmes geared towards children with

---

7    http://amusine.typepad.com/art/reconnecting-the-art-and-dementia-program-at-macquarie-university-art-gallery.html.
8    http://www.utas.edu.au/wicking/edu/iremember.
9    http://lmg.hurstville.nsw.gov.au/Reminiscence-Therapy-kits.html.

special needs, including autism, and their families and carers. Leicestershire County Council Heritage and Arts Service, Leeds Library and Information Service, the V&A Museum of Childhood (London), Bassetlaw Museum (Nottinghamshire), the Queens Museum of Art (USA) and the DuPage Children's Museum (USA) all offer services for children and young people with ASD (autistic spectrum disorders), including Asperger syndrome. Whilst some of these services are primarily educational, others seek to address some of the behavioural and communication challenges experienced by children with ASD. The Please Touch Museum's (USA) Therapeutic Membership scheme was created especially for organisations that serve children with disabilities. The museum offers a therapeutic environment for children receiving physical therapy, occupational therapy, early intervention and special instruction. Therapists, who pay to join the scheme, are entitled to a range of services and use of the museum for their therapeutic practice.

The National Portrait Gallery has developed a number of programmes working with hospital schools. The Gallery's Learning and Access team has created a highly respected and renowned arts outreach programme, including a toolkit which highlights the methods used and challenges faced when working in a hospital school environment. In 2007 the Gallery launched a one-year programme focused around its *Pop Art Portraits* exhibition, which was used to inspire children from four hospital schools to work with artists, comic artists and photographers on a multimedia project focusing on animation and collage. The programme included the participation of leading Pop artist Sir Peter Blake at the Evelina Children Hospital (part of Guy's and St Thomas' NHS Foundation Trust) and work continued at Great Ormond Street, St Mary's and University College London Hospitals. Subsequently, the Gallery has organised several programmes within hospital schools in collaboration with a range of partners and serves as an exemplar for working with this audience.[10] There are several other examples of museums working with hospital schools, such as the Museum of London's learning programme for special and hospital schools, which offers outreach and museum-based sessions involving: drama, storytelling and theatre performances; object handling and replica costume; art workshops; and interactive gallery workshops.

## REHABILITATION, MIXED AUDIENCES AND INTERGENERATIONAL AND TRAINING PROJECTS

Several museums offer health and well-being services targeting a wide range of participants, including older adults, mental health services users, hospital patients, training for healthcare professionals and carers. The aforementioned *Heritage2Health* programme developed in collaboration with the National Trust

---

10    www.npg.org.uk/learning/outreach/hospital-schools.php

and English Heritage offers services for people who consider themselves to be excluded due to age, disability, the demands of caring and those who are socially isolated. This includes people of all ages living with long-term health conditions, such as HIV or heart disease, those who have been disabled due to brain or physical injury, those with mental health issues, those with learning disabilities, carers and those who are isolated due to social and economic status (including asylum seekers, refugees and single parents). The objective of the programme is to create a unique therapeutic and shared learning experience involving a range of participants with varying health and well-being needs. Health, social care and arts professionals work with people of all ages and abilities to jointly plan and host team challenge events in heritage spaces. Participants are invited to take part in events through a trusted source, such as a community nurse, therapist or local voluntary organisation, and historic and open spaces are used as a creative place to enable participants to design and host a shared creative, historic, physical and social challenge.

The Fitzwilliam Museum in Cambridge offers a variety of sessions in venues such as hospitals, community centres and prisons which can be multi-sensory, discussion-based or include a practical art activity. The Museum of Hartlepool's *Come Dance with Me* was an intergenerational dance project that engaged five different community groups with a range of abilities and needs. Dance routines were inspired by handling sessions with objects from the Museum's collections, which, along with personal objects brought in by the participants, helped the reminiscence process, inspired moves and encouraged participants to share their memories with the group. The groups came together in a participatory dance event at the end of the project to perform their routines to families and friends. The collected stories, collections from the Museum and loaned objects from participants were showcased in a community exhibition at Arts Hartlepool, an experimental multi-arts space at Middleton Grange Shopping Centre in Hartlepool.

NML's *House of Memories* training project aimed to change the professional lives of social carers in the north-west region and create a positive quality of life experience for people living with dementia. The programme sought to demonstrate how a museum (or, by association, a library, arts centre or theatre) can provide the social care sector with practical skills and knowledge to facilitate access to an untapped cultural resource which is often within their locality. The project targeted those people living with dementia and their carers, including over 1,200 health and social care staff from across Merseyside and North Cheshire. Participants explored the collections of the Museum of Liverpool based on the local history of the region, learning how to engage with people living with dementia using objects and memorabilia from the Museum relevant to participants' personal histories. As discussed in Chapter 1, NML recently published an evaluation of the training programme which highlighted a series of valuable outcomes for those caring, working with and supporting people with dementia. Importantly, the

project recognised that museums are experts at recording and caring for people's memories (whether they are objects, thousands of years old, or items from living memory) and this alludes to the unique and valuable role that museums can play in understanding the complex and often distressing challenges faced by those living with dementia and other memory-related health problems, and their carers.

Glasgow and Leicestershire's Open Museums both offer a range of health and well-being services and resources targeting a wide diversity of audiences. The Open Museum in Leicestershire has developed several well-being projects which explicitly target the New Economics Foundation's *Five Ways to Well-being* (connect, be active, take notice, keep learning, give; NEF 2011) and the Museum states that: 'Museum objects and artworks have an important role to play in helping people to build resilience, and have good mental health and well-being.'[11] To this end, the Open Museum has developed an impressive and diverse array of well-being projects:

- Touch Tables comprising interactive artworks designed especially for people in the later stages of dementia or with severe learning disabilities;
- 'sharing stories', an intergenerational project bringing teenagers with behavioural problems together with older adults;
- projects aimed at developing parenting skills;
- reminiscence projects focused around the use of resources boxes for use in hospitals, care homes and charities such as Age UK;
- arts projects focused on mental health such as 'Opening Minds';
- after-school clubs for teenagers with autism.

Many of the initiatives involve collaborations with other local organisations such as arts and health groups and charities, and some of the activities have been run for over 40 years, such as the reminiscence box project. The Museum's recent achievement report, entitled *Opening Minds: Mental Health, Creativity and the Open Museum*,[12] outlines a series of projects targeting mental health and brings together a host of responses from mental health service users through to occupational therapists, mental health professionals, artists and museum professionals. The report is extremely valuable in bringing together the emotional responses elicited through engagement with the Open Museum and provides valuable insight into the therapeutic outcomes of such engagement.

Glasgow's Open Museum[13] undertakes many projects associated with health and well-being (see e.g. Case Study 3). Some of this work is located in care institutions

---

11    http://www.leics.gov.uk/index/leisure_tourism/museums/open_museum/wellbeingprojects.htm.

12    http://www.leics.gov.uk/openingmindsreport.pdf.

13    http://www.glasgowlife.org.uk/museums/our-museums/open-museum/Pages/home.aspx.

like hospitals, but most is based in community spaces and the museum has targeted a range of participants from health and social care organisations and voluntary groups. Specific projects have focused on asylum seekers and refugees, daycare users, those on low incomes and mental health service users. The museum's *Journeys* project, for example, worked with adults under the age of 60 diagnosed with Alzheimer's disease and provided a range of museum-led activities, including gallery tours, object handling, discussions and practical art sessions involving group members and their carers. The *Shared Earth* project worked with female victims of torture, whilst the *Wall of Mystery* project involved young, short-stay and long-stay patients at Yorkhill Children's Hospital. All of the projects use museum objects, usually supplemented by group activities such as workshops which also provide opportunities for social interaction; some projects have been going for 10 years, while others are one-off workshop sessions.

In 2008 the National Social Inclusion Programme and the Museums, Libraries and Archives Council in the UK developed a mental health and social training package for museums and galleries entitled *Open to All* (Stickley et al. 2008). Developed in conjunction with a number of museum and gallery partners, the package contains a series of modules which aim to raise awareness of issues relating to mental health and social inclusion, and to build skills and confidence in developing activities for this audience.

## MUSEUMS, HEALTH AND WELL-BEING CASE STUDIES

This section comprises a series of health and well-being case studies provided by UK museums and galleries. Respondents to the survey were asked to provide details of project aims and objectives, health and well-being outcomes, learning outcomes, evaluation methods, participants, partners, costs and funders, sustainability, advice and training. Eight case studies have been selected for inclusion here, exemplifying the diversity of health and well-being projects across the UK. The information has been provided directly by museum or project staff involved in developing and delivering health and well-being activities, and the content of their responses has been left largely unchanged in order to hear their perspectives about how their projects/programmes are run, organised, evaluated and funded.[14]

---

14    Contact details have been removed.

## Museums, Health and Well-being – Case Study 1

### Museum/gallery: Beamish, the Living Museum of the North

### Project title: Reminiscence Activities

### Summary (aims and objectives):

The huge and diverse collections at the museum are used as inspiration for a variety of meaningful and engaging reminiscence-based activities with older people in the north-east, both at the Museum and within community settings. We are currently focusing on developing our activities and resources for working with people with dementia and their families.

Themed loans boxes, containing objects, photographs and oral histories, are used with groups in community settings, such as residents in a care home, and are used to stimulate reflective discussions and help people to remember events from their lives.

Reminiscence sessions are held inside one of the Miner's Cottages in the Pit Village at the Museum. Groups can take part in a variety of activities, such as making toast on the fire, baking, making proggy mats (rag rugs), washing using a 'dolly tub', cleaning brass, singing, art work and craft.

Through evaluation and consultation with participants, group facilitators, carers and larger organisations who support older people in the region, we are developing a dedicated, engaging, adaptable and fully accessible reminiscence space on-site. This will be in the new 1950s area at the Museum. This space will be decorated as a 1950s home and will have all the furniture and objects inside from that era. It will be designed as an 'immersive' reminiscence environment for the groups who use it.

We will continue to provide support to staff and volunteers who work with older people in the region through providing Reminiscence Loans Boxes and reminiscence workshops. We also plan to develop the work we do and facilitate intergenerational sessions and projects. We feel it is important to value the memories shared as they an be used to help inform the Museum's interpretation of the history of the region.

### Health/well-being outcomes:

The reminiscence activities provide a safe and enjoyable opportunity for social interaction. Various studies have shown how involvement with these types of activities can improve people's sense of well-being, self-confidence and mental health. Providing opportunities for reflective discussion can also help people to reflect on their own sense of identity and can help care providers and family members 'remember the person', which in turn has a positive impact on relationships amongst residents/group participants and care staff and family members.

*'Reminiscence evokes some wonderful memories and promotes people to interact with others. Relatives sometimes feel they get the person back'* (quote from Care Home Manager).

Care staff from residential and care homes frequently remark on the improvement in residents' mood and behaviour during and after being involved in the reminiscence activities. We work with staff to help them develop their own activities which aim to continue these benefits for the participants.

## Learning outcomes:

Many participants engage with the objects and in conversations, and contribute their own memories. The nature of reminiscence often means that people discover new things about people and different experiences in different areas from the ones they are familiar with. Encouraging participation in activities, for example, proggy mat making and tile painting, allows people to develop and learn new skills.

Reminiscence workshops have been held at Beamish and off-site for care home staff and staff from other organisations who work with older people. Sessions aim to share knowledge and good practice about reminiscence and its benefits throughout the sector, and to create a network of support for all agencies in the region.

## Evaluation or measurement methods used:

Informal evaluation: observations of participant's behaviour before and during the sessions and through conversations with staff and group facilitators and the participants themselves.

Evaluation forms for care home staff/group facilitators. These aim to evaluate how the staff thought the sessions went in terms of how the participants participated, and aims to gauge their level of engagement. There is space for staff to record comments from the participants during the session.

The second part of the evaluation aims to encourage staff/group facilitators to consider the benefits of the session for each participant; recording each person's mood before, during and after the session and how they participated in the session. Copies are then kept by the staff and are also kept by Beamish staff. It was devised through consultation with Beamish's Older People's Advisory Panel.

We maintain relationships with many groups and we consult groups when developing new resources and activities. The Older People's Advisory Panel meets quarterly and is made up of representatives from care homes, voluntary organisations, NHS staff and representatives from organisations such as the Alzheimer's Society and Age UK.

## Participants:

Care home residents, NHS outpatients, daycare centres, Alzheimer's Society groups, Age UK service users and voluntary organisations.

## Project partners:

Beamish Museum, care homes in the north-east, the Alzheimer's Society, NHS Tees and Esk Valley, Age UK County Durham, Age UK Gateshead and Age UK South Tyneside

(these are the main organisations we work with, but we also work with smaller and voluntarily run organisations too).

**Length of project:**

Began in 2006. Larger focus on older people began 2009. Post of Active Ageing Officer created in 2011 with the focus upon working closely with partners to develop a designated space for reminiscence and associated activities and resources.

**Cost of project:**

Cost of resources very low as almost all are from the Museum's collection.

Travel expenses for museum staff approximately £300 per month.

Travel expenses for groups travelling to the Museum (e.g. care home residents) approximately £1,500–2,000 per year.

One full-time member of staff approximately £24,000 per year.

**Funders:**

Beamish Museum, the Heritage Lottery Fund and the Arts Council.

**Sustainability of the project:**

Continuing relationships and support networks with care homes and other support and health care agencies in the region is essential. We will continue to consult with our Older People's Advisory Panel over the development of services at the Museum and to evaluate activities and act upon recommendations.

We made links with several museums in the UK and in Europe to share best practice and knowledge about working with older people. In December 2011 we visited Den Gamle By in Denmark which has recently opened a 'House of Memories'.

We continue to keep up to date with research and discussions on the role of heritage, the arts and mental health through attending conferences, workshops and seminars. We are actively involved in several research projects with Newcastle University and UCL.

**Advice/challenges:**

Working with this type of group can be challenging and sometimes overwhelming, especially for staff and volunteers with little experience. We hold regular reminiscence workshops for Beamish staff and volunteers to share our ideas and tips with each other. We provided training for staff in association with the Alzheimer's Society in 2012.

The reminiscence workshops have proved very popular with staff from care homes, other organisations and volunteers. Feedback has indicated that staff felt much more confident about delivering reminiscence sessions and felt more enthusiastic about developing activities and using the Reminiscence Loans Boxes.

There is a huge demand from care homes to deliver reminiscence sessions. The workshops were a response to this demand, but it is important to encourage staff to actively develop their own reminiscence sessions and for the Museum to continue to provide support, advice and resources. The evaluation forms aim to encourage staff to take ownership of their role in improving the well-being of participants and to recognise the benefits of these activities for themselves.

**Training:**

We provide training for staff and volunteers about reminiscence activities and its benefits.

Museum staff have completed the NCFE Level 2 Certificate in Dementia Awareness and training in association with the Alzheimer's Society.

**Further information:**

http://www.beamish.org.uk/reminiscence.

## Museums, Health and Well-being – Case Study 2

**Museum/gallery: Whitworth Art Gallery, the Manchester Museum and Manchester Art Gallery**

**Project title: +Culture Shots; Museums and Galleries Week**

**Summary (aims and objectives):**

This week-long event was essentially an advocacy campaign promoting the resources, expertise and the participatory programmes of Manchester's museums and galleries. We wanted to raise awareness amongst our hospital community about the positive benefits to health and well-being that engagement with culture and creativity can bring about.

Central Manchester Hospitals NHS Foundation Trust already has a sound relationship with the two museums, which are in close proximity to each other on Oxford Road. The Children's Hospital and also the Manchester Royal Infirmary works with both the Whitworth Art Gallery and Manchester Museum. There are five hospital sites, with over 10,000 staff and with a footfall of over 1,000,000 patients and visitors throughout the year. In partnership with the NHS Foundation Trust, we wanted to promote the resources of museums within the Greater Manchester area to staff and patients.

**Aims:**

1. To promote the proven contribution to health and well-being that engagement with museums can bring about.
2. To enhance the well-being and satisfaction of hospital staff through informative and enjoyable activities.

3.    To promote the work of museums and galleries in Greater Manchester to staff, patients and visitors.

+Culture Shots was a week-long series of events, a chance for hospital staff to find out why culture works and how they can use the expertise within Manchester's museums and galleries to improve their professional practice, and their patients' health and well-being. We also produced a publication, 'Health+Culture, How Museums and Galleries Can Enhance Health and Well-being' (print run of 3,000).

To view the full programme of events throughout the week and the publication, visit: www.healthandculture.org.uk.

### Health/well-being outcomes:

Research has shown that cultural experiences can help improve health and well-being, and can result in benefits that range from the physiological to the emotional. From reduced heart rates and requests for analgesia to a reduction in the sense of loneliness felt by those suffering from mental ill-health, cultural experiences have been proven to help improve the lives of patients and those who care for them.

Hospital staff felt that sessions offered a welcome break from their busy working schedule. They have set up their own knitting group that runs during their lunchtime break as a result of participating in 'Get Knitting'.

### Learning outcomes:

The hospitals staff intranet ran a short survey asking staff about their experience during +Culture Shots; over 60 per cent said that they would like to see more of these types of well-being activities in their workplace.

Hospital staff were able to talk to curators, museum educators and senior cultural managers throughout the week about the range of events and activities delivered in our museums, as well as about our outreach work. Objects from our collections were also brought into the hospitals as along with live animals from the vivarium – staff, patients and visitors were able to handle these under the expert supervision of our curators and conservators.

Training was also provided by museum specialists for hospital staff in the use of objects for reminiscence sessions and how this might enhance well-being by improving confidence, self-esteem and sociability.

A further series of programmes have been devised and delivered as a consequence of the week's events. We are currently formalising our partnership with Central Manchester University Hospitals NHS Foundation Trust through the development of a five-year strategic arts for health plan.

### Evaluation or measurement methods used:

During the +Culture Shots week, we gathered the following information: the site had 1,963 unique visits (2,545 since launch); there have been 10,245 webpage views and the average visitor looked at six pages and stayed on the site for 5.4 minutes; It also gained 131 Twitter followers.

**Participants:**

Over 3,000 staff, patients and visitors from all five hospital sites (Manchester Royal Infirmary, St Mary's Hospital, the Royal Eye Hospital, the Children's Hospital and the Dental Hospital) participated in the workshops.

Groups from community service providers also visited the hospital during the week to participate in selected workshops.

**Project partners**

Whitworth Art Gallery, the Manchester Museum, Manchester Art Gallery, Central Manchester University Hospitals NHS Foundation Trust and LIME arts in health charity.

**Length of project:**

+Culture shots is a pioneering scheme, the first time an event of this type has been held in the context of the hospital environment.

It was a one-week event and was followed up with monthly 'Booster Sessions'. We will be delivering +Culture Shots on an annual basis.

**Cost of project:**

£40,000–45,000.

**Funders:**

Renaissance North West, Whitworth Art Gallery, the Manchester Museum, Manchester Art Gallery and Central Manchester University Hospitals NHS Foundation Trust.

**Sustainability of the project:**

+Culture Shots is to be an annual event primarily funded through the hospital's charitable funds.

**Advice/challenges:**

- The main challenge was for staff to find time within their busy working day to attend the workshops/sessions. Sessions that were 20–30 minutes were better attended. Drop ins, particularly object-handling sessions, were the most popular and also enabled staff to revisit them when they had extra time to find out more information.
- Delivering creative sessions in public hospital spaces requires thorough planning and flexibility to adapt to challenging environments and limitations of particular spaces.
- Noise levels MUST be considered when delivering performance or music-based sessions.
- Communication between participating organisations is paramount, requiring a team of dedicated people to market the programme appropriately. Working with the hospital's communications team enabled us to present our cultural message in their language and work together to find the right tone of voice.
- Target the 'warm spots' in the hospital to find cultural champions rather than going for the 'frosty spots'.
- A launch prior to the week-long event was a chance to bring together strategic senior managers, executives, councillors from across both sectors and a fantastic media opportunity.

## Training:

For this type of event and level of delivery, those involved all had the appropriate skills. It was more about managing people's expectations.

## Further information:

http://www.healthandculture.org.uk.

# Museums, Health and Well-being – Case Study 3

### Museum/Gallery: The Open Museum, Glasgow Museums, Glasgow Life

### Project title: The Gardener's Ark

### Summary (aims and objectives):

This project started in June 2008 and the work with the group has been ongoing. In partnership with the Open Museum, Acorn Gardening, Community Learning and Occupational Therapy, the adult learning group have worked towards the following aims:

- The creation of a 'living' travelling display that toured around the city in 2010. This is a 10 ft boat, built by the group and Acorn Gardening, based on boat models in Glasgow Museums' Collection. The boat was planted out by Acorn Gardening and the group, and toured the Glasgow Museums Resource Centre, the Winter Gardens at the People's Palace, the Hidden Gardens and Leverndale for the Scottish Mental Health Arts and Film Festival. The Ark is now permanently situated on the roundabout at Leverndale Hospital.
- Creation of content for a gardening website.
- Publication (http://www.glasgowlife.org.uk/museums/our-museums/open-museum/Pages/home.aspx).

The publication features work created by the group and the artworks that inspired the project. The group's artwork, literacy work, documented boat build and a step-by-step guide to gardening also feature in the publication. The Open Museum, Acorn Gardening, Community Learning and Occupational Therapy have worked together to develop these strands under a longer-term vision. The publication aims to show the combined benefits of art, literacy and horticulture in promoting positive mental health. The theme was chosen by the group and the purpose was to source artwork that was relevant and enhanced their experience; linking art to their daily life (gardening and literacy work) in a meaningful way. Working together using a holistic approach that utilises several areas of expertise can have a much greater impact on the health and well-being of the patients involved.

The participants have been involved from the beginning, from early design input to the physical touring and maintenance of the display. To achieve this, the group has worked with Community Learning to write content for the publication; it have taken part in an eight-week art-based session which culminated in content for the publication, the website and an onsite exhibition of its work; it has been on several visits to Glasgow Museums Resource Centre for inspiration and learning, and has attended several project meetings; it has been working with Acorn Gardening to build the boat which will form the core of the touring display; and it has been involved in the design and practical gardening for the final display. The participants helped tour the display around the city and maintain it throughout 2010 and beyond.

**Health/well-being + learning outcomes:**

The project aimed to support the patients' rehabilitation using a holistic approach combining object-based learning, gardening and literacy work. The project resulted in a 'living' travelling display, a first for the Open Museum. The holistic approach means that the health/well-being and learning outcomes are integral to each other, so are summarised here. The project:

- developed and supported learning through museum objects;

- coordinated several learning outcomes under a holistic approach: object-based learning, literacy and numeracy work, practical gardening work, healthy living skills and community participation;

- supported and enhanced the rehabilitation programme;

- aided the social integration of the Leverndale and Dykebar groups under a common project.

This resulted in the following:

- Literacy skills.

- Creating an exhibition.

- Social skills and team working.

- Confidence and capacity building.

- Healthy living skills.

- Practical gardening skills.

- Raising expectations.

- Working towards rehabilitation into the community.

**Evaluation or measurement methods used:**

- Formal Open Museum session evaluation forms throughout the project (because of the experimental nature of the project, feedback informed each subsequent session and influenced the outcomes).

- Informal evaluation with patients (oral feedback transcribed).

- Regular meetings with partners to evaluate each cornerstone.

- Individual Learning Outcomes recorded by Community Learning.

- The body of work produced by the group.

- The publication gives an overview of the project by each partner, detailing the nature of the partnership, the challenges and successes, and the impact on the group.

**Participants:**

The members of the group involved were long-term residents at Leverndale and Dykebar Hospitals with mental health issues and a wide range of learning difficulties; some have physical or motor impairments. The majority of residents have spent their lives in care from an early age and have somewhat limited life experience outside of the hospital. Some of the group can be deemed to be difficult to engage with due to the nature of their illness or because of the challenging behaviours they present. The overall aim for this group is rehabilitation into their community – a long and gradual process. Some of the group may move on and some may continue to spend the rest of their lives in care. This project had to take all these factors into consideration for this project to have value for the range of residents involved. The project involved a core group of nine long-term residents at Leverndale Hospital plus intermittent input from Hospital Outpatients and patients from other units at Leverndale and Dykebar (up to 22 participants in total). This particular rehabilitation unit involved had little precedent for external project partnership working.

**Project partners:**

NHS (Occupational Therapy, Leverndale Hospital), Acorn Gardening and Glasgow Life's Community Learning.

**Length of project:**

Two years.

**Cost of project:**

£3,000–4,500.

**Funders:**

The Open Museum provided curatorial and design expertise throughout the project and has funded the art sessions, ward exhibition, boat build, commissioned carved figureheads for the boat, plus marketing, etc. – in the region of £4,500.

Acorn Gardening provided boat-building expertise and ongoing work with the group, and funded the planting from its existing budget.

## Sustainability of the project:

*Creating new pathways of opportunity*

Since the project began, Occupational Therapy at Leverndale Hospital has had a precedent to form new partnerships with outside agencies. Other units within the Hospital have requested to work in partnership with the Open Museum and several have started using our loan resources, and others have made visits to Glasgow Museums Resource Centre.

The newly built Arts and Resources Centre (ARC) at Leverndale has been so-named after the Gardener's Ark project, which has provided inspiration for future projects and ways of working.

## Advice/challenges:

See the Gardener's Ark publication for further details.

## Training:

None specific – this project built on an existing relationship with the group. The Open Museum consulted with Occupational Therapy previously as to hospital procedures and regulations, and set this out in a document. There were always at least two ward staff members present to support/supervise the group. Because this was a new way of partnership working, much of it was trial and error, evaluating and adjusting procedures step by step.

## Further information:

http://www.glasgowlife.org.uk/museums/our-museums/open-museum/Pages/home.aspx.

Below are some useful links:

Link to publication 'The Point – An Alternative Voice on Mental Health Issues', *SAMH*, Winter 2010 issue; see page 30 for the article on the Gardeners' Ark: http://www.samh.org.uk/media/19805/the_point_issue_34.pdf.

Link to article in the Learning Museum: http://www.lemproject.eu/in-focus/other-related-projects/open-museum-the-gardener2019s-ark.

Link to article from NHS media centre: http://www.nhsggc.org.uk/content/default.asp?page=s1192_3&newsid=11780&back=home.

## Museums, Health and Well-being – Case Study 4

### Museum/Gallery: The British Museum

### Project title:

Age Collective – museums and galleries working with and for older people

### Summary (aims and objectives):

A series of seminars across the UK for museum practitioners and specialists from other sectors to discuss how, through collaboration, museums and galleries can better support older people in their communities, in partnership with organisations from other sectors. The aim of the seminars will be to:

- explore the needs of diverse older people and the varied provision for meeting these needs across the UK, and share good practice;

- develop ideas to support museums across the UK to cater better for the older people within their localities in partnership with other organisations;

- encourage social care, health and advice providers for older people to view museums as potential, valuable partners;

- create a cross-sector network to drive change, with the aim of increasing opportunities and well-being for the diverse communities of older people in different parts of the UK.

### Health/well-being outcomes:

- An action plan for change in the heritage sector to support engagement for older people leading to small-scale and large-scale changes, which lead to greater opportunities to support well-being.

- Increased understanding and advocacy between sectors engaged in work with older people and researchers across relevant disciplines (museology, ageing, health and well-being, society and communities, social policy, etc.) to work collectively to improve the quality of life and well-being for older adults in their communities.

### Learning outcomes:

- Four seminars in different UK locations bringing together key partners with experience in the field of working with older adults, but coming from very different disciplines/organisations.

- A conference to disseminate the findings of these meetings and to open up the discussion and outcomes to the widest possible audience.

- A succinct document outlining the perceived needs of this diverse audience.

**Evaluation or measurement methods used:**

Four partnership seminars will be delivered utilising 'Open Space' techniques to enable collaborative discussion between museums working with older people and stakeholders beyond the heritage sector. 'Open Space' is a way of facilitating a discussion as democratically as possible. Its methodology ensures that the meeting agenda and discussions best reflect the needs of all participants. Participants agree to attend to take an active part in a dialogue within a pre-determined theme, all discussions focus on actions to be taken forward. Discussion content and action points are collated and prioritised, and are the work of the entire group.

Discussions and outcomes of the seminars will be recorded, documented and analysed to draw out key recommendations aimed at dramatically improving provisions and opportunities for older people. This document will be disseminated to all attendees for comment and revision and will be developed into a working document that could include a toolkit, action plan and/or manifesto. The discussions will shape the format to ensure that the final working document is most fit for purpose.

Importantly, the working document and its recommended changes will have been built jointly with representatives of a range of other sectors and older people themselves. This process will develop and support holistic, interconnected ideas for local provision developed through collaboration, and this model therefore aims to increase the sense of investment and likelihood of take-up for the findings from all involved in the process.

**Participants:**

The seminar will be for practitioners and representatives of organisations already working with older people. Older people will have a voice throughout the seminars and conferences, and will be reached through participating cross-sector organisations. Attendees at the seminars and conference will be encouraged to attend with someone who already utilises their services, or a potential user. The idea is to bring together strong voices and facilitate a discussion where all attendees can raise and discuss pertinent issues and ideas.

**Project partners:**

The British Museum and its national partners.

**Length of project:**

One year and ongoing.

**Cost of project:**

£15,000.

**Funders:**

The Esmée Fairbairn Foundation.

**Sustainability of the project:**

To create a cross-sector network to drive change, with the aim of increasing opportunities and well-being for the diverse communities of older people in different parts of the UK.

Other museums and galleries across the UK may choose to replicate this model of cross-sector conversation in their regions, to support the development of new or existing programmes to engage older people in their communities.

**Advice/challenges:**

The British Museum views its role as an equal working party member and facilitator of discussion, helping to set up the meetings, develop invitation lists and providing staffing to support the seminars in collaboration with the seminar hosts. This support will be tailored to suit each partner, as some partners are likely to require more support than others. In addition, the British Museum's role is to keep the programme as a whole on target in terms of aims and timescale, to bring resources into the programme and to ensure that the analytical write-up includes the varied voices of the seminars and conference that make up the full programme. The British Museum will encourage and support the voices of the diverse partners to be included equally, aided by the 'Open Space' discussion technique.

**Further information:**

http://www.britishmuseum.org.

# Museums, Health and Well-being – Case Study 5

**Museum/Gallery: The Museum of Oxford**

**Project title: Museum of Oxford Reminiscence Project (MOOR)**

**Summary (aims and objectives):**

Museum objects and photographs are used to stimulate reminiscence with groups of older people in Oxford, at the Museum and with groups in the community. The primary aim of the project is to enable older people, who may be too frail, to access the Museum and Heritage service. These groups also contribute useful social history information to the Museum and Heritage service.

**Health/well-being outcomes:**

There is evidence of improvement in mood; the participants find the sessions enjoyable and there is much laughter. There is an increased sense of well-being. The project also showcases individual talents, which improves self-esteem. The sessions held at the Museum of Oxford encourage people to venture out and take the trip to the Museum, which brings them into a social situation. This helps to reduce isolation and the mental health problems that isolation can lead to.

In addition, the fact that the memories that the participants are sharing are very valued by the service (they have been displayed in our permanent and temporary displays) is very empowering for the participants, increasing their self-esteem and making them feel valued.

**Learning outcomes:**

Participants learn about the topics discussed and also about other members of the group, although learning outcomes are not a primary aim of the project.

**Evaluation or measurement methods used:**

Session leader, group leader and participants evaluation forms. Focus group events.

**Participants:**

Older people in day centres, sheltered housing, care homes and user-led groups. Hospital in-patients at the Fulbrook Centre, Oxford and the Adams Ward at the John Radcliffe Hospital.

**Project partners:**

The Oxfordshire Partnership comprising Oxford City Council, Oxfordshire County Council and Oxford University Museums Partnership, the Oxford University Hospitals NHS Trust and Oxford Health NHS Foundation Trust.

**Length of project:**

October 2009–April 2015 (end of current funding agreement, but may continue beyond this date).

**Cost of project:**

£80,000 per annum approximately.

**Funders:**

Arts Council England.

**Sustainability of the project:**

Dependent on core funding.

**Advice/challenges:**

The project has proved very popular with participants and feedback has been extremely good.

**Training:**

Age Exchange and on-the-job training.

**Further information:**

http://abcofworkingwithschools.files.wordpress.com/2011/06/oxford-reminiscence-rse-case-study-final.pdf.

## Museums, Health and Well-being – Case Study 6

**Museum/Gallery: Sudley House (National Museums Liverpool)**

**Project title: The Sudley Project 2010: 'LISTEN'**

**Summary (aims and objectives):**

The aim was to examine the value of a creative approach to mental health care delivered in a gallery setting. The project was commissioned by Mersey Care NHS Trust. The project explored the experience of a group of adults and carers with a range of mental health issues who participated in a creative arts group in a gallery setting. The creative sessions were devised and delivered by professional artists, Steve Rooney and Sue Williams – TAG (the Artists Group) – in partnership with Mersey Care, and healthcare staff and service users and carers all participated. The creative sessions culminated in an exhibition at Sudley House (part of National Museums Liverpool).

The evaluation looked at the social value for participants both at an individual and a collective level.

Questions explored the following areas of enquiry:

* Value as viewed by the participant.
* Impact on health and well-being.
* Role of setting in impact.
* Role of cultural partner in impact.

**Health/well-being outcomes:**

There were a number of emergent themes that pointed to well-being outcomes.

*Identity*

Service user and carer participants expressed the beneficial impact on self-esteem arising from participation. People experienced increased positive views of self that they perceived to have arisen as a result of the creative process:

'The big thing was it stopped you feeling inferior. Once [the artist] said to me you're an artist, I felt real because he put me in that position where I understood who I was for the first time in my life and it was a bit late, but thank God not too late. Since then I've pursued artistic pursuits with a great deal of enthusiasm and some amazing things have happened to me.'

As the quote demonstrates, the reframing of the individual's identity as an artist enabled people to view themselves in a more positive way and as a result they were able to pursue this 'new identity' outside of the project.

*Independence*

This growth in confidence that was expressed by all participants had also led to increased independence for several people:

'It brought him out of himself a lot. We would go to galleries. It was like coming out of prison for him.'

Some of the project participants were supported by health staff to attend. By the end of the project, a number of these people had begun to attend the project either independently or with other peer participants, using public transport, in some cases for the first time in many years:

'I wanted to go so much that when [staff member] wasn't able to take me one time, I made myself go and get the bus on my own.'

### Improved social contact

The group of participants included a range of ages and differing diagnoses. Consequently, people came from different settings and most had not met previously. This presented a challenge for some people initially. However, all participants described the impact of the supportive environment created by the professional artists on social contact and one of the strongest outcomes both observed and articulated involved the growth in interaction amongst all members:

'When [xxx] first came he wouldn't speak to anyone, he sat at the end of the table withdrawn, but then he just had a go and then he's turned out a beautiful piece of art work. I know when he first came he wouldn't do anything. Well we all mucked in, talking to him and then giving him hugs. We all supported him and then over time he just came out of himself and now he's looking forward to going back to College.'

'At first I felt overwhelmed. I felt I had nothing to give. But the others in the group kept talking to me and encouraging me. After a few weeks they gave me a palette of colourful paints and I just dabbed them on a piece of material. I shed tears at first because I felt useless, but the others were very encouraging to me. I then started to draw my stories and put them on a piece of material. And everyone encouraged me, so I started drawing things, the playground, my memories.'

'In the art group I could ask for help, it was safe to because we were all in it together equally, and because of this I learnt to ask for help from other people when I need it.'

The setting of the sessions in an art gallery were also viewed as causative in the creation of a supportive and relaxed environment:

'I come to a beautiful place, I am here amongst people who are so loving, everybody is supportive. Because everyone has got a common enemy, mental illness, so we join together and make each other stronger.'

'It's great coming to Sudley House, there's quite a bit of envy, you know it makes you feel good, others look at you, they are impressed, the ambience here is so important.'

This theme also related to contact between service users and healthcare staff. Both parties voiced the breaking down of boundaries that had been experienced as a result of the 'third party' facilitation. Staff were no longer the 'expert' in the room, the professional artists were and this broke down notions of distinct groups and created an equality of participant that people described as improving communication:

'The clinical staff who come along just seem to blend in, they just seem to be one of the gang, like. There's no differences between us. We all just get along here, there's no problems, no friction.'

### Mood

In the context of mental health, a particular outcome for service user and carer participants concerned the theme of mood or mental health symptoms. Carers identified 'uplifted' states of being in their family members/partners and individuals repeatedly voiced:

'You've got to be very positive, to help yourself feel better. I've got a thing like Alzheimer's and it's important how you treat your brain, this helps you keep active and learning new things helps with that.'

### Learning outcomes:

Setting the project in the art gallery brought unexpected benefits:

- Increased independence experienced by participants described above. Holding sessions away from a ward setting led to use of public transport when either carers or staff were unable to accompany participants.

- Creative initiatives in non-clinical settings rely on healthcare staff to promote the initiative to potential participants. It is important to work with healthcare staff prior to starting the creative sessions to ensure that they understand and value the purpose of sessions. Taster sessions for staff may be an effective approach to ensuring support and promotion.

- Museum staff were on hand to show the group around the gallery and answer any questions people had about the work. This introduced a new group of people to the Gallery.

- Sudley House reported an increase in visitors following the exhibition of people who had not previously been aware of it, but had visited to see the Mersey Care/TAG exhibition.

- Sudley House made the gallery available for an exhibition following the project, but the exhibition could only be on for a short time, as the space was booked out for other organisations.

### Evaluation or measurement methods used:

The evaluation used a multi-method approach. Formative evaluation consisted of participant observation by two researchers. The researchers participated in sessions and used the above questions as a framework to record observations. At the final session, semi-structured interviews were held with participants, as well as a short focus group to explore the questions collectively.

Data analysis was approached using a grounded theory approach. The data was broken down and coded as it was explored to identify concepts or themes and then categories or main themes, which were constantly compared, in order to develop strong themes or 'theoretical saturation'.

### Participants:

Hospital outpatients and inpatients, carers/family members and healthcare staff.

**Project partners:**

Mersey Care NHS Trust, TAG and National Museums Liverpool (Sudley House).

**Length of project:**

This particular evaluative project explored one of the annual creative partnerships between National Museums Liverpool, Mersey Care and TAG. The Sudley House project was intended to last for approximately 12 weeks of three-hour sessions. However, it was found that further time was needed for participants to complete their work and the project lasted 15 weeks in total.

**Cost of project:**

£5,000 (in 2010). The project actually went over-budget, with 15 workshops needed, and so this figure was an underestimate of costs.

**Funders:**

Mersey Care NHS Trust.

**Sustainability of the project:**

For this particular project, funding was provided by Mersey Care NHS Trust. These funds are agreed on an annual basis and this affects the sustainability of the project. This means that the professional artists, healthcare staff and participants do not know if there will be a further project the next year. Mersey Care NHS Trust is currently working on developing longer-term budgets for creative approaches to ensure that participants can sustain the personal developments and benefits gained.

Sustainability can also be affected by staff turnover of healthcare staff who are supportive to the aims of creative approaches. Staff may change roles and so ongoing promotion of creative sessions to staff may be needed to sustain the project.

**Advice/challenges:**

Liaison with Gallery – the workshop space was made available by National Museums Liverpool for the project free of charge. This is extremely important when funds for this type of initiative are often limited. This came about from a previous successful project and exhibition, which involved TAG working with people from the Trust's Brain Injuries Unit. The Head of Decorative Arts at National Museums Liverpool offered TAG the space for future projects and exhibitions. The Sudley House staff were very helpful and accommodating.

Some participants required support to attend initially as the project was in a non-healthcare setting.

**Training:**

The TAG artists have a wealth of experience of working within similar contexts and settings and therefore training was not necessary for the professional artists. Moreover, healthcare staff attended each session.

**Further information:**

For details, see Liverpool Museums blog on the exhibition:

http://blog.liverpoolmuseums.org.uk/default,date,2010-08-13.aspx.

## Museums, Health and Well-being – Case Study 7

**Museum/Gallery: Salford Museum and Art Gallery**

**Project title: Memories Matter**

**Summary (aims and objectives):**

To provide reminiscence resources free to organisations working with older people across Salford, to encourage a high-quality stimulating reminiscence activity to assist with improving the adult social care provision and to offer reminiscence training to care staff working with older people.

**Health/well-being outcomes:**

Proven outcomes include increased socialisation and communication between both older people and care staff, and between older people, improved self-esteem, increased understanding of the heritage provision in Salford and the city's local history, a sense of pride in achievements and experiences, and more positive outlooks on life from more isolated older people. Some individual comments have indicated that workshops using museum objects have actively helped recall and their ability to remember events long ago.

**Learning outcomes:**

Informal learning outcomes, mainly based on attitudinal learning, often in terms of communication and relationships with others around them, but also some knowledge-based learning outcomes regarding local history and social history, and some creative work including a new area of work around creative activity for people with dementia and their carers. It has become evident how important museum objects and images are for stimulating memory and conversation, even if just as a starting point. The physical and tactile nature of them is important and, where possible, the inclusion of other senses, such as smell and sound, have been a positive addition.

**Evaluation or measurement methods used:**

Both formative and summative: formative with evaluation forms that go out with each loan or that are completed at all training sessions, with ideas and suggestions fed back into the programme; summative by way of numbers and quantitative monitoring.

**Participants:**

Any older person living in Salford, but mainly those using day centres, living in sheltered or residential housing or care, those accessing services provided by PCT/council services, Age UK, the Alzheimer's Society, housing trusts, etc.

**Project partners:** Salford City Council Adult Social Care team, Salford PCT, Salford Community Leisure, the Alzheimer's Society and Age UK.

**Length of project:**

Five years of funding, now part of the core museum provision.

**Cost of project:**

£60,000.

**Funders:** During the funding period: Social Care Reform Grant, administered through the Joint Commissioning team. Post-funding: Salford Community Leisure Ltd.

**Sustainability of the project:**

Project funding has finished and the service has been mainstreamed into museum provision. Money has been found for the part-time post, but with no running costs. We anticipate Memories Matter to continue as a loans service for many years to come, and also to run concurrent creative projects in-house, based either at the Museum or in the community or care settings. An example of this is a planned programme of monthly creative activities based on heritage crafts and daily activities, inspired by the Museum's Victorian Street. This programme will provide positive and relaxed time for carers to spend with their loved ones away from more day-to-day concerns and will equip them with new ideas and skills to create personalised reminiscence stimuli, for example, through making a story box or a personalised book. We also hope this will help encourage carers to see museum, galleries and cultural venues as places that have a lot to offer them in their role as a carer.

**Advice/challenges:**

Research shows that this activity and provision has huge benefits, but can also be time-consuming for staff. As organisations and homes working with older people have found out about our programme, demands have become increasingly heavy on time requested to go and deliver reminiscence sessions in specific venues. The training we offer has gone some way to combat this, creating capacity within these venues to do it themselves, but advice would need to be realistic about what you can deliver. Also, frequent staff changes in care settings can make it challenging to develop and maintain ongoing working relationships within the care sector. We would also advise that staff thinking of working with this audience group undertake training and gain confidence in delivering sessions, due to the numerous and wide-ranging challenges that it can raise.

**Training:**

Memories Matter staff did a number of training sessions at the start of the project, including sensory awareness training, dementia awareness training and a suite of reminiscence training at Age Exchange in Blackheath. As part of the project, we now deliver Introduction to Reminiscence training free to care staff in Salford, covering areas such as the benefits of reminiscence, how museum objects and images work as memory triggers, ideas for activities and icebreakers, and how museums can support this work in the care sector.

**Further information:**

http://www.salfordcommunityleisure.co.uk/culture/salford-museum-and-art-gallery/communities-and-outreach/memories-matter-reminiscence.

# Museums, Health and Well-being – Case Study 8

## Museum/Gallery: Nottingham City Museums and Galleries

## Project title: 'Suitably Sensory' (Museums of the Mind)

## Summary (aims and objectives):

'Museums of the Mind' funding, through Renaissance East Midlands, was secured to launch a 12-month pilot project to develop a unique loans box of four 'suitably sensory' replicated and redeveloped museum objects, tailor-made for use on the Autumn ward at Highbury Hospital in Nottingham (part of Nottinghamshire Healthcare NHS Trust). The Autumn ward is a secure ward in the hospital catering for people aged 65 and over with a diagnosis of a progressive dementia who can exhibit challenging behaviours, including smashing and eating inanimate objects; without necessarily intending to harm, in-patients can resort to investigating objects physically and orally, as children do.

Original museum objects were identified and selected from our collections primarily for their social history significance (representing the strongest recollection of memories; work life, childhood and parenthood) and decorative possibilities. The objects were redeveloped to magnify their original sensory qualities to engage and fulfil service users' needs. They were designed to suit the behaviours and habits of the personalities on 'Autumn' at the time of observing the ward and are puzzle-like, responsive to touch, featuring multiple textures, edible where appropriate, musical and smell-enhanced as a result, yet all still in keeping with their original heritage.

The seven in-patients on the Autumn ward are dominated by men due to the high levels of risk anticipated with their challenging behaviour, which influenced the way in which objects were selected and developed, and because they are not originals, they are able to be replenished if required for hygiene reasons from oral exploration or replaced due to damage.

*The Steering Group*

A highly motivated multi-disciplinary steering group was formed at the very beginning of the project to ensure greater understanding of the service users and to gain technical knowledge in object development. The group had representation from *heritage, dementia care, product design* and *evaluation.*

As a result of our collaborations, we secured 'Stimulating Innovation for Success' match-funding to ensure that the quality, safety and innovation for the service users was paramount and the teams who work closest to the service users were consulted during the development of the 'Suitably Sensory' loans box – both the objects and support pack – to ensure that it appeals to them and is recommended by them in the field of mental health care and beyond.

**Health/well-being outcomes:**

Although inspired by 'Autumn' and other wards at Highbury Hospital, anyone can hire the loans box. The resource pack includes recommendations about which groups would benefit most from using it, which includes all mental health wards and groups in the city, several of whom we consulted during the project and will consequently market this to. The information provided in the resource pack will raise awareness of mental health issues and the activity suggestions will encourage group work to avoid isolation and brain games to encourage well-being.

**Learning outcomes:**

Evaluation results are pending, though an evaluation consultant will examine the benefits using the methods below and we expect to notice improvements in mood and general well-being; engagement and curiosity, relationships with staff (for example, enabling them to feed or clean the in-patients), improved sleep and to compliment prescribed medication.

The loans box is popular for out-patient/service user groups who are usually unable to access museum objects due to challenging behaviour, but also with groups who want to question design as the originals are provided alongside the redeveloped objects. With all groups, however, mental health is raised as an issue to be openly discussed, supported by the guidelines of the resource pack.

**Evaluation or measurement methods used:**

Members of the Mental Health Services for Older People team will use observation to look sequentially at each sensory modality as well as service user 'Challenging Behaviour Scales' to gauge change. Their Activity Co-ordinator, who will recognise the most changes, will use a voice recorder after one-to-one sessions, giving a score for patients' responses. An audio clip of ward activity will capture service user responses to the 'suitably sensory' objects and this will also be a way of educating the general public on mental health illness and providing non-visual museum visitors with information.

**Participants:**

In-patients aged 65 and over with mental health issues and challenging behaviour on a secure ward at Highbury Hospital in Nottingham.

**Project partners:**

Nottinghamshire Healthcare NHS Trust and Nottingham Trent University.

**Length of project:**

A 16-month pilot project (complete July 2011).

**Cost of project:**

£12,000: £7,000 'Museums of the Mind' (Renaissance East Midlands: REM) funding and £5,000 *'Stimulating Innovation for Success'* funding (Nottingham Trent University: NTU).

**Funders:**

REM and NTU.

**Sustainability of the project:**

The 'Suitably Sensory' loans boxes are available to hire by local community groups and there are plans to continue our collaborative research which will enable us to use our knowledge from this pilot project and maintain our energy for exploring the importance of heritage and design in mental healthcare.

**Advice/challenges:**

Working with a group previously not targeted by museums and delivering a project which appears to have never been done before.

**Training:**

'Open to all' training was provided by REM to all projects funded regionally.

**Further information:**

In July 2012 we exhibited the 'Suitably Sensory' objects at the 'Design 4 Health' conference in Sheffield.

## EVALUATION REVIEW

A key aspect of the *Museums, Health and Well-being* survey was to ascertain how museums evaluate the impact of their activities on the health and well-being of participants, so respondents were asked to comment on their evaluation methodology and health, well-being and learning outcomes, amongst other things. A review of these findings reveals that museums are currently using a mosaic of different approaches to evaluate the impact of their programmes and activities. Evaluation methods were grouped into the following categories:

- Verbal feedback/Focus Groups/Video/Observation.
- Questionnaires (to include survey/feedback forms).
- Collaboration with external evaluator/research group/healthcare professional.
- Standardised healthcare outcomes measures (e.g. health scales).
- Inspiring Learning for All Framework.
- None.

A snapshot of the variety of approaches is described below; note that some museums use more than one approach and the exact evaluation questions asked (which are not discussed in detail here) vary too.

Relatively few museums who responded directly to the survey reported using no evaluation; however, it was not possible to find evaluation information about many

of the museums included in the survey database (c. 60 per cent). This is probably related to the fact that such information is not available publicly, but could also indicate a lack of evaluation.

Many museums adopt an informal approach to evaluation, using verbal feedback from participants and partners to gauge the success of activities and services, and to help them adapt or develop new activities. Oxfordshire Museums Services undertakes informal evaluation of its reminiscence service by interviewing participants and group organisers. The Geffrye Museum in London does not carry out formal evaluation with participants in its service for people with dementia or stoke survivors, but it gathers informal verbal feedback from the staff and volunteers who work with the groups on a regular basis to ensure that it is meeting its aims. In the past, the Museum has used the Inspiring Learning for All's Generic Social Outcomes[15] for evaluating longer projects where it has been able to build up a relationship with its partners and ask more in-depth questions. These findings suggest that some museums may find that the use of more detailed, in-depth, evaluation techniques is not appropriate or feasible for one-off activities and that a sustained relationship is required before such an approach is possible. It may also indicate that these are fledgling activities and museums need to gain some experience of working with healthcare partners before a more formal evaluative, evidence-based approach is employed.

Several museums reported the regular use of questionnaires, including St Albans Museums, Salford Museum and Art Gallery, Leicestershire's Open Museum and the Museum of Oxford, which also reported the use of focus groups to gather feedback. Glasgow Museums (including the Open Museum) have used a range of evaluation tools including participant quotes, questionnaires, verbal feedback (which is later transcribed), both formal and informal, and meetings with partners/participants which are used to assess the progress of projects.

Likewise, NML (National Museums Liverpool) has used various approaches from questionnaires to participant observation, interviews and documentary methods. The service has worked in collaboration with a variety of partners, including Mersey Care NHS Trust, artists groups, consultants (e.g. AFTA Thought, a team of consultants who use drama to help people think differently), external evaluators and researchers to undertake detailed evaluation using a mixed-method approach (i.e. a combination of quantitative and qualitative methods), resulting in reports such as their *House of Memories* evaluation report (NML 2012). Colchester and Ipswich Museum Service used evaluation forms that measured levels of well-being and social inclusion with participants in its project geared towards mental health service users. It also conducted a small end-of-project pilot evaluation with research group comprising academics, plus

---

15    http://www.inspiringlearningforall.gov.uk/toolstemplates/genericsocial.

current and former mental health service users, to assess the impact of the programme on skills development, confidence, motivation, positivity and relationships.

Examples of museums working with external or academic partners to carry out evaluation include the following:

- London's Dulwich Picture Gallery (with the Oxford Institute of Ageing, Oxford University: Harper and Hamblin 2010).
- Woking's Lightbox (with Brunel University, London: Bryant et al. 2011).
- Tyne and Wear Museums (with the Institute for Ageing and Health, Newcastle University).
- Manchester Museums, Manchester's Whitworth Art Gallery, Manchester Art Gallery, Carlisle's Tullie House and Art Gallery, Bolton Library and Museum Service and Preston's Harris Museum as part of the *Who Cares?* programme (with the Psychosocial Research Unit at the University of Central Lancashire: Renaissance North West 2011).
- Colchester and Ipswich Museum Service (with SE-SURG (South Essex Service User Research Group) and Anglia Ruskin University).
- The *Heritage2Health* project (coordinated through the Faculty of Health and Social Care Sciences, St. George's University of London).
- New York's Museum of Modern Art (with New York University: Rosenberg et al. 2009).
- UCL Museums' *Heritage in Hospitals* project (coordinated through UCL Museums and Public Engagement and the School of Life and Medical Sciences; Chatterjee et al. 2009; Ander et al. 2011; Lanceley et al. 2011; Thomson et al. 2011; Ander et al. 2012a, 2012b; Thomson et al. 2012a, 2012b).

In the above examples, a more academic approach is often employed, in some cases using mixed-methods or quasi-experimental approaches (an empirical method which looks at the impact of an intervention on a target population, similar to a randomised controlled trial (RCT), but lacking random assignment to treatment or control); this has given rise to a more in-depth understanding of the impact of activities on participants' health and well-being (see Chapters 1 and 5). The main advantage of such collaborations is that the evaluation and research practices tend to follow standardised formats using methods which have been tried and tested for repeatability and reliability. The scholarly approach adds robustness and weight to the findings, such that the outcomes can be more effectively tied to real changes in participants' health and well-being.

The use of clinically recognised health and well-being measures is not widely practised in museums, although they have been used within the arts and health field, albeit not extensively (see e.g. Staricoff 2006). The Museum of Hartlepool used a mixed-methods approach in the evaluation of its *Come Dance with Me*

*Hartlepool* project, which included the use of the shortened version of the Warwick-Edinburgh Mental Well-being Scale (SWEMWBS 2007) alongside a visual analogue scale (a psychometric scale showing numbers, usually from 0 to 100, where respondents rate how they are feeling against various measures/words, e.g. happiness and wellness), plus qualitative approaches including questionnaires and interviews. As discussed above, the long version of this scale was also used in the *Arteffact* project evaluation carried out in museums in North Wales (Neal 2012a, 2012b). Similarly, as previously discussed, the *Heritage in Hospitals* project used a psychological well-being measure (PANAS: Watson et al. 1988) and visual analogue scales (EuroQol Group 1990) in tandem with qualitative methods (Thomson et al. 2011, 2012a, 2012b; Ander et al. 2012a); Chapter 5 explores these approaches in more detail.

Other museums have worked with a range of partners to develop bespoke evaluation forms. Beamish Museum in north-east England, for example, involved its *Older People's Advisory Panel* to help devise forms that it uses within sessions involving older adults from care homes. The panel includes a local representative from the Alzheimer's Society, a representative from Tees, Esk and Wear Valley NHS Older People's Mental Health Team, Activities Coordinators from private care homes and organisations, a care home manager and a representative from Mind Active, an organisation which works with older people in Northumberland. The Museum uses two evaluation forms, the first of which seeks to capture the session facilitator's perspective regarding the success of the session and includes space for the facilitator (usually a member of museum staff) to include comments or quotes made by the participants. A second form provides an opportunity for care staff to record the participants' usual character, their mood before and after the session, how participants were involved in the session, and whether they think the participants enjoyed the session. The involvement of care staff in the evaluation process gives both the museum and the care home a sense of whether the sessions are meeting their objectives, as well as a better understanding of how the sessions are impacting participants; this is particularly enlightening for care staff who know the participants well and will therefore be able to notice differences in behaviour not just during or immediately after the session, but sometime after the session has finished (e.g. hours, days or even weeks later). Such longitudinal information is important for understanding the sustained effects of museum interactions on health and well-being, which to date has been poorly studied and is an area in need of further work.

One of the biggest challenges in advocating the health and well-being benefits of museum encounters is identifying exactly what these benefits are. Whilst there is considerable informal and anecdotal evidence, pinpointing the particular and often bespoke improvements in participants' health and well-being is more complex. The reason for this is that health and well-being are person-specific and individuals respond differently, both in terms of physical and psychological

responses; capturing these subtleties and understanding the role of the museum encounter is crucial if we are to truly understand how museums can contribute to enhanced health and well-being. Most studies to date cite emotional responses such as increased happiness, enjoyment, alertness or subjective well-being as the key outcomes from museum interactions (e.g. Wood 2008; Davenport and Corner 2011; Ander et al. 2012a), but measuring and understanding these psychological responses can be tricky. The methodological and evaluation approaches used to capture these responses is therefore a matter of great importance and is the focus of the next chapter.

## SUMMARY

This chapter has demonstrated the wide diversity of current *Museums in Health* practice across UK museums. Results show that museums are targeting a range of audiences, including: mental health service users; older adults, many of whom are in care or in hospitals; individuals with specific health and well-being challenges, such as those with chronic diseases (e.g. Alzheimer's disease, cancer); and vulnerable people (e.g. socially excluded audiences). In many cases, museums are working with a range of health and social care partners, including hospitals, care homes, social services and voluntary and charitable organisations, in order to plan, develop and deliver targeted programmes and projects. Museums currently use a range of evaluation approaches and this has led to an enhanced understanding of the impact of museum encounters on participants' health and well-being. Crucially, however, relatively few museums have undertaken rigorous and/or longitudinal studies of the impact of their work on health and well-being, and further work is needed to acquire a detailed understanding of the full psychological and physiological effects of Museums in Health.

# MEASURING HEALTH AND WELL-BEING

The announcement by the UK's Coalition government to measure national well-being in 2010 led to the Office of National Statistics 'measuring well-being programme'. This initiative by the government in well-being, of which health is a contributor (and vice versa), has created a wider interest in the importance of well-being within communities. Some NHS Foundation Trusts place the patient experience as a key objective in their annual plans and central to this is well-being. A key challenge then in understanding and articulating the health and well-being outcomes (or responses/reactions) derived from museum encounters is that of measuring or evaluating the sector's contribution in a language that all stakeholders can understand. It could be argued that a focus on outcomes is unhelpful and it is undoubtedly complex, as the previous chapters have shown. Interaction with museums produces a variety of responses from emotional or psychological through to physical and physiological, but discerning and measuring such outcomes is problematic, not least because no agreed framework currently exists for the heritage sector.

We are in agreement with Silverman (2002) and others that it is important to consider outcomes in order to fully understand and articulate the impact, benefit and contribution of museum encounters. Given the focus on outcome measures in the health and social care sectors, it therefore seems sensible to seek to derive a common language that is understood by all partners. These sectors currently use a vast range of health and well-being outcome measures for a variety of purposes, from assessing the efficacy of a drug intervention to measuring the progression of a particular disease. However, the question is how do we measure, evaluate or assess these outcomes in relation to museum encounters?

## GLOS, GSOS AND GWOS?

The museum sector benefits from having a nationally agreed framework for measuring museum learning and social outcomes, namely the Inspiring Learning for All Framework, which includes the Generic Learning Outcomes (GLOs) and Generic Social Outcomes (GSOs). This framework gave 'museums, archives and

libraries a means of understanding, analysing and talking about learning' (RCMG 2003: 7). Whilst the previous chapter has shown that museums currently use an array of different evaluation or measurement approaches, museums today are facing similar challenges in measuring health and well-being to those experienced a few decades ago when trying to measure museum learning, in that defining museum well-being and then capturing the individual's response is difficult and often conflicts with the more formal methods used in healthcare (Thomson et al. 2011).

The GLOs[1] provided a framework for measuring the impact of learning in museums, archives and libraries, based around the following measures:

• Increase in knowledge and understanding.
• Increase in skills.
• Change in attitudes or values.
• Evidence of enjoyment, inspiration and creativity.
• Evidence of activity, behaviour and progression.

The GLOs are underpinned by the following learning theory:[2]

• A focus on learners and their learning experiences.
• Learning is a lifelong process of meaning making.
• Learning includes change and development in emotions, skills, behaviour attitudes and values.
• Learning as a verb (the act of learning) rather than a noun (learning/ scholarship).
• Enjoyment, amazement or inspiration can provide the motivation to acquire facts and knowledge.
• Learning is a process of identity-building.
• Learning is both individual and social.

This approach provides a valuable framework for evaluating the impact of learning and learning-related museum activities on individuals; indeed, as discussed in Chapter 3, learning may be linked to increased well-being in some situations. GLOs, however, are unlikely to capture nuanced responses related to health and well-being because the frameworks do not go beyond generic, subjective, responses, nor does the underlying theoretical basis for these approaches consider health or well-being. The UK's Museums Libraries and Archives Council (now part of Arts Council England) commissioned research into GSOs (BOP 2005), which showed that very little specific activity, and virtually no evaluation of health and well-being outcomes, had been undertaken by museums. This research also made the assumption that museum health-related work would likely only be in the

1    http://www.inspiringlearningforall.gov.uk/toolstemplates/genericlearning/index.html.
2    http://www.inspiringlearningforall.gov.uk/learning/index.html.

area of mental health. Partly as a response to this, health and well-being are defined as a specific strand of the GSOs,[3] which suggests that museums (and libraries and archives) contribute to the following outcomes:

- Encouraging healthy lifestyles and contributing to mental and physical well-being.
- Supporting care and recovery.
- Supporting older people to live independent lives.
- Helping children and young people to enjoy life and make a positive contribution.

Whilst the GLOs were developed from research with museum users, the GSOs were largely developed from central government policy, which may explain why they have not been widely used by the museum sector. Libraries, on the other hand, have been seen as the main potential for health and well-being outcomes in England (e.g. Hicks et al. 2010) and there is evidence here for the use of GSO's as an evaluation framework (e.g. Rankin 2012). As a response to the lack of a museum-specific well-being framework, Ander et al. developed Generic Wellbeing Outcomes (GWOs), arguing that 'a measure is needed that is self-reporting and yet locks into a consistently-used framework of well-being dimensions and elements, so that it is universally understood, acknowledged and compared' (2011: 247). Ander et al. further asserted that 'qualitative research would be needed to populate it with meaningful (to museum users, the museum sector and policy makers), valid and relevant dimensions of well-being. Measuring tools would be needed which can capture or quantify concepts and are subtle enough to detect small and deep-running changes in well-being, and can also feed into evidence that builds theory around the correlation between health/well-being and culture/museums' (2011: 247). To this end, Ander et al. draw on well-being outcomes identified in the literature and suggest how museums might affect these. The research provides 'the potential basis of a museum well-being outcomes framework, with the caveat that a final well-being outcomes framework needs to be based on future research' (2011: 247). Table 5.1 below, adapted from Ander et al. (2011), summarises the scope of museum-specific health and well-being dimensions and sub-dimensions which could form the basis of a generic well-being outcomes framework. The research draws heavily upon the work of the New Economics Foundation[4] (NEF 2004, 2009). The framework separates health and well-being outcomes whilst asserting that the two are inextricably linked, such that an increase in one affords an increase in the other, in keeping with NEF (2004: 16). Ander et al. conclude that: 'In order to develop a true framework, empirical and qualitative research would need to refine the true meaning of these dimensions in cultural terms' (2011: 247).

---

3    http://www.inspiringlearningforall.gov.uk/toolstemplates/genericsocial/index.html.
4    http://www.neweconomics.org.

**Table 5.1**    Ander et al.'s generic well-being outcomes framework with possible museum contributions (adapted from Ander et al. 2011: 248)

| Dimensions of health or well-being | Sub-dimensions | Possible museum contribution |
|---|---|---|
| **Well-being (resilient mental health, preventive and protective factors)** | | |
| Personal well-being | Satisfying life | Museum participation that leads to fulfilment of goals, drives, expectations and ambitions in life, including learning and skills as well as 'the pleasant life'. |
| | Vitality | A renewed interest and energy, provoked by inspiring or motivating collections or working with other people in a museum or community setting, e.g. motivated to volunteer twice a week and speak to visitors or to join an events committee. |
| | Positive functioning (autonomy, competence, engagement, meaning and purpose) | Improving mobility, confidence, new skills, physical fitness, capacity for work and socialising through participation in museums such as volunteering, social events and clubs, and learning programmes. Activities and learning that encourage thinking for oneself, joining a debate, for example, or using creative processes. Programming and displays that elicit profound thoughts about one's life direction and its meaning, yet in a safe and accessible way. For older people, encouraging their competence in social situations, conversation, orientation and in using their sense of touch in their hands through object handling and group activities. Any individual learning and personal development that goes on at a museum (see GLOs). |
| | Resilience and self-esteem (self-esteem, optimism and resilience) | Activities using objects that increase confidence or capacity to do something new, such as a skill or new knowledge, thus increasing self-esteem. Activities and objects that encourage reflection on own achievements and qualities. Activities that promote a feeling of cultural strength and self-esteem through significant objects or objects that tell inspirational stories. |

| Category | Description |
|---|---|
| Emotional well-being (positive feelings, absence of negative feelings) | Activities within a museum, including displays and exhibitions on certain topics, as well as events and participative activities, that encourage positive emotions such as empathy, tolerance, happiness, kindness and laughter. Activities and collections that distract from or combat negative emotions – calming anxiety and bringing enjoyment and acceptance to depressed, sad or angry people. Providing an environment that is safe, calm and friendly. Using collections to explore emotions and emotional intelligence. |
| Social well-being | |
| Trust and belonging | Working with people from your own and other communities within a 'neutral' space, such as a museum, on projects of mutual benefit. Museums can help people explore their own and their communities' qualities and characteristics through community objects, and can create a feeling of belonging to a certain community through interaction with people or their cultural output. |
| Supportive relationships | Bringing people together through the collections. Participative activities, volunteering and events around objects can all bring people together in new ways. People can gain and strengthen contacts through museums' public role. Museums can also provide a place for families and friends to strengthen their bonds and the roles they play, e.g. parents can encourage children's curiosity and informal learning and get to know their children better in a family museum outing, grandparents can interact with children and grandchildren by contributing their stories and collections and working on intergenerational projects, etc. |
| Cultural well-being | Museums give an opportunity for people to understand their place in the world and where they come from through emotions, feelings and learning. The knowledge that items of cultural importance are kept for their own sake and for the benefit of future generations is important to many people. The intrinsic worth of things of beauty and meaning can contribute to an underlying sense of human cultural well-being. |
| Physical and sensory well-being | Body functioning well, including good nutrition, exercise and hygiene |
| | Learning opportunities about healthy living and anatomy, science and medicine. Increasing multi-sensory and tactile senses and use of touch through object handling. Providing opportunities for exercise, e.g. conservation work at a heritage site and guided walks. |

**Health**

| | | |
|---|---|---|
| Recovery from or management of physical illness or injury | Healing of wounds, towards normal body and cognitive function, fighting of infection and disease, building strength | Objects and learning opportunities, provided at the healthcare setting or by the bedside, can contribute to a positive mental outlook and cultural engagement that improves rehabilitation, treatment and recovery times, and distracts from pain and discomfort. Using objects to think about life and the world can bring acceptance of new life after illness or accident. Using objects in speech therapy, memory, psychotherapy and physiotherapy for rehabilitation. |
| Recovery from mental illness | Reduction and/or control of anxiety, depression, etc., improvement in schizophrenic or other symptoms | Museums can provide a calm, inspiring and safe place in which to explore emotions, culture and past experiences with objects as stimulus. Collections and displays can elicit creative expressions from those who find it hard in other ways to express themselves. These expressions can then promote communication and openness, and then acceptance and self-help.<br><br>Distraction, absorption and new perspectives can help with anxiety or depressive symptoms. Objects can be used with Alzheimer's disease and other elderly patients for memory and orientation work.<br><br>Museums can provide an inclusive and welcoming atmosphere to those who are excluded from society as a result of their illness. |
| Improved hospital care or health care | Increased satisfaction with care.<br>Better communication between healthcare staff and patient<br>Increased trust, dignity, emotional comfort, confidence, interpersonal interaction.<br>Relaxing environment | Museum activities can increase communication and observation skills that are vital in staff and patients for good quality healthcare (Chatterjee and Noble 2009). Improved environments and social interaction both provided through museum-based activities can improve confidence, trust, dignity and emotional comfort. |
| | Staff development | Using museum objects can enhance observation, analysis, communication and bedside skills. Museums can use objects with staff and they can then use objects with patients in their work. |

## MEASURING OUTCOMES

The process of measuring outcomes need not imply quantitative approaches, as the word 'measures' suggests, although many health measures have a substantial quantitative component. Many museums have used a range of largely qualitative approaches to assess the impact of their work on health and well-being; several examples are discussed in the previous chapter. Other museums have looked to alternative methodologies to measure outcomes. The Museum of East Anglian Life (MEAL) used a Social Return on Investment (SROI) model to evaluate its work-based learning programme for long-term unemployed people in Suffolk (MEAL 2010). The SROI approach is founded on seven principles: involve stakeholders; understand what changes; value the things that matter; only include what is material; do not over-claim; be transparent; and verify the result. SROI provides a way to understand and manage 'the value of the social, economic and environmental outcomes created by an activity or an organisation'[5] and the approach is largely based on gathering qualitative feedback derived from conversations with participants.

One drawback of this approach is that it doesn't specifically focus on health or well-being, so, like the GSOs, understanding the discrete health or well-being outcomes derived from museum encounters is likely to get lost amongst the bigger social, economic and environmental issues which the model seeks to tease out. Notwithstanding these drawbacks, the ability of the model to incorporate economic analyses into the evaluation is potentially very valuable. The cultural sector is under increasing financial pressure with many museums facing budget cuts. In parallel, the health sector, which is also facing similar economic challenges, is increasingly being assessed from a health economics perspective with regard to the cost and cost-effectiveness of services and interventions. Thus, gaining an appreciation of the cost-effectiveness of museum-health/well-being services and activities is potentially very valuable and could be a powerful advocacy tool if linked to alleviating health costs in public health services such as the NHS.

The Cinema Museum in London has used the community version of the Outcomes Star™[6] (the Community Star™) as part of an evaluation project funded by the Happy Museum Project. It has used this approach to both assess the benefits of volunteering with the museum and to assess the benefits of participating in an intergenerational project. The Community Star™ comprises a series questions and statements which respondents grade from one to five, covering issues such as how safe participants feel in their local area, whether they have a healthy lifestyle and whether they feel they have learnt new things through being involved in a local project. As with the Outcomes Star™, evaluators are provided with outline information about the

---

5    http://www.thesroinetwork.org/what-is-sroi.
6    http://www.outcomesstar.org.uk.

meaning of attaining certain scores, but detailed implementation of the forms and interpretation of results is acquired through training, which incurs a cost from the consulting organisation that developed the approach, so may be prohibitive for many museums.

Staricoff has highlighted the value of evaluation from the arts and health perspective, noting that evaluation produces evidence of the impact of different art interventions in encouraging beneficial clinical outcomes for patients, enhancing the quality of healthcare services, improving working conditions and job satisfaction (2006: 116). As previously discussed, Staricoff's review brings together the findings of various studies which have used a range of both quantitative and qualitative methods to better understand the impact of arts and health interventions, and finds that those studies which employed rigorous scientific approach were able to demonstrate patient benefits as well as potential budget reductions for the NHS. A study at Chelsea and Westminster Hospital evaluating the physiological and psychological effects of a programme of visual and performing arts on patients involved a two-year investigation with an intervention group and control group (no intervention) (Staricoff and Loppert 2003). Statistical analysis revealed that the combined effects of visual art and live music had a significant effect in the preparation of patients for surgery. Results showed that the intervention: normalised vital signs such as heart rate and blood pressure; reduced levels of the stress hormone cortisol (which was 48 per cent lower in the intervention group compared to the control group); and significantly reduced the quantity of drugs needed for sleep induction prior to anaesthesia (intervention group patients consumed 0.83 mg/kg less drugs compared to control group patients). As part of the same research programme, a study of post-operative hip replacement patients showed that patients recovering on wards containing visual art and twice-weekly live music (study group) had a shorter stay in hospital, were discharged one day earlier than patients recovering in the absence of visual art and music (control group), and that the study group consumed significantly less analgesics compared to the control group (Staricoff and Loppert 2003). The results of this and other studies exemplify the importance of employing robust evaluation methods in order to define real and tangible health and well-being outcomes for patients, staff and the health sector as a whole. This is particularly important if the intervention may be linked to financial savings such as reduced hospital stays or drug consumption.

Staricoff's contributions to the field of arts and health (Staricoff and Loppert 2003; Staricoff 2004 and 2006), particularly her robust, scholarly approach of bringing together the evidence base and advocating a strong evaluation framework, have undoubtedly helped to raise the profile and significance of arts and health practices. The same approach is now needed for Museums in Health if museums and other cultural organisations are to demonstrate the varied ways in which they can improve health and well-being, as well as reducing the burden on health and social care services.

The challenge for museums is establishing and defining a robust protocol that captures the subtle and individual responses of participants during cultural encounters and understanding the wider socio-economic benefits of Museums in Health. The latter could, in principle, be tackled using the same approach as other 'value for money' analyses conducted in collaboration with health economists. The former is perhaps more problematic since even within the healthcare sector, there is no single agreed framework or measurement tool; in fact, the opposite is true – there are literally hundreds of different ways of measuring health and well-being outcomes.

## QUALITATIVE VERSUS QUANTITATIVE?

Staricoff's review of arts and health practices reported that although there was some evidence of good evaluation, generally there was a lack of rigorous research (2006). The same has been said of evaluation within the museum sector; the Museums Libraries and Archives Council's *Review of Research and Literature on Museums and Libraries* reported that whilst there is evidence of some excellent evaluation in museums, there is a lot of weaker evaluation work which lacks a robust research methods framework (MLA 2011). The review also noted that: 'Many studies do not use before-and-after comparisons to determine what difference a particular initiative made to organisations or participants, and rely on self-reported accounts of the difference made, which makes the findings less reliable' and further that 'Studies often do not consider the added value of an initiative, in comparison to what would have happened without it' (MLA 2011: 39). These are extremely pertinent points, especially when considering the impact of museum encounters on health and well-being, where articulating the benefits and added value is vital if the sector is to demonstrate the advantages of a closer engagement between heritage and health.

The methodological approach to evaluation is therefore key to understanding and clearly articulating the outcomes, but identifying which approach is most appropriate is problematic (Raw et al. 2012). In the first instance, there is disagreement within arts and health about what constitutes valid evidence (Putland 2008), with some advocating for the inclusion of quantitative techniques (Hamilton et al. 2003; Staricoff 2006; Dileo and Bradt 2009) and others arguing for qualitative approaches (Angus 2002; White 2009; Simonds et al. 2012). Staricoff proposed that qualitative research relies on 'subjective feedback related to attitudes, feelings and responses' using questionnaires, interviews and focus groups to produce large amounts of data with interpretation 'mainly dependent on the skills of the researcher' (2006: 117). The use of qualitative methods in health research has received criticism for a lack of rigour (Harper and La Fontaine 2008), but recently ethnographic approaches have been recognised for their ability to develop novel theoretical perspectives and new hypotheses, and identify variability in response patterns that might otherwise be missed with other methodological

approaches. Simonds et al. argue that ethnographic approaches 'give researchers insight into human experiences that are otherwise difficult to access' (2012: 157). The integration of ethnographic methods with clinically meaningful outcomes is becoming more widespread (e.g. Gubrium 2000; La Fontaine et al. 2007). Furthermore, some researchers argue for the place of qualitative methods within clinical trials for some conditions, such as dementia, due to the reflexivity of the methods and their participatory nature (Gibson et al. 2004).

Pope and Mays (2006) provide a useful description and explanation of qualitative methods in health research. Qualitative approaches are largely concerned with verbal feedback derived from, for example, conversations, interviews and questionnaires, plus direct observation including the use of video and photography. It often involves observing people in their natural settings rather than experimental or artificial conditions and may involve joining in (also known as participant observation), talking to people (e.g. interviews, focus groups and discussions) and reading what people have written. How such feedback is gathered and analysed varies depending on the qualitative method employed (Pope and Mays 2006). Pope and Mays suggest that qualitative research is concerned with how people make sense of the world and the meanings they attach to their experiences of the social world (2006). Various theoretical perspectives inform qualitative methods, including ethnography, constructionism and phenomenology; these will not be explored further here, but explain why there are such a variety of qualitative methods. The argument for the inclusion of ethnographic qualitative methods in health research is based on the premise that this approach considers the researchers' experiences, derived, for example, from journals or diaries maintained during the study, alongside those of the research participants, including data from text, sound or visual sources such as images or video (Simonds et al. 2012). Many qualitative analyses are informed by Glaser and Strauss' 'grounded theory' (Glaser and Strauss 1967), which is an approach that develops explanatory theories of social interactions based on the data gathered rather than relying on pre-existing theories (Morse and Field 1995; Simonds et al. 2012). Grounded theory has been used in a range of arts and health studies and also applied in certain Museums in Health studies (e.g. Ander et al. 2012a; NML 2012).

In contrast to qualitative methods, Staricoff suggested that quantitative research offers a systematic and controlled observation of the impact of arts programmes on clinical outcomes, which requires representative samples, control groups and collaborative teams to implement measures, analysis and interpretation, before achieving 'critical and rigorous evaluation' (2006: 118). She proposed that: 'The value of using quantitative research for evaluating the effects of the arts in health and healthcare environments resides in the use of objective measurements of the effect of the arts intervention on the physiological, psychological and clinical state of the individual' (2006: 118).

The challenge with quantitative approaches, as highlighted above, is the vast array of different methods available for measuring health, well-being and quality of life (see e.g. Bowling 1997; McDowell and Newell 1996). Some arts and health initiatives have overcome this challenge by developing their own outcome measure. Secker et al. (2009), for instance, developed a social inclusion measure for use with mental health service users in a study assessing the impact of arts participation. Following an extensive literature review, concepts derived from the literature were categorised and mapped against key questions already in use in arts and mental health projects or reported elsewhere (2009: 66). This exercise enabled Secker et al. to develop their own set of questions addressing the following issues: social capital, social acceptance, neighbourhood cohesion, security of housing tenure, engagement in leisure and cultural activities, and citizenship. The questions were first piloted with service users, and feedback was used to refine the questions before field testing with 88 participants. In total, 22 questions were developed and respondents were asked to rate their response using a frequency scale (not at all, not particularly, yes a bit, yes definitely). Secker et al. then undertook a series of statistical tests to assess the validity of their measure and demonstrated that the measure was able to show that poor mental health is generally associated with low levels of social inclusion (2009).

In order to determine which quantitative approach most suited their hospital-based museum object-handling study (*Heritage in Hospitals*),[7] Thomson et al. (2011) reviewed over 100 quantitative measures. The authors appraised key references and searched biomedical databases in order to produce a 'long-list' of potential measures. Measures were excluded if they did not directly measure well-being, for example, if they measured physical disability or psychiatric health, or if they were unlikely to measure change after a short interval, for example, symptoms worsening with age; the latter was relevant since the study was assessing a short, one-off intervention lasting approximately 30 minutes, and this demonstrates the importance of finding a measure which is appropriate for the activity, intervention or encounter being evaluated. This initial culling of potential measures enabled Thomson et al. to review the remaining 'short-list' of potential measures as regards their suitability to selection criteria recommended for health and well-being evaluation, as defined by Staricoff (2006), namely internal and external validity, practicality and sensitivity.

Regarding internal validity, Thomson et al. assessed their 'short-list' of quantitative measures to establish if other researchers had validated the scales, and if so whether these previous studies were able to demonstrate if the measure in question measured what it was supposed to measure. They also assessed external validity by examining the extent to which measures had been previously employed with the healthcare sector; this enabled them to distinguish between disease-specific measures and establish if such measures were more broadly applicable. Given that the *Heritage*

---

7    http://www.ucl.ac.uk/museums/research/touch/heritageinhospitals.

*in Hospitals* study involved a relatively short intervention (c. 30 minutes), Thomson et al. required a correspondingly brief measure which would not take too long to administer. Further, the study required before and after measures, so repeatability was also a key criterion. In order to gauge the fit of the measures to the criteria, they were assessed against various attributes, including the quantity of factors encompassed by the scale as stated by its authors and the total number of questions or phrases to which participants responded. This aspect of review enabled Thomson et al. to reduce the 'short-list' to 10 measurement scales which they placed in three categories: Psychological Well-being; Quality of Life; and Health Status. These measures were further scrutinised since they provided a good match against the selection criteria and were cited in recent psychological, medical and health literature. This final phase of scrutinisation allowed Thomson et al. to narrow the selection down to two measures: the EQ-VAS (EuroQol Group 1990) and the Positive Affect Negative Affect Schedule (PANAS; Watson et al. 1988).

The EQ-VAS was developed as part of the EQ-5D (a standardised health measure) to be a brief standardised instrument to measure physical, emotional and social functioning. Although Thomson et al. found the EQ-5D's coverage was too broad for their project, they discovered that the accompanying pair of visual analogue scales (EQ-VAS, running from zero to 100 for Unwell/Well and Unhappy/Happy) was easy and quick to complete. Furthermore, previous research (Chatterjee and Noble 2009) found that the EQ-VAS was successful in reflecting patients' quality of life (using original phrases: 'Worst imaginable health state' and 'Best imaginable health state'). The PANAS comprises two dimensions (positive and negative emotion) with 10 positive items (such as 'enthusiastic') and 10 negative items (such as 'upset'), which are rated on a five-point Likert scale ('very slightly or not at all' to 'extremely'). Thomson et al. (2011) found that the PANAS produced the most favourable match to selection criteria on the grounds that the mood adjectives appeared relevant to well-being, the five-point scale provided sufficient differentiation of the degree to which each emotion is experienced, and there were a relatively small number of items to administer over two dimensions. After pilot testing the chosen measures and making minor project-specific adaptations, Thomson et al. went on employ the EQ-VAS as a measure of subjective well-being and happiness and the PANAS as a measure of psychological well-being in their study of over 250 museum object-handling sessions in hospitals and care homes (Thomson et al. 2011, 2012a, 2012b; Ander et al. 2012a).

The *Heritage in Hospitals* project combined quality of life and psychological well-being measures, discussed above, with qualitative methods based on Grounded Theory, in a mixed-methods approach to evaluating the effects of museum object handling on hospital patients and care home residents (Thomson et al. 2011, 2012a, 2012b; Ander et al. 2012a). The use of quantitative measures enabled the authors to show that there were significant increases in participants' wellness and happiness, and the use of positive adjectives such as 'enthusiastic' and 'inspired'

following a 30-minute object-handling session (Thomson et al. 2011, 2012a, 2012b). To complement these findings, the qualitative analysis revealed that 'once patient participants were engaged, museum objects provided unique and idiosyncratic routes to stimulation and distraction. The data showed that patients used the heritage objects combined with tailored and easy social interaction, sensory stimulus and learning opportunities to tap into concerns about identity, emotions, energy levels and motivation' (Ander et al. 2012a: 8–12).

Other studies have also employed a mixed-methods framework, involving quantitative and qualitative methods, although this approach is relatively rare in museum evaluation. Mixed methods can offer the dual benefits of scientific rigour backed up by statistical power afforded from quantitative methods, coupled with the richness and deeper, more contextualised understanding afforded by qualitative approaches. As explored briefly in previous chapters, the Museum of Hartlepool developed its own 'Arts and Well-being Evaluation Framework', involving quantitative and qualitative data collection methods. In order to evaluate its *Come Dance with Me Hartlepool* project, it used before and after questionnaires based on the Short Warwick Edinburgh Mental Well-being Scale[8] (SWEMWBS 2007). The SWEMWBS is a shortened version of the Warwick Edinburgh Mental Well-being Scale and it comprises seven statements about mental well-being. Respondents are asked to rate their response to statements such as 'I've been feeling optimistic about the future' and 'I've been able to make up my own mind about things' on a scale of one (none of the time) through to five (all of the time). The SWEMWBS was used alongside a visual analogue scale to form the quantitative arm of the study. Structured interviews, video and photography, plus logbooks which recorded facilitators' experiences formed the basis of the qualitative part of the study. Results from the Museum of Hartlepool evaluation are still pending, but the combination of quantitative and qualitative methods have provided in-depth and robust findings from other Museums in Health studies. Evaluators of the *Arteffact* project employed a mixed-methods approach to understanding the impact of creative art sessions involving people at risk of, or recovering from, mental distress in four museums across North Wales (Neal 2012a). Pre-session (to measure baseline status) and post-session (measured at the end of a c. 10-week course) quantitative effects of the sessions were assessed using the Warwick Edinburgh Mental Well-being Scale (WEMWBS 2006). These data were analysed in association with qualitative feedback derived from interviews conducted during the programme to gain a more complete picture of the impact of the session on participants' mental health and well-being. National Museums Liverpool combined questionnaires, participant observation and interviews in a mixed-methods study of their *House of Memories* training programme (NML 2012). The results of the evaluation were used to inform the delivery and dissemination of the programme, as well as an advocacy tool to

---

8    http://www.healthscotland.com/uploads/documents/14092-SWEMWBSSept2007.pdf.

engage potential trainees, including health and social care staff, plus those living with dementia and their families.

Raw et al. (2012) describe the advantages of an interdisciplinary theoretical framework in arts and health as a means to understanding the outcomes of a complex practice methodology. The Centre for Well-being at the New Economics Foundation recently published a guide to measuring well-being to help practitioners measure well-being outcomes (NEF 2012). Within the guide, they recommend a mixed-methods approach to measuring well-being and in particular using three sets of well-being questions: the Short Warwick Edinburgh Mental Well-being Scale (SWEMWBS 2007); the Office for National Statistics[9] subjective well-being questions; and a question on social trust, which they suggest is a key factor for well-being. We are in agreement regarding the benefits of mixed-methods, interdisciplinary approaches; we advocate that the integration of qualitative and quantitative research methods in evaluation affords an opportunity to demonstrate detailed and nuanced effects from museum encounters in combination with empirically robust outcomes, and offers a valuable way forward in demonstrating and understanding the value of Museums in Health.

## SUMMARY

Whilst there is considerable diversity in the practice of Museums in Health, the evidence base supporting and explaining the benefits of Museums in Health is less robust. To date, museums have employed a variety of approaches to evaluate the efficacy of their programmes and activities on individual health and well-being, but in many cases, evaluation lacks a scholarly rigour and the sector as a whole lacks an agreed framework for measuring health and well-being in relation to museum encounters. Research from allied fields such as arts and health, as well as a few studies from Museums in Health, indicates that the combination of quantitative and qualitative techniques, using a mixed-methods, interdisciplinary, approach, offers a valuable way forward for evaluating the benefits of Museums in Health. Within the heritage sector, those organisations that have worked in association with academic and healthcare partners have derived a deeper and more meaningful understanding of the impact of their work on health and well-being. Critically, the sector requires a more extensive evidence base, gathered from both short- and long-term Museums in Health interventions, in order to understand both the immediate and sustained effects of museum encounters. The next stage is to define a framework for evaluation which is understood and valued by both the heritage and the health/social care sectors. If the sector can agree on such a framework, then studies can be clustered together so that there is a critical mass of information, affording a powerful tool for advocacy, for securing funding and encouraging new partnerships and Museums in Health programmes.

---

9    http://www.ons.gov.uk/ons/guide-method/user-guidance/well-being/index.html.

# MOVING FORWARD AND FINAL CONCLUSIONS

The Marmot Review, *Fair Society, Healthy Lives* (Marmot et al. 2010), outlines the inextricable link between health inequalities and social inequalities, such that there is a 'social gradient in health'. Put simply, the lower a person's socio-economic status, the worse that person's health is likely to be. For example, in England, the poorest people can expect to become ill or experience disability 17 years earlier than people who are wealthier and can expect to die seven years earlier. The Review states that since health inequalities are driven by underlying social factors, including where people are born, grow, live, work and age, actions needed to alleviate health inequalities must tackle a range of social factors. It goes on to propose that in the UK, the NHS and the Department of Health alone cannot reduce health inequalities and that a wider range of societal bodies and actions is needed to reduce the steepness of the social gradient in health.

The government White Paper *Healthy Lives, Healthy People* (DH 2010) endorses many of the findings from the Marmot Review and puts 'local communities at the heart of public health'. The approach set out in this White Paper advocates 'strengthening self-esteem, confidence and personal responsibility', and we propose that museums and associated cultural encounters have a role to play in helping to deliver such outcomes. The Paper also proposes that 'changing adults' behaviour could reduce premature death, illness and costs to society, avoiding a substantial proportion of cancers, vascular dementias and over 30% of circulatory diseases; saving the NHS the £2.7 billion cost of alcohol abuse; and saving society the £13.9 billion a year spent on tackling drug-fuelled crime' (DH 2010: 5). Again, the cultural sector offers a variety of opportunities for both helping to change behaviours (e.g. through public education) and to undertake a healthier lifestyle by engaging in cultural encounters. The White Paper recognises the importance of 'local innovation and outlines the cross-government framework that will enable local communities to reduce inequalities and improve health at key stages in people's lives' (DH 2010: 7), with a focus on child and maternal health, reducing social isolation and improving mental health, and designing communities for active ageing and sustainability, amongst other strategic aims. These are all extremely laudable aims and evidence suggests that such improvements can lead to a reduction in health inequalities, but in reality, given the current economic challenges at local, national and international

levels, how feasible will it be in the future to meet these objectives, and how might the cultural sector be able to help?

The cultural sector, including museums, can contribute to at least two of the six policy objectives outlined in the Marmot Review (Marmot et al. 2010):

- Create and develop healthy and sustainable places and communities.
- Strengthen the role and impact of ill-health prevention.

Liz Forgan, former Chair of Arts Council England (ACE), states 'that the arts and culture are absolutely central to the life of the nation, and that every individual should have the right to experience their richness as part of their life experience, personal development and well-being' (ACE 2011: 3). Given ACE's new strategic responsibility over English museums (and libraries), it is reassuring that its former Chair recognises the value of culture to well-being, albeit at a rather generic level. ACE's strategic document *Culture, Knowledge and Understanding: Great Museums and Libraries for Everyone* promises that the organisation will, amongst other things, 'champion the importance of creative experiences to people's well-being and development and the role access to knowledge and information plays in supporting and inspiring these' (ACE 2011: 21). A valuable element in ACE's strategic document is the link, and potential mutual benefits, drawn between the arts and museums. Creative and participatory arts have formed a vital component of many successful health and well-being programmes in museums, such as the Dulwich Picture Gallery, National Museums Liverpool and Glasgow Museums, to name but a few (see Chapters 1 and 4). ACE go further by recognising that the arts may learn from the experience of museums (and libraries) of innovating in the face of change. Conversely, we draw a strong link between the field of Arts in Health and Museums in Health, and believe valuable lessons can be learnt from the Arts in Health sector in order to define, understand and promote the field of Museums in Health.

ACE also acknowledges the role that museums (and libraries) play in relation to changing lives and communities, citing a contribution to public outcomes such as health, education and return to work. This chimes nicely with documents such as the Marmot Review, where culture and access to cultural heritage, including museums, can be viewed in terms of their wider contribution to individuals and communities. Notably, though, there is very little in ACE's strategic document which outlines the specific and multifarious contributions museums make to enhancing health and well-being; the document does not go beyond recognising the value of creative experiences and the sector's role in public health. Perhaps this is the result of a broad-scoping document which seeks to provide an overview of the sector and ACE's plans for its management and development, or perhaps this highlights the limited profile that this area of museum work has in the eyes of ACE and the wider public sector, including the government. Whatever the reason, it is clear that museums need to articulate their value in enhancing health

and well-being, and the concomitant public health financial savings that cultural encounters can bring about. The latter is beginning to happen, as demonstrated by a reference to the National Museums Liverpool's *House of Memories* training and awareness programme in the recent *The Prime Minister's Challenge on Dementia* report, published by the Department of Health (DH 2012: 8). Initiatives such as the Dulwich Picture Gallery's *Good Times* programme (London) and the Museum of Modern Art's (MoMA) *Meet Me* project (New York) have also attracted considerable media attention, which helps to raise awareness of the sector's contribution to health and well-being.

Internationally, the USA is perhaps the most advanced with regard to the wider recognition of the value of museums to health and well-being. A national initiative *Let's Move! Museums and Gardens*,[1] led by the Institute of Museum and Library Services and launched by the First Lady Michelle Obama, is dedicated to solving the problem of childhood obesity. In a similar vein, the American Alliance of Museums includes a Center for the Future of Museums, which 'helps museums shape a better tomorrow by exploring cultural, political and economic challenges'. One such initiative, *Feeding the Spirit: Museums, Food and Community*, explores how museums can promote food literacy, make their food services healthy and sustainable, and use food to build audiences and strengthen community connections.[2] The associated *Feeding the Spirit Cookbook* provides resources and information for the sector, encouraging museums to act as a 'catalyst for community action on food and nutrition' (AAM 2012: 4).

Although there are numerous international examples of the contribution of museums to health and well-being, discussed in the previous chapters, there appears to be less evidence of national policy or initiatives acknowledging or advocating Museums in Health. The Irish Museums Association and the Irish Heritage Council are seeking to address this issue by raising awareness of Museums in Health initiatives. The Irish Museums Association, for example, recently provided a training day where participants were introduced to the work of *Arteffact*,[3] a project based across various museums in Wales, which seeks to improve the mental health and well-being of people experiencing mental distress through engagement with museums and their artefacts. The eZine of the Irish Heritage Council also produced a special issue on Heritage and Health,[4] featuring the role of natural heritage and heritage planning, as well as Museums in Health. Several other organisations in Ireland, including the

---

1    http://www.imls.gov/about/letsmove.aspx.
2    http://www.aam-us.org/resources/center-for-the-future-of-museums/projects-and-reports/feeding-the-spirit.
3    http://www.lemproject.eu/in-focus/news/arteffact-museums-and-creativity-for-better-mental-health.
4    http://heritagecouncil.newsweaver.ie/newsletter/2uh65615omg8e5c9cgdhxz?a=6&p=29213395&t=22182715.

Irish Museum of Modern Art, the Butler Gallery, Age & Opportunity (a not-for-profit organisation dedicated to older adults) and the Alzheimer Society of Ireland, are working in partnership on an initiative entitled *The Azure Project*[5] which is exploring the potential for greater participation of people with dementia in cultural settings in Ireland, inspired by MoMA's (New York) *Meet Me* project.

In Finland, the Ministry of Education and Culture has developed a specific art and culture programme to promote well-being and health and to enhance inclusion. The Ministry's *Art and Culture for Well-being*[6] initiative identifies three priority areas: 1) culture in promoting social inclusion, capacity building, networking and participation in daily life and living environments; 2) art and culture as part of social welfare and health promotion; and 3) art and culture in support of well-being and health at work. Although the strategy focuses on art and culture in the broadest sense, it is apparent that this includes museums; for example, museums (and libraries and adult education centres) are highlighted as venues that should be supported as meeting and learning places for people, families and groups. In Australia, the New South Wales Government's *Ageing Strategy*[7] highlights active participation in cultural and creative activities to support better physical and mental well-being amongst older adults, although museums and cultural heritage are not referred to specifically.

The above examples highlight the national and international contexts in which Museums in Health might operate, but this reveals that there is still considerable progress to be made with regard to articulating the value of this work and this indicates that a different approach might be required.

## ADVOCATING THE ASSET APPROACH

Foot and Hopkins (2010: 9) argue that current evidence suggests that approaches to improving health and well-being 'aren't working, or aren't working well enough', and they propose an alternative mechanism known as the 'asset approach', which could help by:

- providing new ways of challenging health inequalities;
- valuing resilience;
- strengthening community networks;
- recognising local expertise.

---

5    http://www.artsandhealth.ie/2012/11/20/the-azure-project-some-blue-sky-thinking-on-dementia-and-the-arts.

6    http://www.minedu.fi/export/sites/default/OPM/Julkaisut/2010/liitteet/OKM9.pdf?lang=fi.

7    http://www.artsandhealth.org.au/public/pdf/2012/NSW%20Government%20Ageing%20Strategy%202012.pdf.

The asset approach is defined by Foot and Hopkins as an 'approach [which] values the capacity, skills, knowledge, connections and potential in a community' (2010: 7). The approach has gained significant support, not least from Sir Michael Marmot, who advocates an asset-based approach which fosters confidence and self-esteem for local people and communities as a means to improving health, well-being and resilience (Foot 2012: 3). This approach does not focus on the problems, but instead on assets in the community as a mechanism for solving individual and community challenges. It is compatible with the concept of *salutogenesis*, which suggests that it is more productive to focus on individuals' capacity to support their own health and well-being as opposed to the risks of ill health and disease (Lindström and Eriksson 2005). First advocated by Antonovsky (1979), the salutogenic model explains why some individuals are able to stay well despite personal hardship, while others do not have the power or resources (material, social or psychological) to cope with stress and challenges. Like the asset approach, the salutogenic model focuses on the resources and capacities that people have which positively impact on their health, especially their mental well-being (Foot and Hopkins 2010). This is particularly pertinent when considered in the light of research which demonstrates the links between mental health and physical health, as discussed in the Royal College of Psychiatrists' *No Health Without Public Mental Health* (2010) and later endorsed by the UK government's policy by the same name (DH 2011).

In *A Glass Half-Full: How an Asset Approach Can Improve Community Health and Well-being*, Foot and Hopkins suggest that 'as well as having needs and problems, our most marginalised communities also have social, cultural and material assets. Identifying and mobilising these can help them overcome the health challenges they face' (2010: 6). This is pertinent because the approach puts culture, amongst other assets, at the heart of tackling health and well-being challenges, and offers a way to value the contribution culture makes to improvements in health and well-being.

The asset approach involves asking questions and reflecting on what is already present by focusing on issues such as the following:

- What makes us strong?
- What makes us healthy?
- What factors make us more able to cope in times of stress?
- What makes this a good place to be?
- What does the community do to improve health?

As Foot and Hopkins (2010) explain, the notion of asset working is new and is still being developed, with bespoke methodological approaches (e.g. evaluating community health assets) that are not necessarily transferable to the evaluation of other assets, such as cultural assets. A number of case studies and possible methodological approaches are discussed by Foot and Hopkins (2010) and further

community assets approaches are explored in Foot (2012). The methodological challenge with the asset approach is measuring the specific asset under scrutiny and deciphering the causal relationships between the assets and health. These challenges are not restricted to asset working, as highlighted by numerous health-related studies, and are discussed in Chapter 5 in relation to museums and health and by Davenport and Corner (2011) in relation to cultural activity and health. Whilst it may be possible to show a statistical correlation between museums and health (see e.g. Thomson et al. 2012a and 2012b), proving that one causes the other is more problematic. Notwithstanding these challenges, the asset approach requires a clearly defined goal or set of goals and, once defined, there are a range of techniques available, which are often used in combination with each other, including: asset mapping, storytelling, appreciative conversations and asset-based community development. There is not the space here to discuss any of these at length, but one example is discussed from Foot (2012) of a practice which explicitly acknowledges the power of an asset-based approach for improving health, namely social prescribing.

Social prescribing links patients in primary care with local sources of support within the community. This may include local voluntary or community groups, but there are also examples of cultural social prescribing, such as arts on prescription (Bungay and Clift 2010; Stickley and Hui 2012a and 2012b). As Foot describes, 'many social prescribing schemes use asset mapping tools in order to identify the potential sources of support so that GP practices and others can refer their patients. It connects people to the assets on their doorsteps' (2012: 36).

Foot describes three social prescribing initiatives which have shown that psychosocial, social and cultural interventions improve mental health and well-being. In this context, the notion of museums being an asset in social prescribing initiatives seems obvious, and yet there are very few examples of this in practice. This highlights the mismatch between museums and other community-orientated organisations (such as community centres and voluntary groups) which may be better tied into community health providers (such as GPs or local health and social services). It also strengthens the argument that museums need to develop and maintain effective partnerships with the right kind of partners if they are seeking to actively contribute to the health, well-being and social agendas. There are some excellent examples of museums which are already doing this and offering impressive programmes, but this is far from the norm. The Well London[8] project is a good practical example of this approach, which seeks to get local communities from some of London's most deprived boroughs to work together to improve their health and well-being through arts and culture activities.

The asset approach is valuable in the cultural context as it advocates partnership working (e.g. with local health and social service providers and third sector agencies)

---

8    http://www.welllondon.org.uk.

with a focus on gathering the evidence base. There are parallels with the Social Return on Investment (SROI) model in that the approach focuses on individuals and how their assets, plus associated community assets, can be harnessed to improve health and well-being in a collaborative way in order to build social capital and resilience.

## AN ASSET-BASED APPROACH TO VALUING CULTURE IN RELATION TO HEALTH AND WELL-BEING

> Individuals who are socially isolated are between two and five times more likely than those who have strong social ties to die prematurely. Social networks have a larger impact on the risk of mortality than on the risk of developing disease, that is, it is not so much that social networks stop you from getting ill, but that they help you to recover when you do get ill. (Marmot et al. 2010: 138)

The Marmot Review recognises a clear link between sociality and health and well-being. In Sir Michael Marmot's foreword to 'What Makes Us Healthy?', he states that: 'The [Marmot] review highlights that the health and well-being of people is heavily influenced by their local community and social networks. Those networks and greater social capital provide a source of resilience. The extent to which people can participate and have control over their lives makes a critical contribution to psychosocial well-being and to health' (Foot 2012: 3). Various other studies have highlighted this link. Research by Friedli (2009a) suggests that mental health has a significant social component, for instance. Friedli draws attention to the importance of social networks and practice that sustains community resilience. Further work by Friedli (2009b) advocates interventions that sustain resilience, including those that:

- strengthen social relationships and opportunities for community connection for individuals and families, especially those in greatest need;
- build and enable social support, social networks and social capital within and between communities;
- strengthen and/or repair relationships between communities and health and social care agencies;
- improve the quality of the social relationships of care between individuals and professionals.

Museums and museum interventions could be viewed as a conduit for individual and community 'cultural' assets, with cultural encounters acting as the vehicles which lead to improvements in health and well-being. Harnessing the benefits of cultural encounters through an asset-based approach and encouraging participants

to view cultural encounters through an asset lens may also help individuals, as well as the cultural sector, to value such encounters in a deeper, more meaningful way.

Asset-based working promotes well-being by building social capital, for example, involving face-to-face community networks, civic participation and citizen power, and reciprocal help (e.g. volunteering and time banking). Foot and Hopkins point out that levels of social capital are correlated with positive health outcomes, well-being and resilience, and evidence suggests that 'people with stronger social networks are happier and healthier' (2010: 14).

In *Museums of the Mind*, Wood outlines four aspects of social capital relevant to museums:

- social resources (like the space museums provide for people to come together);
- collective resources;
- economic resources;
- cultural resources (including museums) (2008: 5).

The links between museums, social capital, health and well-being have been highlighted by others (e.g. Silverman 2010) and there is evidence to support the notion that museums can help to build social capital, although this is far from ubiquitous across the sector (e.g. MEAL 2010; Lynch 2011).

So, museums should be valued as places which foster and encourage social interaction, and they should incorporate opportunities for social networking in their access programming. This need not only include offering specific activities which involve social interaction, but could simply involve offering up museum spaces for socialising. This idea is not new and several museums provide their spaces for social engagement outside of their activities/learning programmes – Wolverhampton Art Gallery, for example, offers its space as a meeting place for a women's cancer group. The space appears to have been chosen because, according to the Head of Education and Outreach at Wolverhampton Arts and Museums Service, the Gallery is a 'nice, friendly building' as opposed to the clinical hospital setting (Angela Tombs, cited in Nightingale 2009: 44). Given that 'museums and galleries are one of the few remaining public spaces where people can discuss, learn about, and reflect on life' (Wood 2008: 2), the social element involved in cultural encounters should not be underestimated and is an 'asset' that the sector should build upon and promote. However, the museum as a place for social engagement is not the only asset in the sector's repertoire for improving health and well-being, as the previous chapters have shown. Numerous reports and studies have detailed positive health and well-being outcomes from cultural encounters (see e.g. Table 3.1 in Chapter 3), including and not restricted to:

- positive social experiences, leading to reduced social isolation;
- opportunities for learning and acquiring news skills;
- calming experiences, leading to decreased anxiety;
- increased positive emotions, such as optimism, hope and enjoyment;
- increased self-esteem and sense of identity;
- increased inspiration and opportunities for meaning making;
- positive distraction from clinical environments, including hospitals and care homes;
- increased communication between families, carers and health professionals.

The challenge for the museum sector, as discussed in Chapter 5, is gaining robust evidence to clearly demonstrate these links across the variety of cultural encounters offered by museums. Further work is needed to demonstrate other outcomes, such as the potential link between museum and other cultural encounters and reduced pain intensity or need for medication, for which there is little reliable empirical evidence. Likewise, the role of such encounters in enhanced cognitive functioning and memory improvement is potentially profound, but to date no scholarly studies have explicitly explored this link. There is plenty of evidence which already exemplifies the link between museums and certain positive health outcomes, but other evidence suggests that at present, museums are not articulating this evidence clearly or forcefully enough, and that more robust and empirical evidence is required to properly understand these links and to be able to articulate them to a wider audience, including organisations dedicated to arts, culture and museums (e.g. ACE and the Irish Heritage Council), the health and social care sectors and to governments. Given the uncertain economic future faced by many museums and the imminent change in provision of health and social care in the UK, it is even more imperative now that museums demonstrate their worth and value in good human functioning as a means to maintaining and/or improving health and well-being.

## WAYS FORWARD

When viewed through an assets lens, the above outcomes derived from cultural encounters indicate that museums have a significant role to play in enhancing individual and community health and well-being, and in building social capital and resilience. These assets parallel the key messages outlined in documents such as the Marmot Review and also with many of the UK's think tanks which are focused on health and well-being, such as the New Economics Foundation's 'five ways to well-being' (connect, be active, take notice, keep learning and give: NEF 2011).

The body of evidence collated for this book suggests that if museums really want to contribute to improving individual and community health and well-being, they need to:

- convince the healthcare sector they have a worthwhile contribution to make and disseminate this impact as widely as possible;
- target, albeit not exclusively, those individuals who are most vulnerable/at risk/in need (e.g. socially isolated adults, particularly those in care where resources are woefully insufficient, mental health service users and those in receipt of other healthcare treatments);
- identify target audiences through partnership working (health and social care services, including the NHS, third sector organisations, including voluntary and community sectors, and academic and scholarly institutions such as universities and think tanks);
- develop interventions with partners (this could include any form of museum/ cultural encounter) which are appropriate for their intended audience and which tackle specific health and well-being challenges;
- consult partners and participants to develop the most effective techniques to evaluate and measure the impact of the interventions;
- integrate health and well-being outcomes into mainstream museum programming in order to build resilience and social capital amongst all audiences.

There are numerous examples of successful health and well-being programmes which meet the above objectives (see e.g. Figure 4.1 in Chapter 4), but the key is to provide a sustained 'cultural offer' which focuses on improving health and well-being outcomes as part of the museum's usual programming, rather than the all-too-common 'one-off' time-limited projects for which the long-term, sustained benefits are likely to be minimal. In order to build and sustain resilience in communities, it is clear that museums need to develop long-term relationships with their audiences and partners, so that those communities can reap the maximum health and well-being rewards derived from regular cultural encounters. As Lynch points out in *Whose Cake is it Anyway?* (2011), some community partners have questioned the commitment of their partner museums to developing long-term and sustainable community relationships, largely because museums are often reliant on short-term funding; this is essential if museums want to demonstrate their value by contributing to major agendas such as improving health and well-being, and building social capital and resilience.

## MUSEUMS ON PRESCRIPTION?

Partnership working could take on a new dimension if a more formalised relationship could be developed with the health and social care sectors. As discussed above, social prescribing is a process where health professionals (e.g. GPs) and social care professionals link patients with non-clinical sources of support in their local community. It has been most widely used to tackle mental health issues and social isolation, but many social prescribing services also seek to address a range of

public health challenges, such as obesity and dementia. South et al. discuss various health and well-being benefits of social prescribing and have argued that 'social prescribing extends the boundaries of mainstream primary care to the benefit of patients and professionals' (2008: 317). Although these authors question whether social prescribing is a 'joined-up' solution or simply a 'bolt-on' to mainstream clinical services (2008: 312), they argue that 'the combination of individualised support and linking to community resources makes social prescribing an appropriate public health intervention for primary care' (2008: 316). South et al. suggest that further evidence is required in order to argue confidently for the benefits of social prescribing, but they propose that there is sound evidence that it acts as a mechanism to strengthen community–professional partnerships and that it provides a mechanism to address some of the wider determinants of health.

The idea of social prescribing is of course not new in relation to the cultural sector; art on prescription has been available in a variety of locations across the UK for some time. Although there has been fairly limited research and evaluation of art on prescription programmes, the work that has been undertaken suggests similar benefits to health and well-being as other Arts in Health activities, but because of the direct link with health professionals who refer participants for arts-related therapeutic interventions, more is known about the participants and hence activities can be tailored to their needs (Bungay and Clift 2010).

Stickley and Hui (2012a and 2012b) recently described a qualitative research study evaluating the effectiveness of an art on prescription programme (City Arts Nottingham) aimed at mental health service users. Founded in 2004, the programme has involved 400 service users to date and comprises a 10-week programme led by professional artists, hosted in various community locations. Participants are referred to the programme by mental health professionals from primary and secondary care organisations and the voluntary sector. Stickley and Hui analysed interviews with programme participants and referrers, and determined that a model could be identified whereby the programme provided a 'creative and therapeutic environment' which led to participants experiencing 'social, occupational and psychological benefits', which in turn enable them to 'determine a new future'. The study reports that participants highlighted the importance of providing a 'safe place' in the programme. Stickley and Hui suggest that although the quality of the arts activities is important, it is the safety experienced by the participants that determines social, psychological and occupational benefits. They go on to propose that when grounded in values focused around person-centred humanistic psychology, art on prescription services create an environment which encourages acceptance and support, where friendships develop, people experience peer support, and a group identity evolves' (2012a: 578). The importance of social bonds in well-being, including building friendships, is well known (e.g. Spencer and Pahl 2006) and there is evidence to suggest that people may experience social bonding in 'safe and creative spaces' (Putnam 2000). Furthermore, participants in

the programme reported that it gave them a sense of purpose, which is an aspect of well-being identified by Ryff et al. (2004). Given the diverse range of outcomes reported in this and other social prescribing schemes, it is not hard to envisage how museums could offer such a service, given that many of these outcomes match those already identified by Museums in Health programmes and activities (see e.g. Table 3.1 in Chapter 3).

There are already a few examples of museums and galleries' involvement in arts on prescription services. As discussed in Chapter 3, Dulwich Picture Gallery's *Prescription for Art* service is offered in conjunction with local doctors' surgeries. In another example, the Fitzwilliam Museum in Cambridge offers activities as part of the *Arts and Minds*[9] arts on prescription service. However, whilst the involvement of museums in social prescribing might be on the increase, it is by no means widespread in practice, so the concept of *museums on prescription* or *heritage on prescription* requires some considerable development. Here the sector can learn from well-established arts on prescription services, such as those offered in Nottingham,[10] Stockport,[11] Salford[12] and Cambridgeshire.[13] In addition, libraries may also be a source of advice and guidance via the notion of *Books on Prescription*, a scheme funded by ACE as part of its Libraries Development Initiative.[14]

O'Neill (2010) has explored the idea of 'referral-ready' cultural services. He recognised that given that it can be challenging to persuade non-users or lapsed users to use museums, what is required is 'a referral system that links members of the health service or voluntary organisations with staff in cultural organisations, so that the former can refer their patients/clients/members to the latter' (2010: 27). He has already developed a basic guide for cultural institutions such as museums to become 'referral ready' as he describes it. This includes an efficient and accessible referral method and fully trained staff (front of house and managers) who are aware of the needs of first-time users, which will likely include vulnerable audiences. He argues that such a system 'could transform libraries, museums and other cultural venues from locally based facilities in which access projects take place, into an accessible network of support, entry to any one of which would open up pathways to the cultural and health promotion resources of the entire city or county in which it is based' (2010: 27). But, he warns, the development of key strategic partnerships is essential. As with many museums that run Museums in Health programmes, Glasgow

---

9    http://www.artsandminds.org.uk.

10    http://www.city-arts.org.uk.

11    http://www.stockport.gov.uk/services/leisureculture/libraries/libraryonline/ciss/510484.

12    http://www.startinsalford.org.uk.

13    http://www.artsandminds.org.uk/index.html.

14    http://www.artscouncil.org.uk/what-we-do/supporting-libraries/libraries-development-initiative.

Life, including Glasgow Museums, has focused considerable time on developing partnerships with the NHS and the Glasgow Housing Association in order to develop its referral-ready system.

## THE FUTURE

The future of the health and social care sectors in the UK is set to look very different. The controversial Health and Social Care Act 2012[15] will see radical reforms to the NHS and other services. The Act will abolish Primary Care Trusts and Strategic Health Authorities in favour of *clinical commissioning groups* (CCGs), run in part by GPs and other clinicians, and there is likely to be increased privatisation across the sector. A new national body, *Public Health England*, was established in 2013 as an executive agency of the Department of Health. This body will cascade policy down through local authorities, to whom funding will be transferred, and who will direct local health improvements by coordinating the NHS, social care, housing, environmental health, leisure and transport services. Each local authority will appoint a Director of Public Health who will be a member of a *Health and Well-being Board*. This Board will also comprise local commissioners of health and social care services, including representatives from the CCGs.

A central tenet of these healthcare reforms is a focus on the notion that 'prevention is better than cure' through a 'Big Society'[16] idea, putting individuals at the centre of changing their own lives. The changes will include a greater emphasis on public health and keeping people living independently in the community for longer,[17] in part involving greater involvement of third sector organisations, therefore including museums. It is clear then that given the prospective changes to health and social care in the UK, the museums sector needs to clearly articulate its contribution to health and well-being and that advocacy needs to be directed to members of local Health and Well-being Boards and people such as the Director of Public Health.

Several museums are already well tied into this new era of health commissioning, as demonstrated in the examples explored in previous chapters. The UK Medical Collections Group (UKMCG)[18] recently embarked on an innovative project funded by ACE through its museum subject specialist network funding stream. The *History to Health* project, led by the Thackray Museum (Leeds), looked at collaboration and networking as a means of meeting ACE's goals by using medical and healthcare

---

15    http://www.legislation.gov.uk/ukpga/2012/7/contents.

16    http://www.cabinetoffice.gov.uk/content/big-society-overview.

17    http://www.thackraymedicalmuseum.co.uk/ThackrayMuseum/media/Attachments/historytohealth.pdf.

18    http://www.thackraymedicalmuseum.co.uk/library-resources/uk-medical-collections-group.

collections in innovative ways to engage diverse audiences in projects linked to health agendas. As well as undertaking focused research with over 80 UKMCG members, the project included a one-day conference which included several health commissioning professionals who gave their views on the future role of museums in light of the forthcoming changes to the health and social care sectors. Speakers such as Wakefield District Council's Director of Public Health and the Assistant Chief Executive of Mersey Care NHS Trust acknowledged the potential role of museums in the changing healthcare landscape, seeing museums as 'community assets' and places supporting the development of 'creativity, health and well-being networks'.

Alison Bodley's insightful and highly informative report *History to Health* (Bodley 2012), commissioned as part of the UKMCG project of the same name, offers very practical advice about the opportunities for museums in relation to addressing public health issues, contributing to social care agendas and meeting NHS needs, and creating sustainability and resilience. The report also provides extremely useful information regarding potential funding streams which museums might be able to tap into, particularly in light of the ongoing health and social care reforms which place greater emphasis on the role of third sector organisations in health and well-being.

The document sets out information about the ongoing health and social care reforms in an extremely accessible format, including an overview of the new frameworks which will form the basis for managing and delivering outcomes in the three key areas: Public Health; Social Care; and the NHS. Across each of the three areas, the government has identified a series of domains (Table 6.1) against which achievements will be measured. Bodley proposes that 'virtually any domain' could be used as a focus for museum events or exhibitions.

The Bodley report advocates a wider awareness of Department of Health campaigns, such as *Change4Life*[19] and *Be Clear on Cancer*,[20] as these could be incorporated into aspects of Museums in Health programming, such as public health exhibitions. Specific advice advocates making wider use of buildings and spaces, for example:

- developing trails between buildings or sites;
- providing pedometers encouraging people to count their steps around the museums;
- working with groups with mobility issues where 'exercise' and stimulation around a museum could help recovery;
- making more use of land/park/gardens around museum buildings;

19    http://www.nhs.uk/change4life.

20    http://webarchive.nationalarchives.gov.uk/20130107105354/http://www.dh.gov.uk/health/tag/be-clear-on-cancer.

**Table 6.1** **Public Health, Adult Social Care and NHS domains as defined under the Health and Social Care Act 2012**

| Domain | Public Health | Adult Social Care | NHS |
|---|---|---|---|
| 1 | Improving the wider determinants of health | Enhancing quality of life for people with care and support needs | Preventing people from dying prematurely |
| 2 | Health improvement | Delaying and reducing the need for care and support | Enhancing quality of life for people with long-term conditions |
| 3 | Health protection | Ensuring that people have a positive experience of care and support | Helping people to recover from episodes of ill health or following injury |
| 4 | Healthcare public health (and preventing premature mortality) | Safeguarding people whose circumstances make them vulnerable and protecting from avoidable harm | Ensuring that people have a positive experience of case |
| 5 | | | Treating and caring for people in a safe environment and protecting them from avoidable harm |

*Source*: http://www.legislation.gov.uk/ukpga/2012/7/contents/enacted.

- being aware of the role of museum as a potential safe space with vulnerable groups;
- creating a community around museums and use venues to host slimming clubs, sports clubs, clubs for older people, blood pressure testing, giving blood etc. (Bodley 2012: 14).

Other recommendations focus around public health, social care and the NHS, including:

- making wider use of collections (e.g. archaeological collections, social history domestic objects, recipe books and cookery demonstrations could be used to explore changes in diet over time);
- reviewing and adapting existing programmes in light of 'well-being' agendas;

- contacting Memory Clinics and considering developing reminiscence projects
- museums may have to develop specialised marketing with healthcare professionals tailored to the needs and interests of certain audiences (e.g. older adults);
- being aware of the *Time to Change*[21] agenda and devising exhibitions and events that tackle the stigma around mental health. Also, working with health professionals to devise activities to help people with mental health issues;
- linking dementia and community memory;
- exploring new areas such a palliative care where oral history could provide a therapeutic process;
- considering partnering with the NHS and other healthcare providers;
- developing projects around recovery or specific disease;
- military museums have potential to work with people injured working for the armed services (2012: 15).

Critically, Bodley also recognises that in order for museums to create sustainability and build resilience, it is essential for museums to 'develop partnerships and long-term relationships with healthcare professionals in their area'. As highlighted above, a good place to start is with those people charged with delivering public health services, such as the Director of Public Health and members of the local Health and Well-being Board in the UK. Thus, the importance of developing partnerships across the health and social care sectors in the context of the Museums in Health agenda should not be underestimated, and is perhaps the single most important 'take-home message' of this book.

## CONCLUSIONS

This book makes the case for a new and emerging intervention in health and social care, namely Museums in Health. Diverse examples outlining the practice of museum-led interventions, plus the conceptual framework underlying the field of study, set the scene for a new era of museum programming which is more closely tied to the health and well-being needs of individuals and communities. Whilst we cannot argue that such cultural encounters will cure illness or prevent death, this book has brought together a wide range of evidence to suggest that regular involvement in active, socially engaging activities, such as visiting museums or, better still, being actively involved in museums, can help with a range of health issues and enhance well-being, and in so doing may help to reduce health inequalities, building social capital and resilience. Furthermore, building social resilience in this way enables people to deal better with the negative life changes

---

21    http://www.time-to-change.org.uk.

associated with ageing and lifestyle. Museums have the potential to address a wide spectrum of health, well-being and social needs, including: healthy ageing; health education; reduction of stress; social isolation; pain intensity (possibly linked to reduced drug consumption); enhanced mental health (possibly linked to reduced reliance on mental health services); increased mobility; cognitive stimulation; sociality; and employability. Whilst there is already good evidence for some of these outcomes, others (such as reduction of pain intensity) require a robust evidence base and further work in needed across the field as a whole to fully demonstrate the specific psychological and physical (including physiological) benefits of the wide variety of cultural encounters.

The coming years are likely to bring about uncertainly and significant change in light of health reforms and economic challenges. In addition, the UK and many Western populations are living longer, but are experiencing more age-related diseases (e.g. Alzheimer's disease) and lifestyle-related health problems (e.g. obesity and diabetes). In tandem, as a result of financial pressures and governance changes (e.g. the move in the UK from the Museums, Libraries and Archives Council to ACE), many museums, in the UK at least, are likely to face considerable changes, but this new era of health commissioning, with a focus on prevention rather than cure and greater involvement of the third sector, presents new opportunities for the museum sector. Museums are already well placed to deliver health and well-being outcomes; a track record of delivering social and learning outcomes shows that museums are effective agents of social change. Extending these services and programmes to meet public health, social and healthcare objectives is easily within the reach of all museums, from small, local services through to large national museums, as well as the wider cultural heritage sector. The fact that most museums, and the services they offer, are free means that museums represent 'value for money' as community-based health intervention resources, and can offer venues and programmes to aid with reducing health inequalities, but the health economics evidence for these financial and health benefits also requires considerable work.

These changes need to come about in the context of a fully established Museums in Health movement, grounded in best practice and backed up by a robust evidence base which is valued by both the museum and health sectors. Support will be required from sector-wide organisations such as ACE and Museums Associations, and effective, strategic and sustained partnerships with health commissioners, plus other third sector organisations, are essential. Notwithstanding the above challenges, the potential for museums to contribute to improved health and well-being, and build social capital and resilience is profound.

# BIBLIOGRAPHY

AAM (American Association of Museums) (2012) *The Feeding the Spirit Cookbook: A Resource and Discussion Guide on Museums, Food and Community*. Available at: http://www.aam-us.org/docs/center-for-the-future-of-museums/feeding-the-spirit-cookbook.pdf?sfvrsn=4 (accessed 1 June 2013).

ACE (Arts Council England) (2011) *Culture, Knowledge and Understanding: Great Museums and Libraries for Everyone*. Available at: http://www.artscouncil. org.uk/advice-and-guidance/browse-advice-and-guidance/developing-great-museums-and-libraries (accessed 1 June 2013).

Altheide, D.L. (1987) 'Reflections: ethnographic content analysis'. *Qualitative Sociology*, 10(1), 65–77.

Ander, E.E., Thomson, L.J., Lanceley, A., Menon, U., Noble, G. and Chatterjee, H.J. (2011) 'Generic wellbeing outcomes: towards a conceptual framework for wellbeing outcomes in museums'. *Museum Management and Curatorship*, 26(3), 237–59.

———. (2012a) 'Heritage, health and wellbeing: assessing the impact of a heritage focused intervention on health and wellbeing'. *International Journal of Heritage Studies*. Available at: http://dx.doi.org/10.1080/13527258.2011.651 740 (accessed 1 June 2013).

Ander, E.E., Thomson, L.J., Noble, G., Menon, U., Lanceley, A. and Chatterjee, H.J. (2012b) *Heritage in Health: A Guide to Using Museum Collections in Hospitals and Other Healthcare Settings*. London: UCL. Available at: http://www.ucl.ac.uk/museums/research/touch/publications/heritage-in-health (accessed 1 June 2013).

Angus, J. (2002) *A Review of Evaluation in Community-based Art for Health Activity in the UK*. London: Health Development Council. Available at: http://www.dur.ac.uk/resources/cahhm/reports/CAHHM%20for%20HDA%20J%20 Angus.pdf (accessed 1 June 2013).

Antonovsky, A. (1979) *Health, Stress and Coping*. San Francisco: Jossey-Bass.

Atchison, T.B., Massman, P.J. and Doody, R.S. (2007) 'Baseline cognitive function predicts rate of decline in basic-care abilities of individuals with dementia of the Alzheimer's type'. *Archives of Clinical Neuropsychology*, 22(1), 99–107.

Arigho, B. (2008) 'Getting a handle on the past: the use of objects in reminiscence work', in H.J. Chatterjee (ed.), *Touch in Museums: Policy and Practice in Object Handling*. Oxford: Berg, 205–12.

Baddeley, A.D. (1992) 'Working memory'. *Science*, 255, 556–9.

Balshaw, M., Daniel, J., Mount, P.W. and Regan, D. (2012) 'How museums and galleries can enhance health and wellbeing'. Available at: http://www. healthandculture.org.uk/about (accessed 1 June 2013).

Baron, J.H. (1987) 'Hogarth and hospitals'. *The Lancet*, 330(8574), 1512–14.

——. (1990) 'The Hospital of Santa Maria della Scala, Siena, 1090–1990'. *British Medical Journal*, 301, 1449–51.

Belfiore, E. (2002) 'Art as a means of alleviating social exclusion: does it really work? A critique of instrumental cultural policies and social impact studies in the UK'. *International Journal of Cultural Policy*, 8(1), 91–106.

Belfiore, E. and Bennett, O. (2007) 'Rethinking the social impact of the arts'. *International Journal of Cultural Policy*, 13(2), 135–51.

Bodley, A. (2012) *History to Health: Research into Changing Health Agendas for the UK Medical Collections Group*. UKMCG. Available at: http://www. thackraymuseum.org/uploads/resources/historytohealth.pdf (accessed 1 June 2013).

Bowling, A. (1997) *Measuring Health: A Review of Quality of Life Measurement Scales*. Buckingham: Open University Press.

Brady, M.J., Cella, D.F., Mo, F. et al. (1997) 'Reliability and validity of the Functional Assessment of Cancer Therapy-Breast quality-of-life instrument'. *Journal of Clinical Oncology*, 5, 974–86.

Broderick, S. (2011) 'Arts practices in unreasonable doubt? Reflections on understandings of arts practices in healthcare contexts'. *Arts and Health*, 3(2), 95–109.

Bruera, E., Kuehn, N., Miller, M., Selmser, P. and Macmillan, K. (1991) 'The Edmonton Symptom Assessment System (ESAS): a simple method for the assessment of palliative care patients'. *Journal of Palliative Care*, 7, 6–9.

Bryant, W., Wilson, L. and Lawson, J. (2011) *Ways of Seeing*. London: Brunel University.

Bungay, H. and Clift, S. (2010) 'Arts on prescription: an overview of practice in the UK'. *Perspectives in Public Health*, 130, 277–81.

Burns, S.J.I., Harbuz, M.S., Hucklebridge, F. and Bunt, L. (2001) 'A pilot study into the therapeutic effects of music therapy at a cancer help center'. *Alternative Therapies*, 7(1), 48–56.

BOP (Burns Owen Partnership) (2005) *New Directions in Social Policy: Developing the Evidence Base for Museums, Libraries and Archives in England*. London: Museums, Libraries Archives Council.

Butler, B. (2011) 'Heritage as pharmakon and the muses as deconstruction: – problematising curative museologies and heritage healing', in S. Dudley et al. (eds), *The Thing About Museums: Objects and Experience, Representation and Contestation*. London: Routledge.

Bygren, L.O., Johansson, S.E., Konlaan, B.B., Grjibovski, A.M., Wilkinson A.M. and Sjstr, M. (2009) 'Attending cultural events and cancer mortality: a Swedish cohort study'. *Arts & Health*, 1(1), 64–73.

Camic, P.M. (2010) 'From trashed to treasured: a grounded theory analysis of found objects'. *Psychology of Aesthetics, Creativity and the Arts*, 4(2), 81–92.

Camic, P.M., Brooker, J. and Neal, A. (2011) 'Found objects in clinical practice: preliminary evidence'. *The Arts in Psychotherapy*, 38, 151–9.

Chatterjee, H.J. (2008) *Touch in Museums: Policy and Practice in Object Handling*. Oxford: Berg.

Chatterjee, H.J. and Noble, G. (2009) 'Object therapy: a student-selected component exploring the potential of museum object handling as an enrichment activity for patients in hospital'. *Global Journal of Health Sciences*, 1(2), 42–9.

Chatterjee, H.J., Vreeland, S. and Noble, G. (2009) 'Museopathy: exploring the healing potential of handling museum objects'. *Museum and Society*, 7(3), 164–77.

Classen, C. (2005) *The Book of Touch*. Oxford: Berg.

——. (2007) 'Museum manners: the sensory life of the early museum'. *Journal of Social History*, 40(4), 895–914.

Clark, J.M. and Paivio, A. (1991) 'Dual coding theory and education'. *Educational Psychology Review*, 3, 149–210.

Clifford, S. and Kaspari, J. (2003) 'Australian arts and health'. *Artwork Magazine*, 57, 10–13.

Clift, S., Camic, P.M., Chapman, B., Clayton, G., Daykin, N., Eades, G., Parkinson, C., Secker, H., Stickley, T. and White, M. (2009) 'The state of arts and health in England'. *Arts & Health: An International Journal of Research, Policy and Practice*, 1(1), 6–35.

Clift, S., Nicol, J., Raisbeck, M., Whitmore, C. and Morrison, I. (2010a) 'Group singing, wellbeing and health: a systematic mapping of research evidence'. *University of Melbourne E-Journal*, 2(1). Available at: http://web.education. unimelb.edu.au/UNESCO/pdfs/ejournals/clift-paper.pdf (accessed 1 June 2013).

Clift, S., Hancox, G., Morrison, I., Hess, B., Kreutz, G. and Stewart, D. (2010b), 'Choral singing and psychological wellbeing: quantitative and qualitative findings from English choirs in a cross-national survey'. *Journal of Applied Arts and Health*, 1(1), 19–34.

Cockrill, P. (2012) 'Motoring memories'. *Word of Mouth* (the newsletter of the Oral History Association of Australia, South Australia branch), 63, 14–17.

Cohen, G.D. (2009) 'New theories and research findings on the positive influence of music and art on health with ageing'. *Arts & Health*, 1(1), 48–63.

Cohen, G.D., Perlstein, S., Chapline, J., Kelly, J., Firth, K.M. and Simmens, S. (2006) 'The professionally conducted cultural programs on the physical health, mental health and social functioning of older adults'. *The Gerontologist*, 46(6), 726–34.

Cork, R. (2012) *The Healing Presence of Art*. New Haven: Yale University Press.

Coulson, P and Stickley, T. (2002) 'Finding a voice – artistic expression and practice development'. *Practice Development in Health Care*, 1(2), 85–97.

Craik, F.I.M. and Lockhart, R.S. (1972) 'Levels of processing: a framework for memory research'. *Journal of Verbal Learning and Verbal Behaviour*, 11, 671–84.

Critchley, H. (2008) 'Emotional touch: a neuroscientific overview', in H.J. Chatterjee (ed.), *Touch in Museums: Policy and Practice in Object Handling.* Oxford: Berg, 61–71.

Csikszentmihalyi, M. (2000) *Beyond Boredom and Anxiety: Experiencing Flow in Work and Play*. San Francisco: Jossey-Bass.

Cutler, D. (2009) *Ageing Artfully: Older People and Professional Participatory Arts in the UK*. The Baring Foundation. Available at: http://www.baringfoundation. org.uk/AgeingArtfully.pdf (accessed 1 June 2013).

Cuypers, K., Krokstad, S., Holmen, T.L., Skjei Knudtsen, M., Bygren, L.O. and Holmen, J. (2012) 'Patterns of receptive and creative cultural activities and their association with perceived health, anxiety, depression and satisfaction with life among adults: the HUNT study, Norway'. *Journal of Epidemiology and Community Health*, 66(8), 698–703.

Davenport, B. and Corner, L. (2011) *Review of Policy and Research Evidence Relating to the Ageing, Health and Vitality Project*. Newcastle University. Available at: http://objecthandling.files.wordpress.com/2012/05/policy-research-review-for-ahv1.pdf (accessed 1 June 2013).

Davies, C.R., Rosenberg, M., Knuiman, M., Ferguson, R., Pikora, T. and Slatter, N. (2012) 'Defining arts engagement for population-based health research: art forms, activities and level of engagement'. *Arts & Health*, 4(3), 203–16.

Devlin, P. (2010) *Restoring the Balance: The Effect of Arts Participation on Wellbeing and Health*. Newcastle upon Tyne: Voluntary Arts England. Available at: http://www.voluntaryarts.org/wp-content/uploads/2011/10/Restoring-the-Balance.pdf (accessed 1 June 2013).

DH (Department of Health) (2010) *Healthy Lives, Healthy People: Our Strategy for Public Health in England*. Available at: http://www.dh.gov.uk/prod_consum_dh/groups/dh_digitalassets/documents/digitalasset/dh_127424.pdf (accessed 1 June 2013).

——. (2011) No *Health without Mental Health: A Cross-Government Mental Health Outcomes Strategy for People of All Ages*. Available at: http://webarchive.nationalarchives.gov.uk/20130107105354/http://www.dh.gov.uk/dr_consum_dh/groups/dh_digitalassets/documents/digitalasset/dh_124058.pdf (accessed 1 June 2013).

——. (2012) *The Prime Minister's Challenge on Dementia. Delivering Major Improvements in Dementia Care and Research by 2015: A Report on Progress*. Available at: https://www.wp.dh.gov.uk/dementiachallenge/files/2012/11/The-Prime-Ministers-Challenge-on-Dementia-Delivering-major-improvements-in-dementia-care-and-research-by-2015-A-report-of-progress.pdf (accessed 1 June 2013).

Dileo, C. and Bradt, J. (2009) 'On creating the discipline, profession, and evidence in the field of arts and healthcare'. *Arts & Health*, 1(2), 168–82.

Dodd, J., O'Riain, H., Hooper-Greenhill, E. and Sandell, R. (2002), *A Catalyst for Change: The Social Impact of the Open Museum*. Leicester: Leicester University Research Centre for Museums and Galleries.

Dolev, J.C., Friedlander, L.K. and Braverman, I. (2001) 'Use of fine art to enhance visual diagnostic skills'. *Journal of the American Medical Association*, 286(9), 1020–1021.

Dose, L. (2006) 'National Network for the Arts in Health: lessons learned from six years of work'. *Journal of the Royal Society for the Promotion of Health*, 26(3), 110–12.

Dudley, S.H. (2010) 'Museum materialities: objects, sense and feeling', in S.H. Dudley (ed.), *Museum Materialities: Objects, Engagements, Interpretations*. London and New York: Routledge, 1–17.

Eekelaar, C., Camic, P.M. and Springham, N. (2012) 'Art galleries, episodic memory and verbal fluency in dementia: an exploratory study'. *Psychology of Aesthetics, Creativity, and the Arts*, 6(3), 262–72.

Elliot, D. (1994) 'The effects of music and muscle relaxation of patient anxiety in a coronary care unit'. *Heart and Lung*, 66, 674–82.

Engel, G.L. (1977) 'The need for a new medical model: a challenge for biomedicine'. *Science*, 196, 129–36.

Ereaut, G. and Whiting, R. (2011) *What Do We Mean by 'Wellbeing'? And Why Might it Matter?* Department for Children, Schools and Families, Research Report DCSF-RW073. Available at: https://www.education.gov.uk/publications/eOrderingDownload/DCSF-RW073.pdf (accessed 1 June 2013).

EuroQol Group (1990) 'EuroQol: a new facility for the measurement of health-related quality of life'. *Health Policy*, 16, 199–208.

Falk, J.H. and Dierking, L.D. (2000) *Learning from Museums: Visitor Experiences and the Making of Meaning*. Lanham, MD, AltaMira Press.

Foot, J (2012) *What Makes Us Healthy? The Asset Approach in Practice: Evidence, Action, Evaluation*. Available at: http://www.janefoot.co.uk/downloads/files/healthy%20FINAL%20FINAL.pdf (accessed 1 June 2013).

Foot, J. and Hopkins, T. (2010) *A Glass Half-Full: How an Asset Approach Can Improve Community Health and Well-being*. Improvement and Development Agency. Available at: http://www.local.gov.uk/c/document_library/get_file?uuid=fc927d14-e25d-4be7-920c-1add80bb1d4e&groupId=10171 (accessed 1 June 2013).

Fougner, M. and Kordahl, H.L. (2012,) 'Nude drawing – a relevant tool in health professions education? Developing skills in observation method for reflective physiotherapy practice'. *Arts & Health*, 4(1), 16–25.

Frandsen, J.L. (1990) 'Music is a valuable anxiolytic during local and regional anaesthesia'. *Nurse Anaesthesia*, 1(4), 181–2.

Friedli, L. (2009a) *Mental Health, Resilience and Inequalities*. Geneva: WHO.

———. (2009b) *Resilient Relationships in the North West: What Can the Public Sector Contribute?* NWPHO. Available at: http://www.centreforwelfarereform. org/uploads/attachment/338/resilient-relationships-in-the-north-west.pdf (accessed 1 June 2013).

Frogett, L. and Little, R. (2008) *Precarious Flight: An Evaluation of the Arts Program Running in UCLH.* University of Central Lancashire. Available at: http://clok.uclan.ac.uk/3377/1/Precarious_Flight_Report.pdf (accessed 1 June 2013).

———. (2009) *Evaluation of the UCLH Arts Program: Interim Report July–Dec 2008.* University of Central Lancashire.

Froggett, L., Farrier, A. and Poursanidou, K. (2011) *Who Cares? Museums Health and Well-being: A Study of the Renaissance North West Programme.* University of Central Lancashire. Available at: http://gmartshealth.cubedev. co.uk/CubeCore/.uploads/For%20Cube/case%20studies%20docs/Who%20 Cares%20Report%20FINAL%20w%20revisions.pdf (accessed 1 June 2013).

Galloway, S. and Bell, D. (2006) *Quality of Life and Well-being: Measuring the Benefits of Culture and Sport: Literature Review.* Scottish Government. Available at: http://www.scotland.gov.uk/Publications/2006/01/13110743/0 (accessed 1 June 2013).

Gardner, H. (2006) *Multiple Intelligences: New Horizons.* New York: Basic Books.

GCPH (Glasgow Centre for Population Health) (2010) *The Psychological, Social and Biological Determinants of Health: A Review of the Evidence.* Available at: http://www.gcph.co.uk/assets/0000/0406/GCPH_BP_8_concepts_web.pdf (accessed 1 June 2013).

Gibson, G., Timlin, A., Curran, S. and Wattis, J. (2004) 'The scope for qualitative methods in research and clinical trials in dementia'. *Age and Ageing,* 33, 422–6.

Glaser, B. (1965) 'The Constant Comparative Method of Qualitative Analysis'. *Social Problems,* 12(4), 436–45.

Glaser, B. and Strauss, A. (1967) *The Discovery of Grounded Theory: Strategies for Qualitative Research.* Chicago: Aldine Publishing.

Good, M., Anderson, G.C., Stanton-Hicks., Grass, J.A. and Makii, M. (2002) 'Relaxation and music reduce pain after gynecologic surgery'. *Pain Management Nursing,* 3(2), 61–70.

Goodwin, J.S. (2000) 'Glass half full attitude promotes health in old age'. *Journal of the American Geriatrics Society,* 48, 473–8.

Gregory, K. and Whitcomb, A. (2007) 'Beyond nostalgia: the role of affect in generating historical understanding at heritage sites', in Simon J. Knell, Suzanne MacLeod and Sheila E.R. Watson (eds), *Museum Revolutions: How Museums Change and are Changed.* New York: Routledge, 263–75.

Gubrium, J.F. (2000) 'Narrative practice and the inner worlds of the Alzheimer's disease experience', in Peter J. Whitehouse, Konrad Maurer and Jesse F. Ballenger (eds), *Concepts of Alzheimer Disease.* Baltimore: Johns Hopkins University Press, 181–203.

Hamilton, C., Hinks, S. and Petticrew, M. (2003) 'Arts for health: still searching for the Holy Grail'. *Journal of Epidemiology and Community Health*, 57(6), 401–2.

Harper, S. and Hamblin, K. (2010) *This is Living*. London: Dulwich Picture Gallery.

Harper, S. and La Fontaine, J. (2008) 'Ethnography', in J. Neale (ed.), *Research Methods for Health And Social Care*. Basingstoke: Palgrave Macmillan, 238–52.

Hein, G. (1998) *Learning in the Museum*. London: Routledge.

Hicks, D., Creaser, C., Greenwood, H., Spezi, V., White, S. and Frude, N. (2010) *Public Library Activity in the Areas of Health and Wellbeing. Final Report*. London: Museums, Libraries and Archives Council.

Johansson, S.E., Konlaan, B.B. and Bygren, L.O. (2001) 'Sustaining habits of attending cultural events and maintenance of health: a longitudinal study'. *Health Promotion International*, 16(3), 229–34.

Kaplan, S. (1995) 'The restorative effects of nature: toward an integrative framework'. *Journal of Environmental Psychology*, 16, 169–82.

Kaplan, S., Bardwell, L.V. and Slakter, D.B. (1993) 'The museum as a restorative environment'. *Environment and Behavior*, 25(6), 725–42.

Kavanagh, G. (2000) *Dream Spaces: Memory and the Museum*. Leicester: Leicester University Press.

Khawaja, M., Barazi, R. and Linos, N. (2007), 'Maternal cultural participation and child health status in a Middle Eastern context: evidence from the Urban Health Study'. *Child Care Health Development*, 33(2), 117–25.

Kirklin, D., Duncan, J., McBride, S., Hunt, S. and Griffin, M. (2007) 'A cluster design controlled trial of arts-based observational skills training in primary care'. *Medical Education*, 41, 395–401.

Klein, M. (1997 [1932]) *The Psychoanalysis of Children*. New York: Vintage Books.

Koch, M.E., Kain, Z.N., Ayoub, C. and Rosenbaum, S.H. (1998) 'The sedative and analgesic sparing effect of music'. *Anaesthesiology*, 89, 300–306.

Konlaan, B.B., Bygren, L.O. and Johansson, S.E. (2000) 'Visiting the cinema, concerts, culture or art exhibitions as determinant of survival: a Swedish fourteen-year cohort follow-up'. *Scandinavian Journal of Public Health*, 28, 174–8.

La Fontaine, J., Ahuja, J., Bradbury, N.M., Phillips, S. and Oyebode, J.R. (2007) 'Understanding dementia amongst people in minority ethnic and cultural groups', *Journal of Advanced Nursing*, 60(6), 605–14.

Lanceley, A., Noble, G., Johnson, M., Balogun, N., Chatterjee, H.J. and Menon, U. (2011) 'Investigating the therapeutic potential of a heritage-object focused intervention: a qualitative study'. *Journal of Health Psychology*, 17(6), 809–20.

Lindström, B. and Eriksson, M. (2005) 'Salutogenesis'. *Journal of Epidemiology and Community Health*, 59, 440–442.

Lynch, B. (2008) 'The amenable object: working with diaspora communities through psychoanalysis of touch', in H.J. Chatterjee (ed.), *Touch in Museums: Policy and Practice in Object Handling*. Oxford: Berg, 261–72.

——. (2011) *Whose Cake is it Anyway?* Paul Hamlyn Foundation. Available at: http://www.phf.org.uk/page.asp?id=1417 (accessed 1 June 2013).

Mack, J. (2003) *The Museum of the Mind: Art and Memory in World Cultures*. London: The British Museum Press.

Marmot, M., Allen, J., Goldblatt, P., Boyce, T., McNeish, D., Grady, M. and Geddes, I. (2010) *Fair Society, Healthy Lives*. Macnaughton, J., White, M. and Stacey, R. (2005) 'Researching the benefits of arts and health'. *Health Education*, 105(5), 332–9.

Marmot Review. Available at: http://www.instituteofhealthequity.org/projects/fair-society-healthy-lives-the-marmot-review (accessed 1 June 2013).

Matarasso, F. (1997) *Use or Ornament? The Social Impact of Participation in the Arts*. Stroud: Comedia.

——. (2003) 'Smoke and mirrors: a response to Paola Merli's "Evaluating the social impact of participation in arts activities" IJCP, 2002, VOL. 8(1)'. *International Journal of Cultural Policy*, 9(3), 337–46.

Museum of East Anglian Life [MEAL] (2010) *Investing in Culture and Community. The Social Return on Investing in Work-based Learning at the Museums of East Anglian Life*. MEAL and MB Associates.

McDowell, I. and Newell, C. (1996), *Measuring Health: A Guide to Rating Scales and Questionnaires*. Oxford: Oxford University Press.

McGlone, F. (2008) 'The two sides of touch: sensing and feeling', in H.J. Chatterjee (ed.), *Touch in Museums: Policy and Practice in Object Handling*. Oxford: Berg, 41–60.

McNair, D.M., Lorr, M. and Droppleman, L.F. (1992) *POMS Manual*, 3rd edn. San Diego, CA: EdITS/Educational and Industrial Testing Service.

Merli, P. (2002) 'Evaluating the social impact of participation in arts activities. A critical review of François Matarasso's use or ornament?' *International Journal of Cultural Policy*, 8(1), 107–18.

Miluk-Kolasa, B., Obminski, Z., Stpnicki, R. and Golec, L. (1994) 'Effects of music treatment on salivary cortisol in patients exposed to pre-surgical stress'. *Experimental Clinical Endocrinology*, 102(2), 118–20.

MLA (Museums Libraries and Archives Council) (2011) *A Review of Research and Literature on Museums and Libraries*. Available at: http://www.artscouncil. org.uk/publication_archive/museums-and-libraries-research-review (accessed 1 June 2013).

Morse, J.M. and Field, P.A. (1995) *Qualitative Research Methods for Health Professionals*, 2nd edn. Thousand Oaks, CA: Sage.

Mykletun, A., Bjerkeset, O., Dewey, M. et al (2007) 'Anxiety, depression and cause-specific mortality: the HUNT study'. *Psychosomatic Medicine*, 69, 323–31.

Mykletun, A., Bjerkeset, O., Øverland, S. et al. (2009) 'Levels of anxiety and depression as predictors of mortality: the HUNT study'. *British Journal of Psychiatry*, 195, 118–25.

Naghshineh, S., Hafler, J.P., Miller, A.R., Blanco, M.A., Lipsitz, S.R., Dubroff, R.P., Khoshbin, S. and Katz, J.T. (2008) 'Formal art observation training improves medical students' visual diagnostic skills'. *Journal of General Internal Medicine*, 23(7), 991–7.

Nash, T. and Aitchison, L. (2009) *heritage2health Evaluation report*. Kingston University and St George's University of London. Available at: http://www.heritage2health.co.uk/wp-content/uploads/2011/05/heritage2health-Evaluation-Report.pdf (accessed 1 June 2013).

Nainis, N., Paice, J.A., Ratner J. et al. (2006) 'Relieving symptoms in cancer: innovative use of art therapy'. *Journal of Pain and Symptom Management*, 31, 162–9.

Neal, C. (2012a) *Can Creative Engagement in Museums Improve the Mental Health and Wellbeing of People Experiencing Mental Distress? A Mixed Methods Pilot Study*. Arteffact Final Report. Available at: http://www.acces3ability.co.uk/evaluation (accessed 1 June 2013).

——. (2012b) 'Arteffact: museums and creativity for better mental health'. *Engage*, 30, 39–47. Available at: http://www.engage.org/journal.aspx?id=31 (accessed 1 June 2013).

NEF (New Economics Foundation) (2004) *The Power and Potential of Wellbeing: Measuring Young People's Wellbeing in Nottingham*. Available at: http://www.neweconomics.org/publications/power-and-potential-well-being-indicators (accessed 1 June 2013).

——. (2009) *National Accounts of Wellbeing: What is Wellbeing?* Available at: http://www.nationalaccountsofwellbeing.org/learn/what-is-well-being.html (accessed 1 June 2013).

——. (2011) *Five Ways to Wellbeing: New Applications, New Ways of Thinking*. Available at: http://www.neweconomics.org/sites/neweconomics.org/files/Five_Ways_to_Wellbeing.pdf (accessed 1 June 2013).

——. (2012) *Measuring Well-being. A Guide to Practitioners*. Available at: http://www.neweconomics.org/sites/neweconomics.org/files/Measuring_well-being_handbook_FINAL.pdf (accessed 1 June 2013).

Newman, A. and McLean, F. (2006) 'The impact of museums upon identity'. *International Journal of Heritage Studies*, 12(1), 49–68.

Nightingale, F. (1860) *Notes on Nursing. What it is, and What it is Not*. New York: D. Appleton and Company.

Nightingale, J. (2009) 'Working knowledge: therapeutic museums', *Museum Practice*, Winter, 39–55.

NML (National Museums Liverpool) (2012) *House of Memories. National Museums Liverpool*. Evaluation report. Available at: http://www.liverpoolmuseums.org.uk/learning/documents/House-of-Memories-evaluation-report.pdf (accessed 1 June 2013).

Noble, G. and Chatterjee, H.J. (2008) 'Enrichment programs in hospitals: using museum loan boxes in University College London Hospital', in H.J. Chatterjee (ed.), *Touch in Museums: Policy and Practice in Object Handling*. Oxford: Berg, 215–23.

O'Neill, M. (2009) *Cultural Participation and Health*. Glasgow: Culture and Sport Glasgow.

——. (2010) 'Cultural attendance and public mental health – from research to practice'. *Journal of Public Mental Health*, 9(4), 22–9.

O'Sullivan, J. (2008) 'See, touch & enjoy: Newham University Hospital's Nostalgia Room', in H.J. Chatterjee (ed.), *Touch in Museums: Policy and Practice in Object Handling*. Oxford: Berg, 224–30.

Paivio, A. (1986) *Mental Representations: A Dual-coding Approach*. New York: Oxford University Press.

Pearce, S.M. (1995) *On Collecting: An Investigation into Collecting in the European Tradition*. London and New York: Routledge.

Pes, J. (2009) 'Case study: Museum of Life stories', in J. Nightingale (ed.), 'Working Knowledge: Therapeutic Museums', *Museum Practice*, Winter, 45.

Phillips, L. (2008) 'Reminiscence: recent work at the British Museum', in H.J. Chatterjee (ed.), *Touch in Museums: Policy and Practice in Object Handling*. Oxford: Berg, 199–204.

Pope, C. and Mays, N. (2006) 'Qualitative methods in health research', in C. Pope and N. Mays (eds), *Research in Health Care*. New York: John Wiley & Sons.

Potter, S. (2012) 'The search for a common language: to evidence or not to evidence?' *Engage*, 30, 11–20.

Pressman, S. and Cohen, S. (2005) 'Does positive affect influence health?' *Psychological Bulletin*, 131, 925–71.

Puig, A., Lee, S.M., Goodwin, L. and Sherrard, P.A. (2006) 'The efficacy of creative arts therapies to enhance emotional expression, spirituality, and psychological well-being of newly diagnosed stage I and stage II breast cancer patients: a preliminary study'. *Art Psychotherapy*, 33, 218–28.

Putland, C. (2008) 'Lost in translation'. *Journal of Health Psychology*, 13(2), 265–76.

Putnam, R. (2000) *Bowling Alone: The Collapse and Revival of American Community*. New York: Simon & Schuster.

Pye, L. (2008) *The Power of Touch: Handling Objects in Museum and Heritage Context*. London: University College London Institute of Archaeology Publications.

Rankin, C. (2012) 'The potential of generic social outcomes in promoting the positive impact of the public library: evidence from the national year of reading in Yorkshire'. *Evidence-Based Library and Information Practice*, 7(1), 7–21.

Raw, A., Lewis, S., Russell, A. and Macnaughton, J. (2012) 'A hole in the heart: confronting the drive for evidence-based impact research in arts and health'. *Arts and Health*. 4(2), 97–108.

RCMG (Research Centre for Museums and Galleries) (2003) *Measuring the Outcomes and Impact of Learning in Museums, Archives and Libraries: The Learning Impact Research Project End of Project Paper*. RCMG: University of Leicester. Available at: http://www2.le.ac.uk/departments/museumstudies/rcmg/projects/lirp-1-2/LIRP end of project paper.pdf (accessed 1 June 2013).

Renaissance North West (2011) *Who Cares? Museums, Health and Wellbeing*. MLA Renaissance North West.

Rosenberg, F., Parsa, A., Humble, L. and McGee, C. (2009) *Meet Me: Making Art Accessible to People with Dementia*. New York: Museum of Modern Art.

Royal College of Psychiatrists (2010) *No Health without Public Mental Health. The Case for Action*. Available at: http://www.rcpsych.ac.uk/pdf/Position%20Statement%204%20website.pdf (accessed 1 June 2013).

Ruiz, J. (2004) *A Literature Review of the Evidence Base for Culture, the Arts and Sport Policy*. Scottish Government. Available at: www.scotland.gov.uk/Publications/2004/08/19784/41510 (accessed 1 June 2013).

Ryff, C.D., Singer, B.H., Dienberg Love, G. (2004) 'Positive health: connecting well-being with biology'. *Philosophical Transactions of the Royal Society of London B: Biological Sciences*, 359, 1383–94.

Salom, A. (2008) 'The therapeutic potentials of a museum visit'. *International Journal of Transpersonal Studies*, 27, 1–6.

Sandel, S.L., Judge, J.O., Landry N. et al. (2005) 'Dance and movement program improves quality-of-life measures in breast cancer survivors'. *Cancer Nursing*, 28, 301–9.

Sandell, R. (2002) *Museums, Society, Inequality*. London: Routledge.

Schorr, J.A. (1993) 'Music and pattern change in chronic pain'. *Advances in Nursing Science*, 15(4), 27–36.

Secker, J., Hacking, S., Kent, L., Shenton, J. and Spandler, H. (2009) 'Development of a measure of social inclusion for arts and mental health project participants'. *Journal of Mental Health*, 18(1), 65–72.

Seligman, M.E.P. (2002) *Authentic Happiness: Using the New Positive Psychology to Realize Your Potential for Lasting Fulfillment*. New York: Free Press.

Senior, P and J. Croall, J. (1993) *Helping to Heal: The Arts in Health Care*. London: Calouste Gulbenkian Foundation.

Shacham, N. (1983) 'A shortened version of the profile of mood states'. *Journal of Personality Assessment*, 47, 305–6.

Shapiro, J., Rucker, L. and Beck, J. (2006) 'Training the clinical eye and mind: using the arts to develop medical students' observational and pattern recognition skills'. *Medical Education*, 40, 263–8.

SWEMWBS (Short Warwick Edinburgh Mental Well-being Scale) (2007) Available at: http://www.healthscotland.com/uploads/documents/14092-SWEMWBSSept2007.pdf (accessed 1 June 2013).

Silverman, L.H. (2002) 'The therapeutic potential of museums as pathways to inclusion', in R. Sandell (ed.), *Museums, Society, Inequality*. London and New York: Routledge

——. (2010) *The Social Work of Museums*. London: Routledge

Simmons, L.L. (2006) *Interactive Art Therapy: 'No Talent Required' Projects*. New York: Haworth Press.

Simonds, L., Camic, P.M. and Causey, A. (2012) 'Using focused ethnography in psychological research', in H. Cooper, P.M. Camic, D. Long, A. Panter, D. Rindskof and K. Sher (eds), *The Handbook of Research Methods in Psychology*. Washington DC: American Psychological Association, 157–70.

Smith, H. (2012) 'Art in medical training: a medical perspective'. *Engage*, 30, 105–7.

Sonke, J., Rollins, J., Brandman, R. and Graham_Pole, J. (2009) 'The state of the arts in healthcare in the United States'. *Arts & Health*, 1(2), 107–35.

South, J., Higgins, T.J., Woodall, J. and White, S.M. (2008) 'Can social prescribing provide the missing link?' *Primary Health Care Research & Development*, 9, 310–18.

Spector, A., Orrell, M., Davies, S. et al. (2001) 'Can reality orientation be rehabilitated? Development and piloting of an evidence based programme of cognition-based therapies for people with dementia'. *Neuropsychological Rehabilitation*, 11, 377–97.

——. (2003) 'Efficacy of an evidence-based cognitive stimulation therapy programme for people with dementia: randomised controlled trial'. *British Journal of Psychiatry*, 183, 248–54.

Spence, C. and Gallace, A. (2008) 'Making sense of touch', in H.J. Chatterjee (ed.), *Touch in Museums: Policy and Practice in Object Handling*. Oxford: Berg, 21–40.

Spencer, L. and Pahl, R. (2006) *Rethinking Friendship: Hidden Solidarities Today*. Princeton: Princeton University Press.

Spielberger, C.D. and Sydeman, S.J. (1994) 'State-trait anxiety inventory and state-trait anger expression inventory', in E, Maruish (ed.), *The Use of Psychological Testing for Treatment Planning and Outcome Assessment*. Hillsdale, NJ: Lawrence Erlbaum Associates, 292–321.

——. (2006) 'Arts in health: the value of evaluation'. *Perspectives in Public Health*, 126(3), 116–20.

——. (2007) *A Prospectus for Arts and Health*. Arts Council England. Available at: http://www.artscouncil.org.uk/publication_archive/a-prospectus-for-arts-and-health (accessed 1 June 2013).

Staricoff, R.L., Duncan, J., Wright, M., Loppert, S. and Scott, J. (2001) 'A study of the effects of visual and performing arts in healthcare'. *Hospital Development*, 32, 25–8.

Staricoff, R.L. and Loppert, S. (2003) 'Integrating the arts into healthcare: can we affect clinical outcomes?', in D. Kirklin and R. Richardson (eds), *The Healing Environment: Without and Within*. London: Royal College of Physicians, 63–79.

Stickley, T. and Hui, A. (2012a) 'Social prescribing through arts on prescription in a UK city: participants' perspectives (part 1)', *Public Health*, 126, 574–9.

——. (2012b) 'Social prescribing through arts on prescription in a UK city: referrers' perspectives (part 2)'. *Public Health*, 126, 580–586.

Stickley, T., Price, V. and Foster, M. (2008) *Open to All – Mental Health and Social Inclusion Training for Museums and Galleries*. National Social Inclusion Programme and Museums, Libraries and Archives Council.

Thomson, L., Ander, E., Lanceley, A., Menon, U., Noble, G. and Chatterjee, H.J. (2012a) 'Enhancing cancer patient well-being with a non-pharmacological, heritage-focused intervention'. *Journal of Pain and Symptom Management*, 44(5), 731–40.

——. (2012b) 'Quantitative evidence for wellbeing benefits from a heritage-in-health intervention with hospital patients'. *International Journal of Art Therapy*, 17(2), 63–79.

Thomson, L., Ander, E., Menon, U., Lanceley, A. and Chatterjee, H.J. (2011) 'Evaluating the therapeutic effects of museum object handling with hospital patients: a review and initial trial of wellbeing measures'. *Journal of Applied Arts and Health*, 2(1), 37–56.

Turner, J. and Kelly, B. (2000) 'Emotional dimensions of chronic disease'. *British Medical Journal*, 172, 124–8.

Ulrich, R.S. (1984) 'View from a window may influence recovery from surgery'. *Science*, 224(4647), 420–421.

——. (1992) 'How design impacts wellness'. *Healthcare Forum Journal*, 35(5), 20–25.

UNESCO (1972) *Convention Concerning the Protection of the World Cultural and Natural Heritage*.

Vernon, M. (2008) *Wellbeing (The Art of Living)*. Durham: Acumen Publishing.

Vormbrock, J.K. and Grossberg, J.M. (1988) 'Cardiovascular effects of human-pet dog interactions'. *Journal of Behavioural Medicine*, 11, 509–17.

Walsh, S.M., Martin, S.C. and Schmidt, L.A. (2004) 'Testing the efficacy of a creative-arts intervention with family caregivers of patients with cancer'. *Journal of Nursing Scholarship*, 36, 214–19.

Walther-Larsen, S., Deimar, V. and Valentin, N. (1998) 'Music during regional anaesthesia'. *Regional Anaesthesia*, 13, 69–71.

Wang S.M., Kulkamia, L., Doley, J. and Kain, Z.N. (2002) 'Music and pre-operative anxiety: a randomized, controlled study'. *Anaesthesia & Analgesia*, 94(6), 1489–94.

Watson, D., Clark, L. and Tellegen, A. (1988) 'Development and validation of brief measures of positive and negative affect: the PANAS scales'. *Journal of Personality and Social Psychology*, 54, 1063–70.

WEMWBS (Warwick Edinburgh Mental Well-being Scale) (2006) Available at: http://www.healthscotland.com/documents/1467.aspx (accessed 1 June 2013).

White, M. (2009) *Arts Development in Community Health: A Social Tonic*. Oxford: Radcliffe Publishing.

WHO (1946) Preamble to the Constitution of the World Health Organization as adopted by the International Health Conference, New York, 19–22 June 1946;

signed on 22 July 1946 by the representatives of 61 States (Official Records of the World Health Organization, no. 2, p. 100) and entered into force on 7 April 1948.

Wilkinson, A.V., Waters, A.J., Bygren, L.O. and Taro, A.R. (2007) 'Are variations in rates of attending cultural activities associated with population health in the United States?' *Public Health*, 7, 226.

Wilson, M. (1975) *Health is for People*. London: Darton, Longman & Todd Ltd.

Wilson, S. (2006) 'What can the arts bring to medical training?' *The Lancet*, 368, 15–16.

Windsor, J. (2005) *Your Health and the Arts: A Study of the Association between Arts Engagement and Health*. London: Arts Council England. Available at: http://www.artscouncil.org.uk/media/uploads/documents/publications/yourhealth_phpfUVFl8.pdf (accessed 1 June 2013).

Winnicott, D.W. (1992) 'Transitional objects and transitional phenomena', in *Through Paediatrics to Psychoanalysis: Collected Papers*. London: Brunner-Routledge, 229–42.

Wood, C. (2008) *Museums of the Mind: Mental Health, Emotional Well-being, and Museums*. Bude: Culture Unlimited. Available at: http://www.cultureunlimited.org/museumsof-the-mind.php (accessed 1 June 2013).

Zamierowski, M.J. and Gordon, A. (1995) 'The use of creative artforms to enhance counselling skills of hospice professionals in dealing with the bereaved'. *American Journal of Hospice and Pallative Care*, 12(1), 5–8.

Zeisel, J. (2009) *I'm Still Here: A New Philosophy of Alzheimer's Care*. New York: Avery.

Zigmond, A.S. and Snaith, R.P. (1983) 'The hospital anxiety and depression scale'. *Acta Psychiatrica. Scandinavica*, 67, 361–70.

Zimmerman, L., Nieveen, J., Baranason, S. and Schmader, M. (1996) 'The effects of music interventions on post-operative pain and sleep in coronary artery bypass graft (CABG) patients'. *School Inquest Nursing Practice*, 10(2), 171–4.

# INDEX